Technologies of the Self-Portrait

This book demonstrates how artists have radically revisited the genre of the self-portrait by using a range of technologies and media that mark different phases in what can be described as a history of self- or selves-production.

Gabriella Giannachi shows how artists constructed their presence, subjectivity, and personhood, by using a range of technologies and media including mirrors, photography, sculpture, video, virtual reality, and social media to produce an increasingly fluid, multiple, and social representation of their 'self'.

This interdisciplinary book draws from art history, performance studies, visual culture, new media theory, philosophy, computer science, and neuroscience to offer a radical new reading of the genre.

Gabriella Giannachi is Professor in Performance and New Media, and Director of the Centre for Intermedia at the University of Exeter.

Routledge Advances in Art and Visual Studies

This series is our home for innovative research in the fields of art and visual studies. It includes monographs and targeted edited collections that provide new insights into visual culture and art practice, theory, and research.

Art After Instagram
Art Spaces, Audiences, Aesthetics
Lachlan MacDowall and Kylie Budge

The Artist-Philosopher and Poetic Hermeneutics
On Trauma
George Smith

Art, the Sublime, and Movement
Spaced Out
Amanda du Preez

Visual Culture and the Forensic
Culture, Memory, Ethics
David Houston Jones

Posthuman and Nonhuman Entanglements in Contemporary Art and the Body
Justyna Stępień

Race, Gender, and Identity in American Equine Art
1832 to the Present
Jessica Dallow

Where is Art?
Space, Time, and Location in Contemporary Art
Edited by Simone Douglas, Adam Geczy, and Sean Lowry

Counterfactualism in the Fine Arts
Elke Reinhuber

For more information about this series, please visit: https://www.routledge.com/Routledge-Advances-in-Art-and-Visual-Studies/book-series/RAVS

Technologies of the Self-Portrait

Identity, Presence and the Construction of the Subject(s) in Twentieth and Twenty-First Century Art

Gabriella Giannachi

Routledge
Taylor & Francis Group

NEW YORK AND LONDON

Cover image: Lynn Hershman Leeson. Still from the video *The Electronic Diary 1984–2019*. Courtesy Bridget Donahue Gallery NYC and Altman Siegal Gallery SF.

First published 2023
by Routledge
605 Third Avenue, New York, NY 10158

and by Routledge
4 Park Square, Milton Park, Abingdon, Oxon OX14 4RN

Routledge is an imprint of the Taylor & Francis Group, an informa business

© 2023 Taylor & Francis

Library of Congress Cataloging-in-Publication Data
Names: Giannachi, Gabriella, author.
Title: Technologies of the self-portrait : identity, presence and the construction of the subject(s) in twentieth and twenty-first century art / Gabriella Giannachi.
Description: New York : Routledge, 2022. | Includes bibliographical references and index.
Identifiers: LCCN 2022009978 (print) | LCCN 2022009979 (ebook) | ISBN 9781138604452 (hardback) | ISBN 9781032310183 (paperback) | ISBN 9780429468483 (ebook)
Subjects: LCSH: Self-portraits--Social aspects. | Art and technology.
Classification: LCC N7618 .G53 2022 (print) | LCC N7618 (ebook) | DDC 704.9/42--dc23/eng/20220512
LC record available at https://lccn.loc.gov/2022009978
LC ebook record available at https://lccn.loc.gov/2022009979

ISBN: 978-1-138-60445-2 (hbk)
ISBN: 978-1-032-31018-3 (pbk)
ISBN: 978-0-429-46848-3 (ebk)

DOI: 10.4324/9780429468483

Typeset in Sabon
by Taylor & Francis Books

For my mother, Liselotte Giannachi-Mangels,
and my father, Bruno Giannachi,
with infinite gratitude and much love.

Contents

List of figures ix
Acknowledgements xii

Introduction 1

Introducing the self 1
The self-determining individual 2
Social selves 4
Producing the self 5
Relational selves 6
Post-human selves 7
Mapping the self 7
Presencing 8
The order of things 10

1 The invention of the self-portrait 13

The origin of the self-portrait 14
Performing presence: the self-portrait during the Renaissance 16
The independent self-portrait: the case of Dürer 18
The act of painting 22
Collecting self-portraits 26
Self-portraits as theatres: the case of Rembrandt 28
Beyond representation: the case of Velázquez 34
From self-fashioning to immersion 36
Enter the viewer: the case of Pistoletto 39

2 The photographic self-portrait 43

The origin of the photographic self-portrait 45
The production of the subject in the work of Claude Cahun 49
The intermedial self-portrait in the work of Ana Mendieta 51
The act of becoming in the work of Francesca Woodman 54
The multiplication of the subject in the work of Lynn Hershman Leeson 56

viii *Contents*

 Identity transfer in the work of VALIE EXPORT 60
 Constructing the self as an other: the case of Cindy Sherman 61
 Self-portrait in a mask: the case of Gillian Wearing 65
 Self-portrait as power: Zanele Muholi 67

3 Sculpting the self 71

 The origin of the sculptural self-portrait 71
 The medical self-portrait 74
 Sculpted action: Arte Povera's Giuseppe Penone and Gilberto Zorio 78
 Entering the body: the case of Antony Gormley 82
 Sculpting the body: the case of Orlan 84
 Stelarc's cybernetic body sculptures 87

4 Video self-portraits 93

 Self-perception in the work of Dan Graham 95
 Presence and absence in the work of Gary Hill 100
 Environmental presence: the case of Joan Jonas 103
 Re-presencing the subject: Lynn Hershman Leeson 105
 Surveillance: from wearable computers to AI 110

5 The selfie 114

 The origin of the selfie 116
 The aesthetics of the selfie 121
 Community and museum selfies 123
 Performing selves in character on social media: the case of Amalia
 Ulman 126
 The algorithmic construction of the subject in Erica Scourti's works 129
 Cached Collective 132

 Conclusion 134

 References 136
 Index 149

Figures

1.1 Giovanni Boccaccio, *De Claris Mulieribus*, sent to Audiece de Accioroles de Florence, contesse de Haulteville. Courtesy of the Bibliothèque Nationale de France 15

1.2 Jan van Eyck, *Portrait of a Man (Self Portrait?)*, 1433. © The National Gallery, London 17

1.3 Albrecht Dürer, *The Sick Dürer* (1471–1528), Kunsthalle, Bremen – Die Kulturgutscanner – ARTOTHEK 19

1.4 Albrecht Dürer, *Self-Portrait of Dürer, About Twenty Years Old, The Erlangen Self-Portrait*, 1491. Graphic Collection of the University Erlangen-Nuremberg, B 155 v 20

1.5 Parmigianino, *Self-Portrait in a Convex Mirror*, 1524. Vienna, Kunsthistorisches Museum 23

1.6 Artemisia Gentileschi, *La Pittura*, Royal Collection Trust/© Her Majesty Queen Elizabeth II 2020 25

1.7 Johannes Gumpp, *Self Portrait*, 1646. Firenze, Museo degli Uffizi 27

1.8 Rembrandt, *Self-Portrait with Two Circles*, c. 1665–9. The Iveagh Bequest, Kenwood House, London. © Historic England Archive – PLB_J910070 31

1.9 Rembrandt, *Self-Portrait with Beret and Turned-Up Collar*, 1659. National Gallery of Art, Washington D.C 33

1.10 Elisabeth Louise Vigée Le Brun, *Self Portrait in a Straw Hat*, 1782. © The National Gallery, London 36

1.11 Michelangelo Pistoletto, *The Present – Man Seen from the Back*, 1961. Acrylic and plastic paint on canvas, 200 x 150 cm. Collection Fondazione Pistoletto, Biella. Photo: Enrico Amici 40

2.1 Hippolyte Bayard, *Self-Portrait as a Drowned Man*, 1840, paper direct positive, 18.7 × 19.3 cm. Collection Société française de photographie (coll. SFP), 2008. frSFP_0024im_0269 46

2.2 Marcel Duchamp, *Five-Way Portrait of Marcel Duchamp (Portrait multiple de Marcel Duchamp)*, Broadway Photo Shop, New York City, 21 June 1917. Private Collection, New York; Courtesy Francis M. Naumann Fine Art, New York. © Association Marcel Duchamp/ADAGP, Paris and DACS, London 2021 47

2.3 Claude Cahun, *Self-Portrait (Reflected in Mirror)*, c. 1928, photograph, 18 x 24 cm, © Jersey Heritage Collections Trust 49

2.4 Ana Mendieta. *Untitled: Silueta Series, Mexico, 1973/1991 from Silueta Works in Mexico, 1973–77*. Galerie Lelong. Copyright ARS, NY, and DACS, London 53

2.5 Francesca Woodman. *Self-Deceit #1*, Rome, Italy, 1978. Gelatin silver print, 3 9/16 × 3 1/2 in. © 2021 Woodman Family Foundation/Artists Rights Society (ARS), New York/DACS, London 55

2.6 Lynn Hershman Leeson, *Roberta Construction Chart*, 1975. Print. Courtesy of Lynn Hershman Leeson 57

2.7 Lynn Hershman Leeson. *CyberRoberta. Telerobotic Doll*, 1994. Courtesy of Lynn Hershman Leeson 59

2.8 Cindy Sherman, *Untitled*, 1975/2004. Gelatin silver print, 7 × 4 3/8 inches, 17.8 × 11.1 cm. Brooklyn Museum. Gift of Linda S. Ferber, 2005.10. Courtesy of Metro Gallery 62

2.9 Gillian Wearing, *Me as Cahun Holding a Mask of My Face*, 2012, framed bromide print, 157.3 × 129 × 3.3 cm. © Gillian Wearing, courtesy Maureen Paley, London, Tanya Bonakdar Gallery, New York/Los Angeles, Regen Projects, Los Angeles 65

2.10 Zanele Muholi, *Phila I, Parktown*, 2016. Silver gelatin print. Image and paper size: 80 × 53.5cm. Edition of 8 + 2AP. © Zanele Muholi. Courtesy of Stevenson Cape Town/Johannesburg/Amsterdam and Yancey Richardson, New York 68

2.11 Zanele Muholi, *MaID III, Philadelphia*, 2018. Silver gelatin print. Image and paper size: 90 × 60cm. Edition of 8 + 2AP. Courtesy of Stevenson Cape Town/Johannesburg/Amsterdam and Yancey Richardson, New York. © Zanele Muholi 69

3.1 Michelangelo, *The Deposition* (*Bandini Pietà* or *The Lamentation over the Dead Christ*), 1547–55. Museo dell'Opera del Duomo, Florence 73

3.2 Edvard Munch, *On the Operating Table*, 1902–3. Courtesy of the Munch Museum 75

3.3 Giuseppe Penone, *Soffio* (*Breath*), 1978, fired clay 148 × 72 × 65 cm. Private collection. Photo © Archivio Penone 79

3.4 Giuseppe Penone, *Rovesciare i propri occhi* (*To Reverse One's Eyes*), 1970, mirroring contact lenses. Documentation of the action by the artist. Photo © Archivio Penone 82

3.5 Antony Gormley, *Event Horizon*, 2007. 27 fibreglass and 4 cast iron figures, each 189 × 53 × 29 cm. Installation view, Hayward Gallery, London, 2007. A Hayward Gallery commission. Photograph by Richard Bryant. Courtesy Antony Gormley Studio 83

3.6 Antony Gormley, *Model*, 2012. Weathering steel, 502 × 3240 × 1360 cm. Installation White Cube. Bermondsey, London, England. Photograph by Benjamin Westoby. Courtesy Antony Gormley Studio 84

3.7 Orlan, *Reading after the Operation, 7th Surgery-Performance, Titled Omnipresence*, New York, 1993. Cibrachrome in Diasec mount, 65 × 43. © Orlan 85

3.8 Orlan, *Disfiguration–Refiguration, Precolumbian Self-Hybridization No. 35*, 1998, 150 × 100 cm, Cibachrome. © Orlan 87

3.9 Stelarc, *Stomach Sculpture*. Fifth Australian Sculpture Triennial, National Gallery of Victoria. Photographer: Anthony Figallo 90

3.10 Stelarc, *Ear on Arm*. London, Los Angeles, Melbourne 2006. Photographer: Nina Sellars — 91

4.1 Dan Graham *Performer / Audience / Mirror*, 1975. Single channel black and white video with sound, 22 minutes 52 seconds. Pictured: Second Performance at PS1 NY, 1977 — 98

4.2 Gary Hill. *Crossbow*, 1999. Three-channel video/sound installation. Courtesy Gary Hill — 101

4.3 Lynn Hershman Leeson. Still from the video *The Electronic Diary 1984–2019*. Courtesy Bridget Donahue Gallery NYC and Altman Siegal Gallery SF — 107

4.4 Lynn Hershman Leeson. Still from the video *The Electronic Diary 1984–2019*. Courtesy Bridget Donahue Gallery NYC and Altman Siegal Gallery SF — 107

4.5 Lynn Hershman Leeson. Still from the video *The Electronic Diary 1984–2019*. Courtesy Bridget Donahue Gallery NYC and Altman Siegal Gallery SF — 108

4.6 Lynn Hershman Leeson. Still from the video *The Electronic Diary 1984–2019*. Courtesy Bridget Donahue Gallery NYC and Altman Siegal Gallery SF — 108

4.7 Lynn Hershman Leeson. Still from the video *The Electronic Diary 1984–2019*. Courtesy Bridget Donahue Gallery NYC and Altman Siegal Gallery SF — 109

4.8 Irene Fenara, *Self Portrait from Surveillance Camera*, 2019, inkjet print, 28 × 40 cm. Courtesy the artist, UNA Piacenza, ZERO … Milan — 111

4.9 Ai-Da creating a self-portrait. © Aidan Meller www.ai-darobot.com — 112

5.1 Screenshot of Cindy Sherman, 'Outside in', by permission of the artist and Metro Pictures, New York. Screenshot taken of the app by Gabriella Giannachi — 122

5.2 Rafael Lozano-Hemmer in collaboration with Krzysztof Wodiczko, *Zoom Pavilion*, 2015. Courtesy Rafael Lozano-Hemmer — 125

5.3 Christopher Baker, *Selfie Seer*, 2017. Courtesy of Christopher Baker — 125

5.4 Amalia Ulman, *Excellences & Perfections (Instagram Update, 24th August 2014)*. Courtesy the Artist & Arcadia Missa — 127

5.5 Erica Scourti, *Life in AdWords*, 2012–13, screenshot of Vimeo album. Courtesy Erica Scourti — 130

5.6 Erica Scourti, *Life in AdWords*, 2012–13, screenshot of Facebook update. Courtesy Erica Scourti — 131

5.7 Cached Collective, *Data Selfie*, 2017 — 132

Acknowledgements

I wish to thank all organisations which have facilitated my research for this book over the years, especially The Heinz Archive and Library at the National Portrait Gallery; The Special Collection Archive at Stanford Libraries; the Gallerie degli Uffizi; the Tate archive; the archive at the Royal Academy of Arts; The San Francisco Museum of Modern Art Archive; and the British Library.

My warmest thanks to those organisations which have provided images for this volume and/or feedback: The Kunst Historisches Museum Wien; The Fondazione Pistoletto, Biella; ARTOTHEK, Spardorf; The Royal Collection Trust, London; The University Erlangen-Nürnberg; The National Gallery of Art, Washington D.C.; The Smithsonian; The Historic England Archive; the Bibliothèque Nationale de France; The Munch Museum; The National Gallery, London; the Uffizi, Firenze; the Archivio Fotografico, Duomo Firenze; The Studio Giuseppe Penone; Metro Pictures, New York; the Brooklyn Museum; Francis M. Naumann Fine Art, New York; The Antony Gormley Studio; Société française de photographie; Arcadia Missa; Jersey Heritage Trust; the Ana Mendieta Estate; the Galerie Lelong; The Lisson Gallery; the Woodman Family Foundation; the Kunsthalle, Bremen; the Association Marcel Duchamp.

I am profoundly indebted to the generosity of a number of artists who have contributed their work to this volume: Orlan; Stelarc; Giuseppe Penone; Cindy Sherman; Cached Collective; Erica Scourti; Lynn Hershman Leeson; Irene Fenara; Aidan Meller; Gary Hill; Gillian Wearing; Zanele Muholi; Rafael Lozano Hemmer and Christopher Baker.

I could not have completed this volume without the support and love of my family, especially my daughter, Francesca and my mother Liselotte. I am also most profoundly indebted to my friends Rossana Aimo, Barbara Beninato, Steve Benford, Paolo Bertinetti, Ian Brown, Susanne Franco, Mary Luckhurst, Marina Maestro, Giuseppe Marchisio, Carmen Novella, Dalia Oggero, Manuela Pluchino, Joanna Robertson, Claudia Romano, Michael Shanks, Marco Trabucco, Elena Traversa, Mariella Vessa, my Collodi friends, and the late Anna Balbiano and Maria Perosino. Without their unfailing support, especially throughout the pandemic, and without their wonderful friendship throughout the years, I just would not be who I am today.

As an outcome of Horizon Digital Economy (EPSRC) research and Documenting Digital Art (AHRC), this research has received extensive support from the EP/G065802/1 and AH/S00663X/1 grants.

Introduction

This study illustrates how artists, over time, continuously revisited the genre of the self-portrait by adopting different technologies in conjunction with theatrical and performative strategies to produce works that shaped our understanding of what we mean by 'self'. The study shows how artists often staged their presence by using a range of technologies to capture their appearance, construct their identity, define their personhood, design their relatability, continuously reworking and expanding their conception of what they meant by 'self'. The study illustrates how the self-portrait represents a medium for the exploration of a temporally, spatially, and socially expanded notion of the self which includes, whether through their presence or implied absence, both the artist and the viewer. In this sense, the study shows, the self-portrait is not only about self-representation, but also about the anticipation of reception. The self is in fact constructed not only for but through the actual or implied presence of an other. Hence the self-portrait is about the construction of a space–time that is facing towards both the past (implied by the presence of the artist) and the future (implied by the presence of the viewer), so that the selves in question shift between the artist and the viewer.

I use the term technologies to refer to a range of practices, crafts, and tools which include various kinds of mirrors, chisels, drills, cameras, mobile phones, among others. In using these technologies, artists often produce traces that reveal information about the *actions* involved in the creation of the self-portrait. By looking at these actions it is possible to see how artists constructed their presence, their 'self', whether by adopting combinations of technologies and props, or experimenting with 'palettes' of roles, moods, and staged behaviours. In fact, artists not only documented but also literally practised the performance of their presence, representing themselves, often across a plurality of locations, as both the object (the image) *and* subject (the artist at work). In this sense, the self-portrait could be considered as a selves-portrait, not only a representation of the artist (often as a multiple) but also a shifting act of co-presencing between the artist and the viewer. But before I say more about how these technologies effected self-representation, or what I mean by presencing and co-presencing, I need to revisit how the concept of the self came to be.

Introducing the self

It is very difficult to conduct a study of the self or even define the self, as concepts of the self vary profoundly depending on the cultural frames that are used to analyse them. While I cannot in the short space of an introduction do any justice to the full range of studies that have been written about this topic (for that, for example, see Seigel 2005), it

DOI: 10.4324/9780429468483-1

is useful to briefly recall some of the most important debates in the history of Western philosophy to draw attention to how the concept of a self evolved over time.

The OED tells us that the actual compound self- first appeared around the middle of the sixteenth century and that during the seventeenth century the term became more common, especially in theological and philosophical writings. Before that, writings about the self tended to address the question as to whether there is such a thing as a self, usually in the context of metaphysics and ethics. At this point in time, different terms were used to define the self, often in relation to the soul (Sorabji in Crabbe 1999: 14). Thus, in ancient Greek philosophy, for example, a number of authors used the term αὐτο, i.e. autos or 'same'. One such author was Homer in the *Odyssey* at 11.601–3 where Odysseus is talking to the dead Heracles's shadow while he him*self* is said to be with the gods (Sorabji 2006: 3). Interestingly, the term was not necessarily associated with a singular entity. Hence Epicharmus, for example, believed in the notion of a 'non continuous self' and suggested that humans consisted of different selves, while Plotinus believed people had as many as five selves, including what have subsequently been described as an embodied self, a process in time, discursive reason, pure intellect, and a self that is 'capable of identifying itself with any of the senses' (Remes 2008: 240).

At this point in time the self started to be considered in relation to its perception. Thus, researchers pointed out that Socrates famously implied that self-knowledge comes about in conversations with other people and that knowing oneself is 'akin to, even continuous with, knowing someone else' (Moore 2015: 6), while Aristotle argued for a distinction to be made between self-thinking and self-perceiving, suggesting that self-awareness may depend on the awareness of what is outside of the mind (Owens 1988). These early reflections about the self illustrate how philosophers built on the relationship between self-perception and knowledge creation, formulating interdependencies between them that were subsequently elaborated on by early Christian thinkers.

During the last century BC and first centuries AD there was a proliferation of new ideas about the self. Hence, for example, Seneca and Plutarch made a connection between the self and narrative and the Stoic Panaetius associated the self to the creation of personae and roles (Sorabji in Remes and Sihvola 2008: 21). It was during this period that some philosophers argued that human beings had some sort of self-awareness. Thus, in the fourth century, Augustine suggested that the mind can gain knowledge of itself through itself (Matthews 1992; Cary 2000), though much later, Aquinas, writing in the thirteenth century, and drawing together Platonic and Aristotelian traditions (Cory 2014), suggested a form of awareness for which 'the mere presence of the mind suffices', as well as a form that depends on the cognition of external elements for which 'the mere presence of the mind does not suffice' (Kenny 1993: 120 ff). During this period thinkers became fascinated with the role played by the self in relation to society (see Gill 1990, 1996) and the self became something that could be constructed, staged even, rather than an entity that existed a priori which needed to be captured and reproduced.

The self-determining individual

The notion of a self-determining individual is historically specific to Europe and Northern American societies and has been prevalent since the Renaissance though, as James Holstein and Jaber Gubrium suggest (2000), the first theorisation of a self-determining individual was probably made by René Descartes in the seventeenth century in his dictum '*cogito ergo sum*' – 'I think therefore I am' (1986: 18). It has been shown that two

principles can be identified in the dictum: an I (*'before anything, I am I'*) and a reasoning capacity (*'I make sense'*) (Mansfield 2000: 15, original emphasis). However, as Lex Newman shows, Descartes's reference to an 'I' does not necessarily presuppose 'the existence of a *substantial* self' since in his subsequent sentence the meditator states that they do not entirely understand the 'I', or even know whether it actually exists (2019). Descartes then continued: 'But what then am I? A thing that thinks. What is that? A thing that doubts, understands, affirms, denies, is willing, and also imagines and has sensory perceptions' (1986: 19). As Stephen Menn indicates, the meditator in the text 'knows *that* he is, he does not seem to know *what* he is' (1998: 249, original emphasis) though he clearly perceives and so imagines, understands, affirms, denies, wants etc. While references to a self-determining individual have been made since the Renaissance, these references still did not necessarily amount to a definition of what was in fact meant by a self. Interestingly, with Descartes the self becomes an *action* as well as an object or thing (*res*) that thinks as it perceives. Thus, it is this cognitive action ('I think') causes ('therefore') the recognition of the state of being ('I am'). In this sense there is a connectedness between the self as object ('a thing') and the self as a subject in action ('that doubts, understand, affirms, denies, is willing, and also imagines and has sensory perceptions') that we will see is at the heart of the genre of the self-portrait. This doubling of the self as a subject and an object implies that the object became *a sine qua non* for the subject to recognise itself as such.

David Hulme's philosophy built on these definitions of the complex interrelationship between the perceiving 'I' and the I's act of perceiving itself by stating that one could never catch oneself at any time without a perception, and could never observe anything other than the perception (1739: 534). This proposition implying a cohabitation of a self, or an I, and perception, was of crucial significance in defining the self as something that could not be separated from its own experience. Like Hulme, Immanuel Kant also suggested that 'it must be possible for the "I think" to accompany all my representations' (1929: 152). Thus, Kant went a step further in suggesting that representations are intertwined with the perceiving 'I' which in turn would be interpreted as 'the feeling of connection or consistency between all your perceptions, the collection point of all your thoughts' (Mansfield 2000: 19). Hence for Kant, as for Hulme, the self can 'only be perceived in relation to the world' (Baumeister 1998: 683). This suggests that the self is 'always situated' in its own perception (684). In this sense, for Hulme the self is not an abstract or independent subject or object, rather, it is what is perceived or even 'believed about it' (687; Higgins 1996). So, for Hulme and Kant, the subject cannot perceive itself directly, and our perception of the self is reliant on and intertwined with our perception of the world and our perception of ourselves *within* that world. The making visible of the moment of perception, and the situatedness of this moment, is at the heart of many of the self-portraits analysed in this study.

While for John Locke the self was closely linked to personhood and identity (Torchia 2008: 195), describable as a 'conscious thinking thing' (Martin and Barresi 2006: 92), for George Berkeley material things were not mind-independent as everything was grounded in perception ('*esse est percipi*', 'to be is to be perceived', 1710), for James Baldwin the construction of the self could be described as a dialectical process between a self and what he called 'alter' (1895: 335). Thus, Baldwin writes: 'my sense of myself grows by my imitation of you, and my sense of yourself grows in terms of my sense of myself' (Ibid.). These kinds of 'social selves' are not only situated in the perception of the world or the perception of another, but could be described as 'reflected selves', capturing the idea that

people would come to see themselves in the way they thought others saw them (Tice and Wallace in Leary and Tangney 2003: 91). Building on Baldwin (1895), Charles Cooley introduces the idea of a 'looking-glass self' (1902) and proposes that 'the self develops by mirroring society' (Hormuth 1990: 2). Thus, for Cooley, others constitute a social mirror whose opinions would eventually 'be incorporated into one's sense of self' (Harter 1999: 17). The image of the mirror, of course, was subsequently adopted by Jacques Lacan as a fundamental component in the formation of the *I* as it is experienced in psychoanalysis. For Lacan, the mirror in fact constitutes a metaphor capturing an early stage of development during which the child is fascinated by the reflection of their own image so that, in Lacan's words, the 'Ideal-I' 'situates the agency of the ego, before its social determination, in fictional direction' (1949: 503).

Overall, this period of history saw some of the most significant advances in relation to what philosophers, and, subsequently, psychoanalysts, thought the self to be. These, in turn, led to an understanding of the self as something that was inextricably linked to its perception and social construction, informing a conception of the self that was defined by a mirroring, social *process*. Not merely an entity, the self is formed and reformed through sets of relations.

Social selves

In the late 1890s, William James proposed a theory of the self that foresaw the possibility of a variable self. Thus, James talks about 'mutations of the self' which include multiple personality, amnesia, trance, among others (1983). For him, the self could be described as an object of perception or knowledge, divided into material, social and spiritual, including one's body, clothes, family, home, property, while the social self is what others may think of you. For James, a man in fact 'has as many social selves as there are individuals who recognise him and carry an image of him in their mind' (1983: 281–282). Interestingly, James distinguishes between what he called the 'I' and what he called the 'me', allowing for reflexive self-consciousness in which the 'I' perceives the 'me' (Baumeister 1998: 683). Subsequent critics such as Susan Harter suggest that components of James's I-self include 'self-awareness', 'self-agency', 'self-continuity', and 'self-coherence' whereas components of the me-self include 'material me', 'social me' and 'spiritual me' (1999: 6). Hence, for James the self becomes a complex kaleidoscopic, multifaceted, assembled entity.

For George Mead the self is defined though social construction. Thus, Mead argues in *Mind, Self and Society* (1934) that individuals fashion a sense of their own self-hood through engagement with other selves, in that 'we appear as selves in our conduct insofar as we ourselves take the attitude that others take toward us', adopting the role 'of what may be called the "generalised other"' (1934: 270). For Mead there are in fact two sides to the social self, the 'me' and the 'I' and whereas 'the "me" represents the unique identity a self develops through seeing its form in the attitudes others take towards it', 'the "I" is the subjective attitude of reflection itself, which gazes on both the subjective image of the self and its own responses' (Burkitt 1991: 38) so that in Mead 'the "me" is the individual as an object of consciousness, while the "I" is the individual as having consciousness' (Joas 1985: 83). These theories draw attention to the multiplicity of factors that compose the self, its multifaceted nature, its ability to change over time and its construction in and through what is other to it, forming assemblages that can be seen in so many of the self-portraits discussed in this study.

Producing the self

Alex Watson (2014) shows that, before Sigmund Freud, European philosophers variously believed that human beings had some form of essence which they called 'soul' or 'self'. The self, he suggests, was usually associated to a unitary source and was related with the agency of physical and mental actions. Freud then moved away from the idea of a single entity, showing that we are not only singular but plural (Freud 1933). Thus, because we change over time, we could in fact be described as a multitude of interacting and evolving processes (Watson 2014: 2). This understanding of the self as a complex and variable entity is built on by Erving Goffman who, in *The Presentation of the Self in Everyday Life* (1956), introduces a performative dimension to self-constitution. For Goffman the self does not so much 'derive from its possessor, but from the whole scene of his action' (1990: 252). In this sense, Goffman's self '*presents* itself to others' in that it is '*staged* to accomplish particular moral ends' (Holstein and Gubrium 2000: 36, original emphasis). Thus, Goffman emphasises the performative role of self-representation. For him, the self that appears in interaction is in fact akin to a 'performed character, a dramatic effect that arises from the scene as the actor presents it' (Burkitt 1991: 59). The self is not an ontological given; it is performed, and, in a sense, always already re-enacted.

Michel Foucault indicates that discourses and practices of the self are interrelated to discourses around power which are culturally and historically contingent (1986, 1988). Thus, Foucault identifies four major types of technologies which he claimed often operated concurrently: (1) 'technologies of production, which permit us to produce, transform, or manipulate things'; (2) 'technologies of sign systems, which permit us to use signs, meanings, symbols, or signification'; (3) 'technologies of power, which determine the conduct of individuals and submit them to certain ends or domination, an objectivising of the subject'; and (4) 'technologies of the self, which permit individuals to effect by their own means or with the help of others a certain number of operations on their own bodies and souls, thoughts, conduct, and way of being' (1988: 18). Foucault hence shows that the self is not only modifiable but that the instruments for its modification ultimately belong to the same group of technologies that also effect production, signification, and power. In this sense, the self is not only performed, it is literally produced. Interestingly, Foucault also shows that in Greek philosophy hermeneutics of the self evolved around a set of practices known as *epimeleia heautou*, 'to take care of yourself', which over time were obscured by the more popular *gnothi sauton*, 'know yourself' (1988: 19). With this, Foucault showed, we became victim to the tradition of Christian morality which made 'self-renunciation the condition for salvation' (20). After Foucault, the self is increasingly associated with the processes involved in its production and related discourses of power and representation. What is at stake in understanding the constitution of the self is where its agency and power reside.

Building on Foucault, Gilles Deleuze suggests that the self was 'the product of a process of subjectivation', 'a "fold" that constitutes an "inside" of thought' (Bogue in Bogue and Spariosu 1994: 3). The resulting self in Deleuze's work is 'hardly a self at all in any conventional sense, but instead the locus of an internalization of chance, becoming, and force' (Ibid.). While Foucault looks at how the self is *produced* as well as *practised*, what Deleuze finds in the Greek ethical self that Foucault analysed, *epimeleia heautou*, is 'a fold that forms an inside of the outside – an invagination of forces' (Bogue in Bogue and Spariosu 1994: 12, original emphasis). Crucially, it is in this fold, Deleuze tells us, that the 'inside' space 'is topologically in contact with the "outside" space', bringing the two,

inside and outside, 'into confrontation at the limit of the living present' (1995: 118–19). For Deleuze, to perceive thus means to unfold, something which can only occur 'within the folds' (1993: 93). The self is built at the edge of its own negation, at the edge of what is not present, not alive, not *here*.

Relational selves

In more recent times the self has been interpreted in terms of its relational or, nowadays, even relatable capabilities. Norbert Elias, for example, reads the self in relation to figuration, which could be described as an interlocking network of relations among people (1978). Thus, Jacques Derrida points out that the self is not necessarily a singular subject or object and suggests that 'the singularity of the "who" is not the individuality of a thing that would be identical with itself, it is not an atom' but rather that the self should be read as 'a singularity that discloses or divides itself in gathering itself together to answer to the other, whose call somehow precedes its own identification with itself' (in Cadeva, Connor and Nancy 1991: 100). Hence the self is not identifiable with a single entity. Rather, it is dispersed. As Jean-François Lyotard suggests, the self is organised 'at the intersections or nodal points of specific communication skills' so much so that

> no self is an island; each exists in a fabric of relations that is now more complex and mobile than ever before. Young or old, man or woman, rich or poor, a person is always located at 'nodal points' of specific communication circuits, however tiny these may be.
>
> (1986: 15)

In this sense, for Lyotard, the self is positioned at different points in a rhizomatic structure formed by communication processes.

Numerous studies built on these findings about the relational character of the self. Thus, for Antony Giddens, for example, self-identity operates 'as a reflexively organised endeavour', which is able to lead to the 'sustaining of coherent, yet continuously revised, biographical narratives' (1991: 5). In fact, self-identity for Giddens is fundamentally unstable. Thus, he continues, 'a self-identity has to be created and more or less continually reordered against the backdrop of shifting experiences of day-to-day life and the fragmenting tendencies of modern institutions' (185–6). The process of identity construction is therefore, for Giddens, ongoing, so that ultimately 'an individual has as many selves as there are divergent contexts for interaction' (190). The capturing of these selves evidences the effect of context on 'self-identity' construction. It also shows why, historically, the genre of the self-portrait has shaped how we construct our identity.

As Giddens shows, the self can be described as a contextual response to circumstance. John F. Kihlstrom and Stanley B. Klein offer a conceptual definition of the self as a representation of what we know about ourselves which is formed in relation to a set of narratives that address our past, present, and future, an image-based representation including information about faces and bodies and an associative network containing information about personality, autobiography, etc. (1997). The self, for them, is 'a fuzzy set of context-specific selves', which might be united by what they called 'a prototypical self, or by an overarching theory of why we are one person in some situations, and another person in others' (15). For them the self is formed by a set of stories, or narratives 'which we have constructed, rehearsed to ourselves, and related to others' (Ibid.). In

this sense, the self, they suggest, can be viewed as 'an associative network' or 'a bundle of propositions' (Ibid.). The self becomes associated with its narratives, part of multiple histories.

Over the last century, the self has been described as contextually produced and performed (Goffman 1956); situationally mobilised (Milgram 1974; Zimbardo 2007); 'saturated' (Gergen 1991); reflexive (Giddens 1991); related to biographies of choice (Beck 1992). The self is no longer an ontological 'given' – rather it could be described as a 'task' (Bauman 2001: 144), or 'ongoing project' (Jopling 2000: 83). Moreover, the self is no longer associated with a single entity but rather viewed as 'an open system' in that it has become increasingly difficult to establish some precise 'boundary where "we" stop and where the world begins' (Cilliers, de Villiers and Roodt 2002: 11). This environmental notion of the self, comprising a wider ecology of beings, will most likely play a significant role in years to come.

Post-human selves

With the introduction of more and more complex technologies into everyday life, the self is nowadays often described as a cyborg, a semi-technological entity, human and machine hybrid, that persists in an augmented state as part of a network, within the Internet of Things, as an artificial intelligence of sorts. The term cyborg was proposed by Manfred E. Clynes and Nathan S. Kline in 1960 to indicate how the self-regulatory control function of individuals could be extended to adapt to new (extra-terrestrial) environments (in Gray 1995: 31). Cyborgs radically altered cultural representations of the self. Since cyborgs have been variously defined as 'the melding of the organic and the machinic, or the engineering of a union between separate organic systems' (Gray, Mentor and Figueroa-Sarriera in Gray 1995: 2); 'a self-regulating human–machine system' (Featherstone and Burrows 1995: 2); or even any of us who either have an artificial organ (Gray, Mentor and Figueroa-Sarriera in Gray 1995: 2), understandings of the self have increasingly come to include non-human or machinic elements.

Undoubtedly, with the appearance of the cyborg, the opposition between the natural (the biological, the organic) and the human-made (the technological, the artificial) that had underpinned philosophical and socio-political thought for centuries began to blur. The cyborg, as suggested by Donna Haraway, in fact became identified with a new type of 'a cybernetic organism, a hybrid of machine and organism, a creature of social reality as well as a creature of fiction' (1991: 149). With this, as Katherine Hayles suggests, cyborgs became both 'entities and metaphors, living beings and narrative constructions' (in Gray 1995: 322). The cyborg 'self' then became an often-dispersed system, comprising humans, non-humans, and machines. The self is no longer just a physical entity, it is a data set, an assemblage that forms part of the production of what we have become within the Internet of Things. Here, the self is the object of its own production as well as the data that result from this process. These data are the gold mines of the twenty-first century.

Mapping the self

In recent years some of the most significant advances in medical science have come from neuroscience. Neuroscientists have shown that the self is identified with the insula, which is located below the neocortical surface of the brain, in the allocortex. The insula is

believed to be involved in self-reference and consciousness, playing a role in relation to compassion and empathy, as well as perception, motor control, self-awareness and other forms of cognitive functioning and personal experiences. This suggests that the self is related to or even based on a neurobiological process (Damasio 2003: 254) and that it is at the heart of our ability to engage with and participate in the world. For Antonio Damasio, the self 'requires a composite representation of the ongoing state of the organism as reflected in subcortical and cortical somatic maps within the central nervous system' (253). Thus, for him the basis for these maps is constituted by signals originating in different sectors of the body and while some of these signals 'portray the actual state of the body as modified by emotions in response to interactions with the environment', other signals 'are the result of internal simulations controlled from other regions of the central nervous system' (253). In other words, the neurobiological formation of the self occurs as an ongoing mapping process, continuously merging external and internal processes. The self is not what we conventionally call self. Rather, the self exists only in relation to what is other to it.

For Damasio, the self is not, in his words, 'the infamous homunculus, a little person inside our brain perceiving and thinking about the images the brain forms. It is, rather, a perpetually re-created neurobiological state' (1994: 99–100). In fact, he elaborates, the self should not be identified with 'a single central knower and owner', nor should we think that the self represents 'an entity' that would 'reside in a single brain place' (238). Rather, Damasio suggests, the neural basis for the self 'resides with the continuous reactivation of at least two sets of representations' (238). A notion of identity can therefore 'be reconstructed repeatedly, by partial activation in topographically organized sensory maps' (238). The 'self' then is formed by its fragments, through a continuous and laborious act of construction.

In this sense, the self is a state which is never in the present but rather is always, like Walter Benjamin's Angelus Novus (1940), caught in its own past while catapulted towards an unknown future. So, Damasio states, 'what is happening to us now is, in fact, happening to a concept of self based on the past, including the past that was current only a moment ago'. Moreover, for Damasio, the self is so 'continuously and consistently reconstructed that the owner never knows it is being remade'. As our 'metaself' 'only "learns" about that "now" an instant later', our presence as we perceive it is always already in the past (1994: 240). The present, and so the perception of our presence in the now, is ultimately unachievable. Thus, Damasio's work revealed a crucial factor that we must bear in mind when thinking about the self-portrait. The relation between perception, consciousness, and knowledge, a relation that most of the thinkers mentioned in this introduction elaborated on, is not part of a synchronous operation. Rather, as we incessantly map our changing neurobiological state, we find that we are always, in his words, 'hopelessly late for consciousness' (Ibid.) and that our presence can never quite be captured in the present moment. In other words, our sense of presence can never take place in the present and the self is consequently displaced from it.

Presencing

In my analysis of the concept of the self, I have often referred to the term presence. Presence is a fundamental and widely written term in philosophy, and, increasingly, in computer science, but I adopt it here more in relation to its use in the field of performance studies where articulations of presence have often hinged on the relationship

between the live and mediated, as well as on notions of authority, authenticity, and originality. Debates over the nature of the actor's presence have in fact been at the heart of key aspects of theatre and performance work since the late 1950s and since then an engagement with the production and enactment of experiences of 'presence' through a wide range of technological means has come to the fore (Giannachi and Kaye 2011). In many of these works, presence is not resolved into the occupation of a certain location. Rather, the performer's presence is invariably displaced from the 'present' moment in which the work is produced to its image and potential reception. Hence, presence is constructed, often environmentally, and usually in relation to an audience. Ultimately unperceivable in the present moment, presence is past and future facing. In this sense, presence is an essential absence (what is between the no longer and the not yet).

In his address to *The Hospitality of Presence* (2008), an examination of otherness in Edmund Husserl's *Phenomenology*, Daniel Birnbaum proposes that 'presence' is 'the very medium through which things present themselves to consciousness' (Birnbaum 2008: 13). Thus, for him presence becomes the response to things that emerge in time. This has to do with what he calls a 'hospitality' of presence, and, by implication, 'the present', which is seen as a 'letting in what is other than itself' (181). Indeed, it follows that not only is the position of 'the I' and so the presence of the self articulated in a 'hospitality' toward the other, but the experience of the other is itself a function of this separation, of this coming to consciousness of one's presence. Hence, Birnbaum proposes a mechanism of alterity within the experience of presence that functions at the level of both the temporal ('living') present and an identity of consciousness defined in an openness to the other. He concludes that 'the living present, far from being a self-sufficient atom, involves a fundamental form of alterity' (Ibid.: 152–3).

I have shown that for Damasio the present is ultimately unreachable, and our perception of our presence is displaced from the present moment. For Birnbaum, the present only exists as a form of hospitality, the letting in of an otherness. Hence, our presence in the present cannot be consciously grasped, but it can be understood as an act of presencing, the act of constructing the self in '*relation to*' an other (Giannachi and Kaye 2011: 12, original emphasis). Co-presencing, following Foucault's reading of *epimeleia heautou* (2005), is a call to participate in society, to become part of the wider environment we share with others. Artists working with self-portraits, I go to show in the next chapters, tried to capture their (co-)presence through a range of technologies. These made visible not only their often reflected, mediated, or simulated image but also their act of co-presencing, the very construction of the hospitality of presence offering insight into the set-up of the organising principles that frame the construction of their presence in a specific moment in time and space for others to experience the world through. The present participle here (co-presenc*ing*) deliberately suggests the establishment of a continuity of time, not only in relation to the past, which we know from Damasio is inescapable, but also towards a hypothetical future act of being seen, implicit in the construction of the presence of the viewer (their space and time) who is placed in charge of completing the original act of self-perception. In this sense, I show, the self-portrait is an act of co-presencing, the setting up of an in-betweenness among different individuals and their respective environments which are, through the self-portrait, brought together into an expanded and protracted act of self-perception.

In this attempt to augment and prolong the self within the internet of things, in its becoming a data self, the subject may, as Shumon Basar, Douglas Coupland and Hans Ulrich Obrist's *The Extreme Self* suggest (2021), become part of a twofold process: on

the one hand, literally, our bodies and selves are 'extracted' (7) so much so that an 'ever-large part of [us] now exists everywhere and nowhere' (43); on the other hand, we exist in the cloud, but we are not as we think we are, rather we are only what algorithms see us as (49). For this reason, the extreme self only feels comfortable when it is continuously 'narrating itself' in that without narration the extreme self 'ceases to exist' (101). This is no longer the era of '*cogito ergo sum*' or even '*esse est percipi*' but rather of 'I self-document therefore I am'. To manage this constant state of self-documentation, in which the self becomes the image or story that can be continuously interpreted by others, including machines, the extreme self has been postulated to produce micro-others by using 'ever thinner slices of identity to define, de-platform and limit the agency of others' (149). The extreme self then has become a producer of self-simulations which are con-structed and shared according to their function. The extreme self creates its own market in which presence is the principal capital.

The order of things

The evolution of the self-portrait is fundamentally intertwined with interpretations of the self that have been produced over time in number disciplines, including Cultural and Art History, Performance Studies, Film Studies, New Media Theory, Psychology, Psychiatry, Gender Studies, Philosophy, Religion, Sociology, Computer Science, and Neuroscience. In this sense, the self-portrait could be read as a nodal point through which to understand the ways in which different disciplines and related societies have constructed what we commonly call 'self'. To illustrate this, I have devoted a considerable section of this introduction to show how the concept of the self has been described by several thinkers in the Western world. In their studies, the self has been described as multiple, capable of changing over time, captured through its perception, reception, and even reflection, staged, produced, fragmented, associative, rhizomatic, fluid, tied to the past, and perpe-tually unfolding into the future. The self-portrait is not only an image but also, however subjectively interpreted, a verisimilitude. It is also a moment of perception, an act of hospitality, a form of communication as well as an environment formed through co-pre-sencing. It is at once technique and a world view, a *dispositif* through which we produce knowledge about who and what we think we are. Self-portraits do not only show the artist as subject and object, they also show their technique and world view. In this sense, the self-portrait is not only *where* but also *how* the artist situates her or his viewers in relation to them becoming-object.

 This volume traces the evolution of the self-portrait through a range of technologies. I use the term technology loosely, in reference to the term *techne*, meaning art, craft, technique, or skill. The first chapter focuses on the mirror; the second on the photo-graphic camera; the third on chisels, drills, and other sculptural tools and surgical instruments; the fourth and fifth on video and mobile phone cameras, respectively. In each of these chapters, I look into how a number of key artists explored one or more media for self-portraiture, analysing how they represented and indeed even performed their presence through them, showing how they staged their appearance, fragmented it, multiplicated it, augmented it, went inside the body, documented the traces left behind by its actions, and positioned the viewer within this process. There are many intersections among these chapters, especially when artists cite each other in their work, showing the emergence of legacies and even micro-histories within the genre. Throughout the volume, I use the term self-portrait somewhat loosely and my analyses encompass not only

paintings, but also sculptures, installations, performances, photos, selfies, videos, and digital works resulting in forms of self- or selves-representation through what I call presencing.

The first chapter traces the origins of the self-portrait, focusing on how artists used the mirror to reflect and construct, physically and through props, their presence in the work. Looking at very early examples of self-portraiture, often building complex relationships between several more or less verisimilar representations of the artist in the self-portrait, the chapter analyses the evolution of the genre through the work of key artists such as Jan van Eyck, Albrecht Dürer, Parmigianino, Sofonisba Anguissola, Artemisia Gentileschi, Cerlo Dolci, Rembrandt, Diego Velásquez, Johannes Vermeer, Frieda Kahlo, and Michelangelo Pistoletto, among others. Often appearing in the self-portrait both as a subject (at work) and an object (to be looked at), these artists literally painted themselves in the *act* of looking at the mirror *and* the work, reflecting their attempts to capture themselves as they perceived themselves while painting their self-portrait. Over time, artists made visible the staged nature of these acts and viewers became gradually more implicated in the self-portrait, though it is only with artists such as Yayoi Kusama or Pistoletto that the mirror started to coincide with the self-portrait, making it possible for the viewer also to be mirrored within the work.

The second chapter traces the evolution of self-portraiture in early photography, looking at works by Marcel Duchamp and Andy Warhol, before moving on to analyse key works by Claude Cahun, Ana Mendieta, Francesca Woodman, Lynn Hershman Leeson, VALIE EXPORT, Cindy Sherman, Gillian Wearing, and Zanele Muholi. More specifically, the chapter shows how these artists used cameras to capture their performance of multiple roles and personae, including those generated by other artists. Looking into fabrication, documentation, and legacy creation, the chapter shows how the artists' problematised the viewer's gaze and herewith subverted canonic discourses of power.

The third chapter traces the history of the sculptural self-portrait starting with one of the earliest examples of self-portraiture located in the tomb of Ptah-hotep near Sakkara, and ending with one of its most current ones, Stelarc's *Prosthetic Head*, a computer-generated head with real lip-synching, speech synthesis, and facial expressions. The chapter shows how artists such as Giuseppe Penone and Antony Gormley became increasingly interested in capturing their presence as an environment comprising the traces produced by their actions and their impact on others. Whether, as in Stelarc's case, bodies are seen operating as prosthetic and synthetic sculptures, or, in the case of Orlan's work, they are treated as materials that could be reformed time and again in an operating theatre, artists discussed in this chapter often used sculpture to expand and infiltrate the body, exploring presence, being in the 'now', as a set of spatial and temporal parameters through which to establish what they meant by 'self'.

The fourth chapter analyses how artists used video to experiment with self-representation. Looking at works by Dan Graham, Gary Hill, Joan Jonas, and Lynn Hershman Leeson, as well as a number of works produced by artists using surveillance cameras and an example of an AI artwork, this chapter illustrates how the video camera afforded artists the ability to experiment with self-perception in and over time. More specifically, the chapter illustrates how Graham and Hill experimented with the perception of their presence, creating spatio-temporal dislocations between the performer and the audience's attempts to construct their own co-presence. The chapter also analyses works by Joan Jonas and Hershman Leeson who used a series of biographical narratives that featured across multiple works and functioned as a lens through which to read self-representation

in society at large. The chapter concludes by discussing wearable computing, showing how data selves are becoming our gateways to the Metaverse and how, in turn, what we are in the Metaverse may affect who we are in the physical world.

The fifth chapter traces the emergence of the phenomenon of the selfie by linking it to the development of early photography, especially in relation to Kodak. The chapter also analyses the social dimension of the selfie, looking at data selfies and showing that selfies could be read as online assemblages in which images of the subject are both independent and plugged into each other to produce relatable, connected, rhizomatic distributed selves. Including case studies by Amalia Ulman, Erika Scurti, and Cashed Collective, the chapter shows that selfies prompt participation into a 'self' that the subject no longer controls, and which is shared and continuously reproduced by those who consume it within the Internet of Things.

Finally, the conclusion brings together key findings relating to the evolution of the genre of the self-portrait, speculating about which technologies and self-representation strategies artists might use in future years to explore a more inclusive and ecological understanding of the notion and practice of the self.

1 The invention of the self-portrait

In his introduction to *The Self-Portrait: A Cultural History*, James Hall suggests that the self-portrait has become 'the defining visual genre of our confessional age'. Self-portraits, he notes, 'migrated far beyond the church, palace, studio, academy, museum, gallery plinth and frame' to the internet and the school classroom (2014: 7). Unquestionably, the self-portrait has become one of the most important *and* pervasive genres in the history of art. However, I show here, this is not only due, as Hall suggests, to the genre's potential to give image to 'our confessional age'. Rather, this is because artists have used this genre to explore what they meant by 'self', often by capturing themselves through a mirror, chisel, camera, video or film, computer, or mobile device. In this chapter I trace the history of the self-portrait by showing how the practice of self-portraiture evolved over time, especially, though not exclusively, in relation to the mirror. By illustrating how and why this genre became so popular, I also look into what it tells us about how we conceive of ourselves and what we may in fact mean by 'self' in the first place.

A portrait, Shearer West notes by citing the *Oxford English Dictionary*, is a 'representation or delineation of a person, especially of the face, made from life, by drawing, painting, photography, engraving, etc.' that expresses 'a likeness', but also, referring to the Italian word for portrait, *ritratto*, a portrait is 'a portrayal, copy or reproduction' (2004: 11). Yet portraits, West continues, 'are not just likenesses but works of art that engage with ideas of identity as they are perceived, represented and understood in different times and places', where 'identity', she claims, 'can encompass the character, personality, social standing, relationships, profession, age, and gender of the portrait subject' (Ibid.). A self-portrait is a crucial indicator of what artists understand not only by a 'person' but also by a 'self', a rendering of themselves as a subject, often seen in the act of painting, and a staged (social, professional, political, medical, etc.) object, a presence to be looked at, or even interacted with, by others. The self-portrait does not only consist of the reproduction of the artist's likeness, person or persona, but also, often, of the representation of the process involved in creating this reproduction. By process I mean the performative act that generated the painting, as well as the setting of a series of props for the staging of this action within the painting. In this sense, the self-portrait can be read as the representation of the effort and technique involved in the construction of a presence, that of the painter, in relation to another 'presence', that of the absent viewer.

A portrait is at once a likeness, a copy or reproduction, an exhibition of a technique, *and* a statement about the painter's role and position within society at large. As Jean-Luc Nancy suggests, portraiture in fact encompasses, but also challenges the ontological and societal position of the subject. For Nancy, 'the portrait's identity is wholly contained within the portrait itself' so that, in his words, 'the person "in itself" is "in" the painting'.

DOI: 10.4324/9780429468483-2

Devoid of any inside, the painting, he claims, '*is* the inside or the intimacy of the person' (2006: 225, original emphasis). But, as Nancy proposes, the person can exist here for and by itself *only* under the gaze of the viewer (Ibid.). The self-portrait therefore is a rendering of the 'self' as an object that presumes the presence and gaze of a viewer. Hence the artist is often represented in the painting twice, while at work and in the image that is being created, the painting within the painting, constructing their presence for it to be looked at or engaged with by others. Here, I show how, over time, the viewer became more and more implicated within the self-portrait so much so that towards the end of the twentieth century it is often the viewer who is represented in the work.

This chapter focuses specifically on the role played by the mirror in the construction of the 'self' in self-portraiture. Research has shown that in the period of time considered by this chapter technical advances which made it possible to replace convex mirrors with plane mirrors fundamentally changed the ways in which artists conceived of the construction of the 'self' in self-portraiture. As Sabine Melchior-Bonnet notes, while convex mirrors in fact concentrated space onto surfaces, plane mirrors offered partial or framed images, allowing painters to operate more and more as 'stage directors' (2002: 128). This suggests that implicit in the self-portrait is a certain theatricality comprising the creation of a stage and a place for performance as well as, often, a space for viewing. In this sense the self-portrait tends to entail a plurality of viewpoints. For T.J. Clark, the self-portrait thus represents this 'to-and-fro' movement between 'a self here where I am and another out there' so that, in Clark's words, a 'face of loss stares out from scores of painters' pictures of themselves' to evidence the 'unfamiliarity' this action produces for the artist (in Roth 1994: 266). This uncanniness generated by the fact that the painter can be seen in the self-portrait both as an object and as a subject, often caught in the act of painting, in dialogue with an absent viewer, is what renders the self-portrait such a fascinating genre for the analysis of the construction of the 'self' in art.

The origin of the self-portrait

While the term self-portrait, as Hall suggests, appeared in the English language only in 1831 (2014: 151), it is known that artists have been creating self-portraits since antiquity, only that they were described by the following phrases: 'by their own hand', 'by himself', and 'portrait of the artist' (Reynolds and Peter in Reynolds, Peter and Clayton 2016: 11).

An early reference to a sixth century BC artist who created self-portraits is made in chapter 40, 35,40, of Pliny the Elder's *Historia Naturalis* (Bostock: 1855 [79 AD]), where a woman named Iaia of Kyzikos, or Cyzicus, is described as using a mirror to paint her own image. The same story is also recorded in Giovanni Boccaccio's *De Claris Mulieribus* (*Concerning Famous Women*, c. 1404) where a miniature illustration (1401–2) shows the artist, here called Marcia, painting herself from a handheld mirror (De Girolami et al. 2000: 11; Borzello 1998: 20). Boccaccio also reports the story of Timarete (1401–2). Here, the painter is shown standing 'in front of an easel as she paints, carefully gazing into a mirror, seeing her reflection and comparing it with her painted image' (De Girolami et al. 2000: 12). The illustration of Marcia, who is seen sitting by the easel, is a small part of the folio leaf showing three images of the artist: the one in the painting, representing the artist at work; the one in the mirror held by the artist, representing her reflection; and the one of the artist in the painting within the painting, representing her rendering of the reflection. While at one level it is arguable that the three faces are the same, in that they show the same person, at another level, they not only mark different positions in

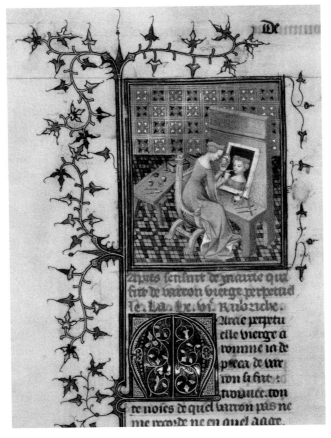

Figure 1.1 Giovanni Boccaccio, *De Claris Mulieribus*, sent to Audiece de Accioroles de Florence, contesse de Haulteville. Courtesy of the Bibliothèque Nationale de France.

space and time but also point to Marcia's different and irreconcilable ontological statuses in the painting: as an artist at work; as a reflection; and as a representation in the artwork within the artwork. This work is one of the earliest illustrations to play with a range of often co-existing representations of the artist. The tools of the trade are placed on display next to the artist whose torso is slightly twisted, possibly so as to be able to show herself at work while holding the mirror, though the image painted is a distortion of the image in the mirror. In this sense, this is one of the earliest works showing the production of the self-portrait as a performative act, in which the artist is seen in the act of staging and producing her work *twice*, as a reflection and as a representation.

Other well-known medieval self-portraits include St Dunstan's *Self-Portrait Worshipping Christ* (c. 943–57), Bodleian Library Oxford, showing the prostrate figure of the saint next to a gigantic figure of Christ looking in a different direction, and father Rufilus of Weissenau's *Self-Portrait Illuminating the Initial 'R'* (c. 1170–1200), Bibliothèque Bodmer, Genève, in which it is possible to see Rufilus painting the tail of the letter R formed by a snake. These early self-portraits, which do not represent mirrors, did not constitute a specific genre within art history. Moreover, there was not at the time a clear word to describe the notion of a 'self' in relation to the practice of portraiture. So, while

it is known that self-portraits existed well before 1831, the term self-portrait, and, more specifically the notion of a 'self', is distinctive of the modern age. This tells us something about the self-portrait, namely that what it aims to depict, or rather how we define what it aims to depict, has undergone a series of changes over time and these changes have primarily to do with how we conceive of ourselves and what performative strategies and technologies we adopt to do so.

The increasing availability of mirrors in the sixteenth century played a substantial role in the development of the self-portrait even though full-length mirrors did not become available until the eighteenth century. The dissemination of the Murano mirror, as Omar Calabrese points out, led not only to the development of perspective (2006: 161) but also the production of increasingly theatricalised works. Thus, artists often depicted the mirrors used to produce their self-portraits in their work, usually only painting the part of themselves they could see reflected in the mirror, sometimes precisely, sometimes deliberately playing with distortion and reflection so as to create a number of perspective viewpoints. Occasionally artists also showed themselves painting themselves. Sometimes the reflected images faced the direction of the painter or viewer as if to enter into a dialogue with them. For Calabrese, the inclusion of the painter, their viewpoint or perspective, was a response to Leon Battista Alberti's proposition that artists should reproduce reality as it appeared on a reflective surface (162) so that, in a sense, the artist painting a self-portrait had 'no choice but to represent himself *while looking in a mirror*' (Ibid., original emphasis). In the self-portrait, therefore, not only there is 'a coincidence between the "I am looking at you looking at me" and an "I am looking at myself looking at you"' (Ibid.), but also an acknowledgement of the uncanny displacement that this act produced.

Through the use of plane mirrors, self-portraits started to be produced that reflected viewpoints which could offer multiple and on occasion even contrasting perspectives of the artists, who often experimented with the ambiguity caused by this multiplication of possible viewpoints. Thus, in the illumination showing the portrait of Marcia in *De Claris Mulieribus*, Marcia is seen looking at herself in a mirror and painting herself in the process of doing so, though her image in the portrait, as Calabrese points out, is not inverted, and so the panel here does not operate as 'a mirror that reflects a mirror', but rather shows the co-habitation of two times: 'the instantaneousness of the moment of reflection and the durational time of the painting' (2006: 163). This uncanny multiplication of views, formed by the representation of a past spatially 'present', usually through the depiction of the artist within a time frame that includes the 'present' time and space of the absent viewer, is a distinctive characteristic of the genre.

Performing presence: the self-portrait during the Renaissance

While it is possible to find self-portraits throughout history in a number of cultures right across the globe, it was primarily during the Italian and Dutch Renaissance that, coinciding with a wider availability of mirrors, self-portraits started to gain in popularity. This phenomenon manifested itself in concurrence with the emergence of a wide range of autobiographical forms, which suggests that the emergence of the genre may have been connected to the burgeoning interest in the role, creativity, and personality of the artist. It is known that artists tended to use self-portraits for practical reasons, so as not to have to pay for sitters, or to experiment with light, especially chiaroscuro, colours, technique, facial expression, and role-play. This is most probably the reason why the self-portrait functioned historically as one of the preferred sites for experimentation with technique,

operating as a laboratory of sorts within which different skills and strategies could be experimented with. It is in this period that the self-portrait became an independent genre.

During the fifteenth century, European individual likenesses started to appear in paintings in Italy and the Netherlands, often in the form of donors in religious works. At this time, artists started to include themselves within crowd scenes of religious or military nature. For Manuel Gasser, these kinds of paintings should be considered as examples of self-portraits (1963: 7). Botticelli and Raphael, for example, both included themselves as part of larger works. Botticelli painted himself in his *Adoration of the Magi* (1476), Uffizi, Florence, while Raphael painted himself in the *School of Athens* (1509–11), Vatican, Rome. In the former, Botticelli appears at the right edge of the painting, wrapped in a long brown coat, opposite Lorenzo de Medici, staring directly at the viewer. In the latter, Raphael painted himself near his fellow painter Sodoma as the Greek painter Apelles, also at the right edge of the painting. Like Botticelli, he too is seen looking at the viewer. In both cases, the viewer is presented with what could be described as a history play, within which the self-portrait of the artist operates, theatrically speaking, as an aside, addressed to an invisible audience from the main stage of history.

Freestanding portraits of named individuals started to appear at this point in time in works by artists like Pisanello in Italy and Jan van Eyck in the Netherlands. van Eyck's *Portrait of a Man (Self Portrait?)* or *Man in a Turban* (1433), National Gallery, London, is especially significant in this context. At the top of the frame, there is an inscription, 'ΑΛC.IXH.XAN', '*Als ich kan*', 'as well as I can', which is said to have been a pun on van Eyck's surname (ICH/EYCK). On the lower end of the frame is the Latin inscription 'Jan van Eyck made me' (where van Eyck is both the painter and 'me'). Here, the use of

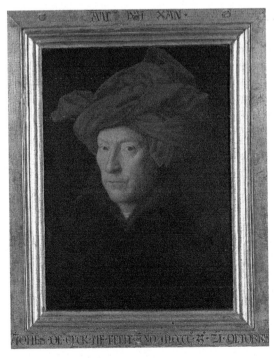

Figure 1.2 Jan van Eyck, *Portrait of a Man (Self Portrait?)*, 1433. © The National Gallery, London.

text replaced the mirror in indicating that the work was a self-portrait. As Nicole Lawrence notes, the eyes are not in equal focus: the right eye is in fact slightly blurred while the left eye is clearly delineated and focussed (in Bond and Woodall 2005: 84). The fact that the eyes are not in equal focus, Laura Cumming suggests, may indicate that that painter is looking at himself in a mirror while also painting himself. Moreover, Cumming notes, the left eye is painted so clearly 'that the Northern light from the window glints minutely in the wet of it – the world reflected; but the other is slightly blurred' (2009: 19). The work, therefore, not only, as Cumming indicates, epitomises the 'I–He grammar of self-portraiture to perfection' (20), but also suggests that the painted subject functions as a mirror, reflecting and representing the environment around them back to the viewer. In other words, the self-portrait operates as a mirror to society at large.

van Eyck famously painted himself within the mirror displayed in the background to the *Arnolfini Marriage* (1434), National Gallery, London. The work represents the Lucchese merchant Giovanni Arnolfini and his wife Giovanna Cenami. Erwin Panofsky asserts that the work operates as a document in that it shows an inscription on the wall saying 'Johannes de Eyck fuit hic' ('Jan van Eyck was here'), with the painter's image appearing in the small mirror in the back as evidence that this had happened (1934). This work, featuring both text and the mirror, is, as Panofsky indicates, both a document *and* a work of art. Because of this, it entails an ontological instability: as a document, it presents something that may have occurred in the past, and as an artwork using a mirror, it implies its creator and so becomes a self-portrait. Hence, as Linda Seidel notes, the tense of the verb is in the past, which draws attention to the fact that the artist is no longer present, 'as we *see* now what he once *saw*' (1993: 10, original emphasis), an indication perhaps of the artist's awareness of the complex temporality of the work as the image of the artist is still reflected in the mirror. This suggests that the work operates as a document, showing that the artist *was* there, illustrating also that, as a work of art, the artist still *is* 'there'. Hence, Calabrese points out, the term 'hic' could in fact refer in this case to four different locations: 'in the room', 'in the scene', 'here below' (i.e., in the mirror), and 'in the painting' (2006: 57), drawing attention to the multiplication of temporalities and spatialities of the artist's presence in the self-portrait. This renders van Eyck, potentially 'here' in a plurality of locations, including the world of the viewer.

Acting, as Melchior-Bonnet suggests in her cultural history of the mirror, both as a microscope and a telescope (2002: 122), the mirror makes visible spaces and dimensions that are impossible to see with the naked eye, and literally displaces the painter both within the painting and as a reflection in the imaginary gaze of the viewer. By doing this, the self-portrait makes visible the presence of the painter in the painting, and hereby, as Leon Battista Alberti famously wrote in his 1435 essay *On Painting*, 'makes the dead seem almost alive' (2011: 44). The use of the term 'almost' goes some way to explain the complex inter-relationship between the presence and absence of the artist in this genre.

The independent self-portrait: the case of Dürer

Some of the earliest works which are clearly identifiable as self-portraits were by Albrecht Dürer. His first self-portrait was a drawing (1484), Graphische Sammlung Albertina, Vienna, in which he appeared as a thirteen-year-old child. There is no representation of a mirror in the work, and the child is, unusually, seen pointing in the direction of his gaze; on the right top corner, Dürer wrote: 'This I drew of myself in a mirror in the year 1484, when I was still a child. Albrecht Dürer' (in White 1981: 20).

The original reads: 'Dz hab Ich aws eim spigell nach mir selbs kunterfet Im 1484 Jar Do ich noch ein kint wad. Abricht Dürir', marking the appearance of the word 'selbs' (self) in relation to his portrait. While the term, as I have shown in the introduction, does not refer to 'self' in the modern sense of the word, this has been described as 'the earliest self-portrait in Germany in which an artist appears isolated from any other scene or decorative program' (Koerner 1993: 35).

Equally groundbreaking is Dürer's *Self-Portrait in the Nude* (1503), one of the first self-portraits in which an artist appears naked (White 1981: 20). In his subsequent drawing *The Sick Dürer* (1471–1528), Kunsthalle, Bremen, Dürer can be seen half-length, wearing no clothes except for a loin cloth, staring at the viewer while pointing his right finger to an area circled near the stomach. At the top of the work, there is an inscription: 'the yellow spot to which my finger points is where it hurts me' (Ibid.: 17–18), a message that was probably meant for a medical practitioner whom he had hoped might cure his illness. However, as Panofsky suggests, since the organ in question may have been the spleen, 'the very kernel of melancholy disease', it is possible that Dürer was in fact signalling that he was affected by melancholy (1955: 171), rendering the work simultaneously an early example of a medical self-portrait as well as a statement about the painter's aesthetic intention, one of the earliest recorded visually in the history of art.

In *Self-Portrait* (1493) Louvre, Dürer painted himself 'as a *persona*' (Smith in Dodwell 1973: 72, original emphasis) adopting some sort of 'theatrical part' (73), that of the 'Italian *gentiluomo*' (75), wearing a 'costume', and holding a mysterious plant, with the

Figure 1.3 Albrecht Dürer, *The Sick Dürer* (1471–1528), Kunsthalle, Bremen – Die Kulturgutscanner – ARTOTHEK.

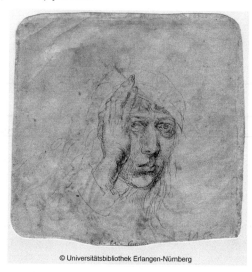

© Universitätsbibliothek Erlangen-Nürnberg

Figure 1.4 Albrecht Dürer, *Self-Portrait of Dürer, About Twenty Years Old, The Erlangen Self-Portrait*, 1491. Graphic Collection of the University Erlangen-Nuremberg, B 155 v.

motto 'My sach die gat/als es oben stat' ('my affairs will go as ordained on high') (73). Likewise, in his *Self-Portrait* (1498), oil on panel, Prado, Madrid, which was described by Panofsky as 'the first independent self-portrait ever produced' (1955: 42), he is dressed as a *nobiluomo*, or nobleman, showing, behind him, a landscape under which an inscription indicates this to be a self-portrait made at the age of twenty-six. Both these works do not show mirrors and could be described as early examples of self-fashioning by which I mean, following Stephen Greenblatt, the 'fashioning of human identity as a manipulable, *artful* process' (1980: 2, added emphasis).

Dürer painted himself in *Two Musicians* (c. 1500) Cologne, Wallraf-Richartz Museum, positioned on the right, facing the viewer, and in *Martyrdom of the Ten Thousand Christians* (1508), Vienna Kunsthistorisches Museum, next to Wilibald Pirckheimer, dressed in a robe. These works show how Dürer placed himself as a patient, a man, or artist, as well as a character through costume, posture, and props. In other works, Dürer chose to paint 'just' himself in the act of representing himself in the self-portrait. Thus, Joseph Leo Koerner notes how *Self-Portrait of Dürer, About Twenty Years Old*, also known as the *Erlangen Self-Portrait* (1491), Graphic Collection of the University Erlangen-Nurenberg, draws attention to the '*Augenblick* of its own making', capturing 'Dürer drawing himself drawing – or seeing himself drawing himself drawing' (1993: 3). The German word *Augenblick*, which means moment, but also, literally, the blink of the eye, possibly referred to the fact that Dürer had complained about being unable 'to move his eye without also altering his object' (5). For Koerner, Dürer's obsession with the act of capturing his 'own body in labour' marked the start of the Renaissance in Germany (9), rendering *The Erlangen Self-Portrait* the first 'modern' self-portrait (37). So, in Koerner's words, self-portraiture is captured here as a 'bodily activity' (6). The fact that the artist's eyes point in different directions illustrates the difficulty of seeing oneself simultaneously in the mirror and the painting. Interestingly, this work, like the later *Self-Portrait in the Nude*, and possibly even *Dürer Ill*, also constitutes an early attempt at portraying melancholia, the expression of an evolving sense of 'self' that Dürer famously revisited in the

homonymous etching, which could be described an illustration of the complexity of producing a self-portrait.

Quite unconventionally, Dürer drew himself in a number of works as a Christ-like figure. In his *Self-portrait* (1500), Alte Pinakothek, Münich, for example, he adopted a frontal arrangement usually only used for Christ, creating an ambiguity as to whether he was painting himself or Christ. These works are related to his self-portraits. Thus, his earlier *Christ as Man of Sorrows* (1498) at the Staatliche Kunsthalle, Karlsruhe, is related to the *Erlangen Self-Portrait* in that both figures are seen leaning against their hands, so that in the former 'the interiority projected onto the viewer originates from the artist as he gazes at himself' (Koerner 1993: 19). This pose is related to the iconography of melancholy where, in Koerner's words, 'the self, turned upon itself, becomes absorbed in, and paralysed by, its own reflection' (21). Likewise, in Dürer's engraving *Melencolia I* (1514) the angel of melancholy is shown as a powerful self-reflective image, caught in some dejection, surrounded by a series of scientific objects to do with geometry. As Koerner indicates, citing Pomponius Gaurucus is *De Sculptura* (1504), these portraits depict 'its subject *ex se*, out of itself' (9). The exploration of melancholy, we know from other illustrious examples, like Shakespeare's *Hamlet* (c. 1599–1602), is characteristic of the Renaissance, indicating that the self-portrait is the rendering of a likeness, as well as an investigation into the fragility of *being*, comprising, indeed, then also the possibility of *no longer being*. Melancholia was subsequently associated by Sigmund Freud with a sense of loss and the 'painful wound' this produced in the subject (1999: 446, my translation; see also Wald 2007), a term that well captures the scarring at the heart of a number of medical self-portraits discussed in Chapter 3.

As Koerner notes, 'each of Dürer's self-portraits has been granted the status of an epochal beginning' (1993: 35). This is largely due to his endeavour to introduce temporality in painting, not only in terms of the relationship between the artist, the object of the painting, and the viewer, but also as a way of evidencing the artist's efforts in interpreting and capturing the act of painting itself. In the following passage, a translation from the Dürer manuscripts at the British Museum, Dürer expands on this particular point:

> I hold nature for Master [...] The Creator fashioned men once for all as they *must* be, and I hold that the perfection of form and beauty is contained in the sum of all men. [...] If I, however, were here attacked upon this point, namely, that I myself have set up strange proportions for figures, about that I will not argue with anyone. Nevertheless they are not really inhuman, I only exaggerate them so that all may see my meaning in them. [...] For we ourselves have differences of perception, and the vulgar who follow only their own taste usually err. Therefore I will not advise anyone to follow me, for I only do what I can, and that is not enough even to satisfy myself.
>
> (in Conway 1958: 250–1, original emphasis)

Finally, in his *Feast of the Rosary* (1471–1528), Prague, Národni Gallery, Dürer appears alone, looking directly at the viewer, holding a scroll bearing the signature and year of execution of the work. Placing his 'signature alongside his likeness', Calabrese tells us, 'the scroll is shown in perspective and follows those rules, but at the same time contains writing and thus refers to the surface' (2006: 72). Here, as in his other works cited above, Dürer creates a new kind of artwork, one that at once represents and documents not so much what the artist saw but their interpretation of it. In the age where the artist was

meant to 'hold the mirror up to nature' (*Hamlet*, 3:2, 17–24), Dürer privileged his own 'meaning' or even 'perception' over realistic representation, drawing attention to the fact that he was not only striving to represent 'the perfection of form and beauty', but to see *his* meaning in them. For him, melancholia had become a way to call into question commonly accepted aesthetic conventions, a stratagem for a transformational representation of the world. With this, Dürer established the viewpoint that changed the very rules through which subsequent artists were to represent their subjective interpretations of it.

The act of painting

In the sixteenth century Italian artists started to experiment with the self-portrait though generally very few Venetian painters painted self-portraits before 1550. Many of them experimented with the genre by adopting some kind of character or role, striving towards more or less explicit forms of what can now be described as self-fashioning or self-production, by which I mean the fabrication of a mythological or theatricalised identity. Giorgione, Titian, Michelangelo, Caravaggio, and Artemisia Gentileschi all represented themselves as what could be described as characters or mythological figures: Giorgione as David (*Self-Portrait as David*, 1510, Herzog Anton Ulrich-Museum, Braunschweig); Titian as St Jerome (*Saint Jerome in Penitence*, 1575, Thyssen-Bornemisza Museum, Madrid); Michelangelo as Nicodemus (*Florentine Pietà* 1547–55, Museo del Duomo, Florence); Caravaggio as Goliath (*David with the Head of Goliath*, 1609–10, Galleria Borghese, Roma); and Artemisia Gentileschi as Judith (*Judith Slaying Holofernes*, 1614–20, National Museum of Capodimonte, Naples). Some of these artists used self-portraiture as part of a more sustained interest in self-presentation. Titian, for example, was part of a group of Italian painters who often represented themselves as subjects of their own paintings though only his late self-portraits survived over time. By painting himself glancing sideways, Titian, like Dürer before him, redefined the relationship with the viewer. Thus in talking about Titian's *Self-Portrait* (1550–62), Gemäldegalerie, Berlin, Joanna Woodall notes that 'an embodied viewer, who stands in the very place occupied by the original artist and actively participates in the completion of the subject, now undertakes the creative role of the other' (2005: 23). As Woodall suggests, the viewer here is asked to complete the work of the artist by looking at their image as they see it in the mirror.

In another work, the Prado *Self-Portrait* (c. 1567), Titian is seen wearing a black skullcap and an ornate brocade jacket and cape, directing his gaze away from the viewer, both to the left and to the right. The self-portrait represents him, unusually, half-length, holding an instrument which identifies him as the artist. His gaze, interestingly, avoids any contact with the viewers. These works coincided with the publication of Giorgio Vasari's biographies (2007 [1550, 1568]) and an autobiography by Benvenuto Cellini (1999 [c. 1558]), which show that the emergence of the self-portrait at this point was linked to the growing interest in the artist's personality (Freedman 1990: 39) and, as we have seen from the extract by Dürer, or could see in Cellini's very adventurous autobiography, the artist's own interpretation of the world. The emergence of the genre of self-portraiture thus occurred concurrently to a redefinition of the relationship between the painter and the viewer, as well as a new understanding of the artist as a 'personality', i.e., a set of self-fashioned values, attitudes, memories, skills, and relationships.

During this time, artists started to write about the use of the mirror, often meta-phorically, as an instrument to arrive at an understanding of their perception and representation of the world. Thus, Leonardo, for example, wrote:

> The painter should be solitary and consider what he sees, discussing it with himself, selecting the most excellent parts of the appearance of what he sees, acting as the mirror which transmutes itself into as many colors as exist in the things placed before it, and if he does this he will be like a second nature.
>
> (da Vinci 1956: 49)

Leonardo, who famously used mirror writing, indicated that the mirror made it possible for painters to see whether paintings conformed 'with the thing drawn from nature' (160) but he also made it clear that artists were to 'select the most excellent parts of the *appearance* of what' they saw (Ibid., original emphasis). For him in fact the value of the mirror rested in its ability to distort the appearance of the physical world and possibly show 'the most excellent parts' that could otherwise not be seen. Thus, he wrote: 'you see a painting made on a flat surface display things so that they seem to be in relief, and the mirror does the same thing on a plane; the painting has only a single surface as does the mirror' (Ibid.). Herewith, the mirror became a means for looking at and representing the world.

Artists often used mirrors not just to copy the physical word but also to capture how they could inform and deform it. Thus, Simon Luttichuys's *Vanitas Allegory* (1646), Pittsburgh, Teresa Heinz and the late Senator John Heinz, shows a portrait of the painter's master Anthony van Dyck, while his own self-portrait is a reflection in a mirror suspended on the table which shows him at work. Parmigianino's *Self-Portrait in a Convex Mirror* (c. 1524), Kunsthistorisches Museum, Vienna, shows the artist as distorted by a mirror. Here Parmigianino executed his self-portrait *as* a reflection on a convex mirror with the entire frame of the picture coinciding with that of the mirror and the frame of the painted image being visible only in part at the edge of the painting.

Figure 1.5 Parmigianino, *Self-Portrait in a Convex Mirror*, 1524. Vienna, Kunsthistorisches Museum.

Breaking away from notions of 'ontological resemblance, fundamental to the notion of man as image of God', Parmigianino deforms his image so much that his hand becomes 'a monstruosity' (Melchior-Bonnet 2002: 226) occupying a good part of the painting.

Sofonisba Anguissola, or Angussola or Anguisciola, an Italian Renaissance painter known for her portraits of her family as well as a number of self-portraits, used self-portraiture as a form of self-fashioning, often impersonating a range of roles towards this goal. Thus, in *Self-Portrait at the Easel* (1556), Łańcut Castle, Anguissola, who had been taught by Michelangelo for one year in 1554 (Perlingieri 1992: 75), painted herself as St Luke the Evangelist, said to have been the first painter who portrayed the Virgin Mary, establishing herself as the first female painter of this topic. Here, Anguissola showed herself as if turning towards a mirror positioned outside the threshold of representation. For Woodall, 'in such uses of the mirror we can recognise a distinction between the exterior and the interior self and a dynamic concept of selfhood still familiar to us today' (in Bond and Woodall 2005: 20). Anguissola also depicted herself as if painted by her master in *Self-Portrait with Bernardino Campi* (c. 1550), Pinacoteca Nazionale di Siena, in which she looks more prominent and a head higher than him, while in *Self-Portrait* (1610), Gottfried Keller Collection, Bern Switzerland, she portrays herself in a 'three-quarter length pose as the elder stateswoman of the Renaissance: seated as an elegant octogenarian' (Perlingieri 1992: 194).

We have seen that during this period in time artists showed a tendency to theatricalise their works. Thus, according to Ilya Sandra Perlingieri, Angguissola's works 'took sixteenth century art in a new direction, that of action: the sitter is shown here in the act of being engaged in some kind of activity' (1992: 49). This is noticeable in her *Self-Portrait* (1552), Uffizi, Florence, as well as in her *Self-Portrait* (1554), Kunsthistorisches Museum, Vienna, in which her name is spelt as 'Sophonisba' possibly in reference to the sack of Rome in 1527, having perhaps associated 'the mercenary troops of Charles V with the ancient Romans who wanted to take Sophonisba prisoner' (63). As Annibale Caro puts it, 'Anguissola's several self-images in the act of painting were understood by contemporaries as embodying *two* "marvels" [...]: the rarity of a work created *by* a female, and a simulacrum *of* its prodigious creator' (in Woods-Marsden 1998: 192, original emphases). Interestingly, when van Dyck travelled to Genoa in November 1621, he heard about Anguissola, who at the time was 96 years old, and whom he painted later, twice, in 1664 (Perlingieri 1992: 201). In his sketchbook, where he drew and took notes of the people he met, he recorded seeing her (Brown 1982: 70) while drawing her and writing up his conversation with her around her drawn image. Curiously, 'When I drew her portrait', he said, 'she gave me several hints: not to get too close, too high or too low so the shadows in her wrinkles would not show so much' (in Nicodemi 1927: 232). He later turned this into the well-known painting *Sofonisba Anguissola* (1624), Dulwich Picture Gallery.

Other artists experimented with self-portraiture during this period, often by playing with novel narrative strategies which, in turn, determined how artists constructed the space and time represented in the work. Masaccio's self-portrait as an apostle from the *Tribute-Money* (1425–8) at Santa Maria del Carmine in Florence, for example, is completely immersed in the world of the painting, as if, theatrically speaking, a third wall separated him from the world of the viewer. Here, Masaccio used simultaneous narrative, and there is 'no disjuncture in time and space'; instead, everything is contained in the world of the painting in which Saint Peter appears three times and the tax collector twice (Cole 1980: 161).

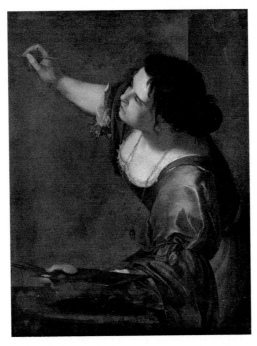

Figure 1.6 Artemisia Gentileschi, *La Pittura*, Royal Collection Trust/© Her Majesty Queen Elizabeth II 2020.

Artemisia Gentileschi's *Self-Portrait as 'La Pittura'* (1630), Royal Collection, London, sees the artist represented in the act of painting as the allegory of painting, integrating 'the painter as agent with the painting as product' (Woodall in Bond and Woodall 2005: 27). As Mary Garrard notes, the image represented in this painting is in fact the product of a movement, in that to paint herself in near profile, Gentileschi would have needed to use double mirrors since, positioned at an angle of slightly less than 90 degrees, the painter could see her left profile by looking at the right mirror (1989: 361 and 564) though neither of these mirrors are shown in the work (Miller 1998: 193). Here Gentileschi reveals several of the attributes of the female personification of Painting as set forward in Cesare Ripa's *Iconologia* (Garrard 1980: 97). The work initiated a trend that was subsequently adopted by Diego Velázquez in *Las Meninas* and Johannes Vermeer in *The Allegory of Painting* (109), which I will discuss later in this chapter. In this sense, Gentileschi's *Self-Portrait as 'La Pittura'* literally captured the *act* of painting, marking the beginning of a practice that was to become more and more prominent in years to come.

It is at this stage in the history of the genre that self-portraiture started to affect composition in other forms of painting. Thus, Michael Fried notes in relation to Caravaggio's *Boy Bitten by a Lizard* (c. 1594), Fondazione Roberto Longhi, Florence, that Caravaggio's work could be read as a mirror representation of the artist at work which was then 'disguised and distorted just enough' not to be interpreted as a self-portrait (2010: 10). Fried's finding is based on an iconographic study of a number of self-portraits including works by Parmigianino, Raffaello, Anguissola, among others, which show the artists in particular positions, twisting, between two angles, sometimes mirror-reversed (25). Fried notes how the majority of these paintings were produced before 1600 after which rather than paint themselves in the act of painting, painters, often using right-angle mirror

representations, started to paint themselves as they would be seen by a viewer (Ibid.). This important change shows that more attention started to be paid to the reception and so also the perception of the work by viewers. Interestingly, as self-portraits became more and more about technique, representing some form of advertisement for the artist, they also started to become increasingly collectable.

Collecting self-portraits

Self-portraits were usually donated and then collected upon admission to academies or guilds. Thus, for example, the Painters Guild in Harlem asked artists to present a work in their specialism when they became masters. Similar practices were adopted by other academies, like the Accademia di San Luca in Rome, the French Académie Royale (as *morceau de reception*), and the Academy of Fine Arts in San Petersburg. However, the earliest most significant collection of self-portraits was held at the Gallery of Self-Portraits at the Uffizi in Florence. This was based on a collection of *uomini illustri* by Cosimo de Medici (1519–74) and then expanded through the addition of a number of self-portraits by Leopoldo de Medici (1617–75) who left 700 paintings including about 70 self-portraits when he died. The collection, which was continued by his descendants and includes works by Domenichino, Guido Reni, then moved to the Uffizi in 1714. By this time, it comprised 186 works.

Leopoldo had started collecting self-portraits by painters from various parts of Italy and abroad (Bologna, Venice, France, Flanders). He accumulated self-portraits by Guercino and Pietro da Cortona, Paolo Veronese, Lavinia Fontana, Bernini, Carracci, Vasari, Rembrandt, and van Dyck, to name a few, including also a fake Leonardo da Vinci self-portrait. Cosimo II, Leopoldo, and Cosimo III, who collected English and Dutch painting, all contributed to the growth of the collection. By 1782, there were over 300 self-portraits including works by Reynolds, Raphael, Zoffany, and Angelica Kauffmann. The corridor, built in 1565, had been the vision of Cosimo I de Medici who wanted to connect Palazzo Vecchio with Palazzo Pitti. It is said that he remembered that Homer had mentioned a passage connecting, in Troy, Priam's to Hector's Palaces (Berti 1973: 5) as he wanted his family to be able to cross the city undisturbed and reach Palazzo Strozzi in case of an attack (Giusti 1996: 1). He then commissioned Vasari who built the corridor over a five-month period. Inside the corridor, which opened to the public in 1865 when Florence became capital of Italy, there is a view of the Chiesa di Santa Felicita which resembles a stage looking down onto the church. By the eighteenth century it became traditional for artists to offer a self-portrait to the Uffizi collection and today the collection includes nearly 1500 works (West 2004: 45). The self-portraits were exhibited in the part of the corridor which goes over the Ponte Vecchio to the area opening onto the Chiesa di Santa Felicita between 1952 and 2016 (Caneva 2002: 175). The paintings themselves were shown by school and in chronological order: on the Ponte Vecchio were Italian self-portraits from the sixteenth and seventeenth centuries and at Santa Felicita were foreign self-portraits from the sixteenth and seventeenth centuries; Ritrattini Medicei and Miniatures and Italian self-portraits from the eighteenth and nineteenth centuries. This curatorial choice made it possible to develop a number of histories of the self-portrait tracing the evolution of the genre over time.

Interestingly, patrons occasionally requested that artists painted themselves in a specific manner. Thus in 1676, Frans van Mieris was commissioned by Cosimo III de Medici to produce a self-portrait holding a small painting 'such as those he generally paints'

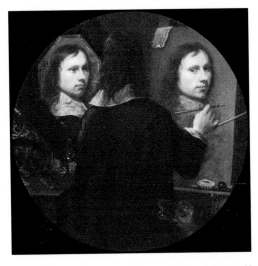

Figure 1.7 Johannes Gumpp, *Self Portrait*, 1646. Firenze, Museo degli Uffizi.

(Reynolds and Peter in Reynolds et al. 2016: 17). But often artists could determine themselves how they would appear in the collection. Among the most unusual self-portraits shown in the Uffizi is Annibale Carracci's *Self Portrait on an Easel in His Studio* (c. 1603–5), which shows an image of the painter that is younger than the age he was at the time of painting the work. Considered as 'one of the most celebrated and mysterious of Italian self-portraits' (Hall 2014: 118), this work shows the artist in a painting within the painting, framed by the scenario depicting the work's own production (Finch and Woodall in Bond and Woodall 2005: 95). The work does not only show a mirror that reflects the artist 'present only at one remove' (Ibid.) but possibly also the shadow of the viewer who, in an attempt to reconcile distant spaces and times, is brought directly within the work of art.

Another important work is Carlo Dolci's *Self-Portrait* (1674), which can be described as a double self-portrait. Here, the artist is seen holding a piece of paper depicting himself at work using a black and red pencil. Fried notes that in the paper the artist is seen holding a brush with his right hand, which suggests the image is not mirror-reversed, while in the second image he is seen holding the image which is being shown to the viewer, marking two separate 'moments' in the creation of the work (2010: 31). Finally, Johannes Gumpp's *Self Portrait* (1646) shows the painter from behind, looking into a mirror positioned to his and the viewer's left so that the painter could paint himself in a canvas to his and the viewer's right. There are subtle differences between his image in the mirror and the image in the painting including the position of the eyes which is a reflection of the fact the artist was looking into the mirror, indicating perhaps that the painted artist is looking back at the artist himself in the act of painting with one eye, while also looking, with the other eye, at the imagined position of the viewer. Hence, the work draws attention to the abyss formed 'between the I, the me and the self' (Arasse 1982: 83), in an attempt to represent the complexity of what was in fact meant by 'self' in this work. So, not only, as Nicole Lawrence suggests, there is a multiplication of the subject here as 'the reflected self, the painted self and the "real" self' (in Bond and Woodall 2005: 123) but also there is a positioning of the viewer within the work. Interestingly, as

Jonathan Miller indicates, this work, showing the making of the self-portrait, raises the question of how the artist could have 'seen himself from behind while painting himself by reflection from the front' (1998: 187). While it is possible, as in the case of Dürer's drawing (1484), Graphische Sammlung Albertina, Vienna, that multiple mirrors were used, this painting draws attention to the artist's mastery and increasingly subjective rendering of their 'self' in art. As Melchior-Bonnett notes, the presence of the tools of the trade in this case, however, further underlines the gap between 'the subject and the representation' (2002: 167).

The self-portraits in the Vasari Corridor show the emergence of a new phase in self-portraiture during which artists paid increasing attention to the representation of the process of painting or, to be more precise, the depiction of the process of both capturing themselves as an object (the painted) and showing the subject in action (the painter seen in the act of painting). This doubling or even trebling of representation, as Daniel Arasse put it, the representation of the 'between the I, the me and the self', rendered the self-portrait in itself a strategy for the exhibition of the subject as a series of displaced fragments located in a plurality of places.

In conclusion, it is worth citing one more development in relation to the Uffizi collection. During the second half of the eighteenth century, the painter Giuseppe Macpherson was commissioned by Lord Cowper to produce a series of miniature copies of the Uffizi self-portrait collection, 224 in total, which were later presented to George III (Reynolds in Reynolds et al. 2016: 217). The painter added his own self-portrait to this collection titled *Giuseppe Macpherson, Autore della Serie* (*Author of the Collection*, c. 1772–80), Royal Collection, London. Curiously, this self-portrait was the only work from this collection he actually signed, though through the phrasing on the signature of his self-portrait he, of course, claimed authorship of the series. With this work, the self-portrait fully entered the 'culture of the copy', to borrow Hillel Schwartz's successful phrasing (1996), which was to play an increasingly significant role in the development of the genre in years to come.

Self-portraits as theatres: the case of Rembrandt

During the seventeenth century a number of studies were published that explored notions of subjectivity and identity in a range of disciplines and practices. Previously, as West suggests, identity was seen to be rooted in external attributes conveyed through the body, the face, and deportment, and only after Romanticism's obsession with personality did the idea that the portrait could communicate something about a sitter's emotional state come to the forefront (2004: 29). From the seventeenth century, portraits and self-portraits became progressively more about a staged self, turning to be, in West's words, increasingly 'filled with the external signs of a person's *socialized* self, denoting what Erving Goffman referred to as the "front" of an individual' (in West 2004: 30, added emphasis and Goffman 1990: 32). This idea of a socialisation of the self in painting is inextricably tied with the construction of a staged persona through the adoption of role or character and the use of a series of props. More and more were mirrors during this time used to create theatrical stages (Melchior-Bonnet 2002: 174) from which the artist could be seen establishing their presence.

One of the most prolific authors of self-portraits was Rembrandt who produced some fifty self-portraits in different media including etchings, paintings, and drawings in which he often adopted different roles and techniques (West 2004: 174–5). We know already

that the term self-portrait did not exist at Rembrandt's time and so his self-portraits were presented as '"contrefeitsel van Rembrandt door hem sellfs gedaen" (Rembrandt's likeness done by himself) or "het portraitvan Rembrandt foor hem self geschildert" (the portrait of Rembrandt painted by himself)', in van de Wetering in White and Buvelot 1999: 17). As was already the case for Dürer's description of his own work, the term 'self' appears in this definition, but, still, it must not be understood in the modern sense of the meaning of the word. Many of Rembrandt's etchings can be described as studies in human emotions and moods rather than self-portraits (21). However, it has been suggested that, despite this, Rembrandt's earliest works should be considered as self-portraits as they were informed by a 'reflective self-consciousness' through which the artist 'conceptualised and projected his self-image and role as artist' (Chapman 1990: 11). During Rembrandt's lifetime only two of these self-portraits were mentioned, and none was referred to at the time of his insolvency (Wright 1982: 14 and 129). Only in the nineteenth century, as the profession of the critic became more prominent, a more substantial documentation of Rembrandt's work was carried out by John Smith. This, in turn, ultimately led to the classification of Rembrandt's career in two main sections, the Leiden period and the Amsterdam period. A large number of his self-portraits stem from the former (Ibid.: 16).

Rembrandt painted himself in the *History piece* (1626) Leiden, Stedelijk Museum, in which he constructed, in Pascal Bonafoux's words, a 'historical painting that does not require a story' (1985: 11). Here, he can be found behind Agamemnon, partly obscured by his figure, looking at the viewer and resembling a number of his later self-portraits (Wright 1982: 17). Crucially, he is no longer positioned at the margin of the painting but occupies a central position (Chapman 1990: 16), though he looks at the viewer, thus establishing a direct relationship with them. Interestingly, an X-ray of *History Piece* revealed that he added himself into the painting at a later point (Buijsen, Schatborn and Broos in White and Buvelot 1999: 86) as if to establish, in a piece about history, a renewed relationship with the contemporary, forever evolving, world of the viewer. Rembrandt also painted himself in *Musical Company* (1626) Rijksmuseum Amsterdam, as the harpist, looking at the viewer, surrounded by a group of musicians wearing Turkish-like clothing. In the foreground, we see props (music books, musical instruments) that, literally, set the scene. In *The Raising of the Cross* (1634) Alte Pinakothek, Munich, and in *The Descent from the Cross* (1633) Hermitage Museum, St Petersburg, he painted himself as a sinner and in the former also as one of the executioner's assistants (Buijsen et al in White and Buvelot 1999: 88). In *Self-Portrait with a Dead Bittern* (1939) in the Gemäldegalerie Dresden, he painted himself as a hunter holding out a dead bittern, the only object to catch the light (Bonafoux 1985: 82). In *The Night Watch* (1642) Rijksmuseum Amsterdam, he painted himself as a figure seemingly ignoring everything unfolding in front of him, located 'directly beneath the keystone of the arch, framed in the angle of a sword-blade and a gorget, over the standard bearer's left shoulder' (92). His inclusion of himself in these paintings represented, according to Ernst van de Wetering, an attraction for his contemporaries because 'the inclusion of their portraits in such a setting provided the purchaser with both the portrait of a celebrated artist and a display of the mastery that had made him famous in the first place' (in White and Buvelot 1999: 30).

While these self-portraits remain, of course, portraits Rembrandt made of himself, they are different from the ones in which he painted only himself. The latter in fact allowed him to experiment more freely with a whole range of expressions, often inspired by

works by other artists. Thus, his *Self-Portrait at the Age of 34* (1640), National Gallery, London, probably drew inspiration from Raphael's *Portrait of Baldassare Castiglione* (1514–5), Louvre, Paris, and from Titian's *Portrait of a Gerolamo (?) Barbarigo* (1510) at the National Gallery, London (Sullivan 1980: 238). Here, we see him 'wearing a hat in the style of Baldassare Castiglione, resting his arm in the manner of Titian's Ariosto' (Bonafoux 1985: 90). Rembrandt knew the Italian masters, including Raphael, Mantegna, the Carracci, Guido Reni, Michelangelo, and Titian, among others, as his studio was found full of prints done after them (90). Rembrandt was also increasingly interested in representing his personal emotions. So, in his *Self-Portrait at the Age of 63* (1969), National Gallery London, reveals, by an X-Ray investigation, that he painted out a number of elements that would have caught the eye so as to focus the viewer's attention on his own gaze (Van De Wetering 1997: 168).

One of Rembrandt's most interesting self-portraits is *The Artist in His Studio* (1606–9), Museum of Fine Arts Boston which consists of a large bare room, with crumbling wall plaster, a grindstone for preparing pigments, and a closed door leading to an unknown space. Rembrandt is seen here standing alone, holding a brush in his hand. There is no mirror, and Rembrandt looks tiny, stepping back into a shadowy area while facing a gigantic canvas that the viewer can only see the back of. For Simon Shama, the painting consists of a 'visual inventory of tools and practices' (1999: 14), almost 'a letter of introduction, nothing short of a pronouncement on the nature of Painting itself' (15). What is unusual, are Rembrandt's own eyes which seem to have 'no convexity' but rather 'lie flat against the face [...] literally, black holes-cavities behind which something is being born rather than destroyed' (20). The reason for this, Ernst van de Wetering notes, is explained in the similarities between *The Artist in His Studio* and *Jan Lievens in the Workshop* (1630), Malibu, The J.P. Getty Museum (29). Both works have a large stone used by the artists to ground their own colour. Hence, the painting could be depicting a concept from the theory of art regarding the first of three modes of creation, to work from imagination, the others being through chance and practice (in Brown et al. 1991: 29). In the first case the artist would form an image of the work in their mind and only when that was consolidated, they would paint it. Hence *The Artist in His Studio*, van de Wetering proposes, does not only depict the artist at work but also literally illustrates the artist's creative thinking process coming into shape, emerging out of the shadow, caught in between forms (Ibid.).

Rembrandt's etched self-portraits from Leiden and Amsterdam, as well as those from Kassel and Munich, show evidence of what has been described as an 'astounding' variety of emotions, moods, and expectations (Wright 1982: 19–20). His *Self-Portrait* (1629–31), Rijksmuseum in Amsterdam, for example, is part of one of numerous etchings produced in the late 1620s in which he experimented with facial expression. In some of these he appeared older than he would have been at the time of painting the works, as was the case of his *Self-Portrait* (c. 1629), Mauritshuis, The Hague, in which his face literally appears to be emerging from the shadow (20). In others, like his 1664 *Self-Portrait* Uffizi, Firenze, he appears an old man for whom, in John Berger's words, 'all has gone except a sense of the question of existence, of existence as a question' (1972: 112). Interestingly, fellow painter Oscar Kokoschka, writing many years later, wondered why Rembrandt produced so many self-portraits and noted:

> I looked at Rembrandt's last self-portrait: ugly and broken, frightful and despairing, and so wonderfully painted. And suddenly I understood: to be able to observe oneself

vanishing in the mirror – to see nothing more – and to paint oneself as 'nothingness' the negation of man.

<div align="right">(in Bonafoux 1985: 127)</div>

As Kokoschka realised, Rembrandt's late self-portraits are an exploration of the progressive fading of life itself.

Svetlana Alpers suggests that 'Rembrandt moved away from depicting actions to offer the act of painting itself as the performance we view' (1988: 32). So, for example, figures in *The Night-Watch* (1642), Rijksmuseum, Amsterdam, 'were presented as if they were part of a staged or enacted scene – the gestures of certain individuals as well as the action of the group as a whole, the interest in the display of costumes and the prominent setting' (35). To paint the self-portraits, Alpers notes, Rembrandt must have had to 'become an actor', indicating that these self-portraits also constitute a form of documentation of a performative act (38). Chapman too talks about Rembrandt's self-portraits as studies in acting based on the fact that Horace's idea, prevalent in Dutch and Italian theory since Alberti, suggesting that the poet 'had to imagine emotions he wanted the beholder to feel', was also true for painters (1990: 20). Thus Rembrandt's pupil Samuel van Hoogstraten, for example, advised his own pupils to 'empathise as closely as possible with the emotions of the figures in history pieces while looking into a mirror: "thus must one reshape oneself entirely into an actor [...] in front of a mirror, being both exhibitor and beholder"' (van de Wetering in White and Buvelot 1999: 21; van Hoogstraten 1678: 109–10) or, to put it in Chapman's words, 'both performer and beholder, or represented and representer' (1990: 20).

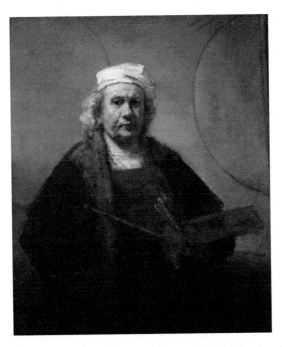

Figure 1.8 Rembrandt, *Self-Portrait with Two Circles*, c. 1665–9. The Iveagh Bequest, Kenwood House, London. © Historic England Archive – PLB_J910070.

One of Rembrandt's most interesting self-portraits is *Self-Portrait with Two Circles* (c. 1665–9) in Kenwood House, London, whose two mysterious circles have been the subject of several studies due to their probable philosophical significance. Thus, van de Wetering notes that an X-Radiograph of the painting shows that Rembrandt

> must have initially painted himself in the act of painting, exactly as he saw himself in the mirror, with palette, brushes and maulstick in his right hand, and his left hand holding a brush, which is raised in such a way as to suggest that he was working on the canvas.
>
> (in White and Buvelot 1999: 12)

However, Rembrandt subsequently made changes to the work by moving the palette, brushes and maulstick to his left hand and reducing the right hand 'to an indistinct blur' (Ibid.), probably, van de Wetering points out, making an accurate representation of which hand he used in the painting (Rembrandt was right-handed) (13). For van de Wetering this indicates that the mirror used by Rembrandt may have shown him to the hips but he 'must have stepped up to it in order to study his face more closely' as it is known that mirror images are smaller than the physical word they show (Ibid.). As in other works discussed in this chapter, there is therefore a clear 'duality' between 'the painter scrutinising himself and addressing the viewer' (Podro 1999: 556), which is reflected here in the presence of two circles. These appear to be in front of and behind the artist as if he was looking at himself from two points of view (front and rear). It is possible that the two circles had something to do with this act of stepping forward and backwards, recording his movement, and presence, in space and time.

In *History Piece* (1626), and in *Self-Portrait as a Young Man* (1628), Rijksmuseum, Amsterdam, Rembrandt is seen looking at a viewer, more than half of his face in shadow, establishing what has been described as an act of 'reciprocity of painting and looking' (Podro 1999: 553). Rembrandt may have intended to experiment here with *chiaroscuro* (Buijsen et al. in White and Buvelot 1999: 95) but may have also aimed to capture the vanishing of his own presence in front of an other, the coming to end of the present moment. Playwright Jean Genet pointed out that in Rembrandt's self-portraits we can in fact 'follow the evolution of his method and the effect of that evolution on the man' (1958 no p.n. cited in Bonafoux 1985: 130). Unquestionably, as Svetlana Alpers indicates, Rembrandt established the self-portrait 'as a central mode for painters' that was to affect future generations for centuries to come, so much so that even nineteenth century artists shaped the 'myth of the lone genius' as an interpretation of Rembrandt's 'art and life' (1988: 3). His experimentation with theatricality and performativity, especially evident in works like *Self Portrait Leaning on a Stone Wall* (1639), Rijksmuseum, Amsterdam, where he is seen wearing a sixteenth century costume looking straight at the viewer, renders his self-portraits instances of experimentation not only with *how* to present himself as or through an other, but also with how to conceive of 'himself' in the first place.

As Alpers points out in *The Art of Describing* (1983), Dutch painters 'historiating' portraits do not succeed in showing the act of 'transformation' required by this genre. Rather, in these works there is a 'collusion between portrayed and portrayer' so much so that 'it is the insistent identity of the Dutch sitters, present in the look of their faces and their telling domestic bearing, combines with the insistently descriptive mode of the artist representing them to make them unable to appear other than themselves' (14). In Rembrandt's late self-portraits it is no longer possible to see the character that has been

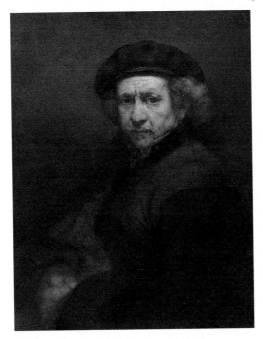

Figure 1.9 Rembrandt, *Self-Portrait with Beret and Turned-Up Collar*, 1659. National Gallery of Art, Washington D.C.

constructed but rather what manifests itself is the fading of a person, a stark reminder of his and indeed our fugacious *act* of being.

Ten years before his death Rembrandt painted *Self-Portrait with Beret and Turned-Up Collar* (1659), National Gallery of Art, Washington D.C. Here, Rembrandt, sits sideways, staring right at the viewer, his hands clasped in his lap. Rembrandt's face is lit in such a way that his cheeks appear somewhat hollow, his brow furrowed. The prevailing darker colours almost completely absorb his figure, so that his body appears to be disappearing into the background, except for his hands and face which are lit. Interestingly, *Self-Portrait with Beret and Turned-Up Collar* was originally meant to show the artist at work, except that Rembrandt changed the white coloured cap which he used in self-portraits where he is seen at the easel to a dark beret (White and Buvelot 1999: 202). There is no easel here, no beret, no paintbrush, only Rembrandt. His folded hands, caught in the light, remind us of whom we are looking at.

In analysing Rembrandt's late self-portraits, the painter Francis Bacon notes:

> you will find that the whole contour of the face changes time after time; it's a totally different face, although it has what is called a look of Rembrandt, and by this difference it involves you in different areas of feeling.
>
> (in Sylvester 1975: 58–9)

Thinking specifically about Rembrandt's *Self-Portrait with Beret* (c. 1659), Musée Granet, Aix-en-Provence, he states: 'if you analyse it, you will see that there are hardly any sockets to the eyes, that it is almost completely anti-illustrational' (in Sylvester 1975: 58). Likewise, Bacon's own self-portraits look disfigured, as is the case of *Self-Portrait* (1973),

private collection, or two of the *Three Studies for Self-Portrait* (1976), Marlborough Fine Art, London. Thus, commenting on his *Study for Self-Portrait* titled *Self Portrait no. 1* (1964), on the reverse, Bacon states: 'I have deliberately tried to twist myself, but I have not gone far enough. My paintings are, if you like, a record of this distortion' (quoted in Cambridge Opinion 1964 in Bacon [no date]). Later he also noted: 'I'm always hoping to deform people into appearance; I can't paint them literally' (Bacon in Sylvester 1975: 146). For Bacon, who often worked from photographs rather than with sitters (in Archimbaud 1993: 15), painting portraits, including self-portraits, was an act of de- and perhaps un-forming the subject, made possible by the mirror and the eye's inability to ultimately capture one's 'self' as a stable entity. Thus, he remarked: 'what I want to do is to distort the thing far beyond the appearance, but in the distortion to bring it back to a recording of the appearance' (Bacon in Sylvester 1975: 41). It is the documentation of one's own (dis-)appearance, the process of establishing one's presence elsewhere (beyond the present), that Bacon, and Rembrandt before him, famously captured in their work.

Beyond representation: the case of Velázquez

H. Perry Chapman points out how during the sixteenth and seventeenth centuries artists became increasingly fascinated with 'the nature of the soul and the relationship between body and soul' (1990: 26). This happened alongside the publication of books on memory, emotions, and states of mind, especially melancholy, as well as physiognomy, cognition, and perception. Thus, the term psychology, for example, was coined, as Chapman indicates, to 'denote the scientific study of the human mind or soul' (Ibid.). One of the most influential books at the time was Juan Huarte's *The Examination of Men's Wits, in Which, by Discovering the Varieties of Natures, is Showed for What Profession Each One is Apt, and How Far He Shall Profit Therein* (1575), which focussed on different types of abilities of the mind and looked into the formation of identity offering also some insight into what I have here called 'self'.

Melancholic temperament certainly caught the attention of this age (Chapman 1990: 26). In fact, according to Raymond Klibansky, Erwin Panofsky and Fritz Saxl, melancholy had become 'essentially enhanced self-awareness' (1964: 231–2). Hence, by the time Robert Burton's *Anatomy of Melancholy* was published in 1621, melancholy was a major trope for drama, poetry, as well as painting. By the seventeenth century, self-awareness and introspection formed a common characteristic of autobiographies and diaries, which were referred to by Dutch scholars as 'egodocumenten' (Dickey 2006: 21). Thus Constantin Huygens, for example, made a direct connection between these forms when he noted 'that the description of the human face represents an unparalleled opportunity to depict "a wonderful compendium of the whole person, body and spirit"' (in Dickey 2006: 22). The role of the viewer also became even more significant. Hence, during the fifteenth and sixteenth centuries Dutch compositions which had previously shown, in Alois Riegl's words, a 'strong internal coherence between sitters lined up in rows as if imprisoned by the frame' became 'more attentive to the viewer, vividly acknowledging his or her presence by opening up what has been described as a process of "intimate reflection"' (in Groorenboer 2012: 1). In talking about Rembrandt's figures Riegl suggests that their 'attentiveness' 'stretches out in front of them in the direction of the viewer' (in Ibid.: 2), literally creating a space between the work and the viewer so that, by the seventeenth century group portraiture existed as a spectacle 'solely for the viewing subject' (Ibid.).

A seventeenth century painting that well illustrates the complexity of the representa-tion of the viewing subject is Diego Velázquez's *Las Meninas* (1656) Prado, Madrid. The painting, as Manuel Gasser notes, is not really about *Las Meninas*, as the title suggests, or even King Philip and Queen Mariana themselves, whom we think we can see reflected in the mirror behind the artist, seemingly placed in the way of the spectator's own posi-tion; rather, it is a self-portrait in the sense that it is 'the painter', as Gasser notes, who literally 'dominates the canvas' (1963: 83). Velázquez's famous work could, however, also be seen as one of the earliest instances of a representation of the viewer within the work. Thus, West points out, the viewer's own 'entrance into the picture is blocked by the placement of the king and queen effectively in the spectator's position' (2004: 40). Point-ing out that Velázquez was probably familiar with the *Arnolfini Portrait*, the mirror, to which a sheen was added to make it clear to the viewer that they were looking at a mirror (Miller 1998: 76), seems to reflect 'otherwise unseen figures' who yet 'play a cen-tral role in any understanding of the painting's construction and meaning' (Seidel 1993: 188). These figures, however, do not seem to assume the artist's 'vantage point' since the painter, we are told, placed himself 'prominently within the representation and is shown looking out at the viewer, ostensibly in the direction of the figures whose reflections are being cast upon the mirror', indicating that they are implicated 'as the subjects of his current work' (189). Thus, Velázquez here painted not so much what he would see reflected in a mirror but what the viewer would see, except that the viewer is reflected as the king and queen, though the mirror is positioned in such a way that the reflection could also be of another painting (Kahr 1975: 228). This means that, as Leo Steinberg notes, if the perspectival vanishing point right to the mirror is the man on the stairs, then this should be opposite the viewer which means that what we see in the mirror is in fact the subject of the painting (1981: 52). For Steinberg, this results in 'an elegant ambiguity: a mirror that transmits data from two disparate places, from the king-and-queen's pain-ted likeness and from where they stand in the flesh. Yet the two are the same' (Ibid.). The painter is still present here, but so are his subjects and the viewer, except that none of these constructed presences are what they seem, or are placed where they should be. Thus, 'by conjuring up presences both within and outside the painting', Velázquez creates 'a psychological as well as a spatial tension between the work of art and the beholder' (Martin 1977: 168) so that arguably this space, the space between the artwork and the viewer, is no longer neutral but rather charged with the problematics and politics of the act of looking. The mirror, which traditionally had been such an important instrument in truthfully reflecting the world, is questioned here, and nothing, as in Shakespeare's *King Lear*, appears to remain what it seemed upon first impression.

Michel Foucault notes that in Dutch painting 'it was traditional for mirrors to play a duplicating role: they repeated the original contents of the picture, only inside an unreal, modified, contracted, concave space' (1994: 7). Thus, what was in the mirror, he points out, coincided with what was in the painting, though the latter was 'decomposed and recomposed according to a different law' (Ibid.). The same could be said for Italian painting, as was summed up by Leonardo's writings about the role of the artist. In Velázquez's work, however, the mirror, as Foucault suggests, 'is saying nothing that has already been said before' (Ibid.). The mirror is not so much copying something that is in the world of the painting. Nor is it merely multiplying spaces. Rather, the mirror here brings into the picture what is, as Foucault notes, 'foreign to it: the gaze which has organised it and the gaze for which it is displayed' (15). In other words, the mirror in *Las Meninas* produces an interaction between the artwork and the viewer that not only

makes visible something to the latter that could otherwise not be seen, but also makes visible the work's own organising principle.

From self-fashioning to immersion

Self-fashioning, which had previously primarily occurred through the creation of role or character, started to manifest itself through reference to other paintings so as to establish not only social but also aesthetic milieu and indicate legacy by association. Johannes Vermeer, for example, in *The Allegory of Painting* (1666–7) Kunsthistorisches Museum, Vienna, represented himself from the back, standing at his easel while painting a young woman holding a trumpet and a book in front of a large map. Much has been written about this work, and the relationship between the map, the representation of the artist, and the sitter. As Alpers points out, Vermeer here 'signed the map and paints the girl' (1983: 168). The use of tenses is interesting as Vermeer 'withdraws to celebrate the world seen' and 'like a surveyor, the painter is within the very world he represents' (Ibid.). With this act, Vermeer turned the self-portrait into a broader statement about the world: as was the case for van Eyck's *Arnolfini Portrait*, the signed map is confined to the past whereas the artwork to which the artist belongs appears to be located in the present. This self-portrait, which, unusually, does not show the artist frontally, foregrounds the cartographic representation facing both the artist and the viewer to signal that this act of presencing, like that of Velázquez's painting, presents the artist within a broader aesthetic, philosophical, and political perspective.

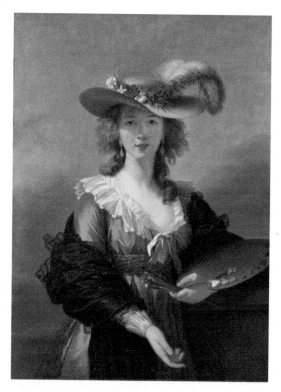

Figure 1.10 Elisabeth Louise Vigée Le Brun, *Self Portrait in a Straw Hat*, 1782. © The National Gallery, London.

Over the years, self-fashioning through self-portraits became ever more popular, almost to the extent that it became an exercise in its own right. Elisabeth Vigée Le Brun in *Self-Portrait in a Straw Hat* (1782) National Gallery, London, practised self-fashioning by representing herself elegantly dressed, holding a palette, having perhaps modelled her self-portrait on Peter Paul Rubens's earlier painting *Portrait of Susanna Lunden*, called *Le Chapeau de Paille* (1622–5) that Vigée Le Brun had seen in the Netherlands, thus placing herself in his tradition. According to Mary Sheriff, Vigée Le Brun's self-portrait became part of a history of art within which paintings were not 'expressions of an artist's inner self, but skilful artistic performances dependant on the ability to mimic signifying codes, gestures and styles' (1996: 215). Of course, self-portraits also continued to operate as demonstrations of the artist's technique. Thus in Dominique Ingres's *Self-Portrait of the Artist at the Age of Twenty-Four* (1867), Musée Condé, Chantilly, Ingres painted himself at the age of twenty-four but then repainted the work later by altering not only his costume and the composition, but also his features, so that the work could be described as 'the fusion of two self-portraits, an authentic one painted in youth and an old man's vision of what he had looked like when he was young' (Gasser 1963: 124).

Jacques-Louis David painted his last self-portrait in 1794, Paris Louvre, from prison where one of his pupils had brought him some painting materials as well as a mirror. In his study of the work, and self-portraiture more widely, Clark postulates that the mirror was what framed the realisation of 'possessing a self, or coming to consciousness of oneself as one' (in Roth 1994: 280) so much so that one could say that the self-portrait is 'the moment that self sees itself' (306). Here, Clark notes, '*the body becomes a form for itself*' which 'lets us look back at what we are' (301, original emphasis). This externalisation or doubling of the 'self' as something that could be formed, or fashioned, through art marks, for Clark, the exposure of a dichotomy between the representation of the self as a subject and that as an object, drawing attention to the uncanny instability but also fabricated nature not only of what was represented (or presented back to the viewer) as the 'self' but also of the entire world view that was associated with it.

Many important works were produced over the coming centuries which this chapter, in its attempt to generate a map of the origin of the genre from which to understand more contemporary developments in the use of technology in self-portraiture, is not able to describe. Crucially for this study though, during the Victorian period, artists became very interested in exposing the veracity of technological framing, exposing also what has been described as 'the question of the reliability – or otherwise – of the human eye, and with the problems of interpreting what they saw' (Flint 2000: 1). During this period the world of representation, of the spectacle, and production became more substantially intertwined with each other (Richards 1990: 16). Representations of the self, increasingly fragmented, were often multiplied across surfaces and media. Hence, over time, self-portraits became more hybrid, comprising a wider range of autobiographical factors, materials, and points of reference. Thus, Joan Miró *Self-Portrait on an Envelope* (1942), which is addressed to himself, shows the location of the birthplace where the artist had taken up a studio, a picture of a dog barking to the moon, an inscription telling us that the grooves of the postal mark symbolise a field, a reference perhaps to his own painting of 1923. Superimposed over a Catalan landscape, it is possible to see the contour of his torso which may have been a reference to his earlier 1919 self-portrait. The work is both a self-portrait and an autobiographical document that expands the painterly self-portrait into an inter-medial hybrid work.

During this time artists became interested in exploring the relational processes involved in the construction of their presence, integrating their 'self' within their environment. For

example, Louis Faurer's *Staten Island Ferry, New York* (1946) and *Self-Portrait, New York City* (1948) used mirrors to superimpose the image of the artist with the background behind the mirror, overlaying the subject with the reflected environment they were part of. As psychoanalysis developed, artists became increasingly interested in the representation of the subconscious dimensions of the 'self'. Thus, Whitney Chadwick notes that the works of women associated with the Surrealists, for example, started to display

> a self-consciousness about social constructions of femininity as surface and image, a tendency toward the 'phantasmic and oneiric', a preoccupation with psychic powers assigned to the feminine, and an embrace of doubling, masking, and/or masquerade as defences against fears of non-identity.

> (1998: 6)

For Chadwick, these works 'both recreate and resist the specular focus and voyeuristic gaze of Western representation' (11), initiating a new kind of self-portraiture to do with the world of the still and moving image.

Over time, artists became more and more confident with citing self-portraiture, often using it as a way to reference other artists in their work. Thus, in *Self-Portrait as the Mona Lisa* (1954) Salvador Dalí substituted his face for that of the Mona Lisa. For Calabrese, this was both an act of self-fashioning and a suggestion, in line with Surrealist thinking, that the *Mona Lisa* was a self-portrait by Leonardo, so that here 'it is no longer the artist who identifies with his representation, but the work itself that identifies with another work' (2006: 122). Likewise, in Norman Rockwell's *Triple Self-Portrait* (1960), Stockbridge, Massachusetts, Norman Rockwell Museum, we see the artist painting a self-portrait based on an image reflected in a mirror. As in Gumpp's case, the artist is painted from behind. On the top left are reproduced a number of sketches for the self-portrait and on the top right we see self-portraits by Dürer, Rembrandt, Picasso, and van Gogh, creating a sort of history of the self-portrait within the self-portrait that concluded with his own work. While there are similarities between the image of the artist in the mirror and the image of the painter, the image that is painted is more similar to those shown in the sketches, suggesting the artist is making a point about the veracity of the genre and so implicitly portraying the mirror as a technology for interpreting the world around him.

Mirrors, we have seen, are not just tools, they are also materials. Frieda Kahlo, for example, whose house was apparently full of mirrors, so much so that some of the photos taken of her are in fact reflections in these mirrors (Grimberg in Chadwick 1998: 83), painted one of her self-portraits directly onto a mirror. Thus, in her work *Self-Portrait 'The Frame'* (1937–8), Georges Pompidou Center, Paris, she appears in the centre of a panel against a blue/purple field with yellow marigolds in her hair which signify the Day of the Dead in Mexican culture, making it seem as if she was looking at us from beyond the grave. Kahlo, who is known for staging her 'self-representation through carefully chosen symbolic images and cultural "props"' (Chadwick 1998: 28), painted a very large number of self-portraits that can be described as medical self-portraits and frequently used 'double images of the self' (30) such as in *The Two Fridas* (1939), Museo de Arte Moderna, Mexico City, and *The Tree of Hope* (1946), Daniel Filipacchi Collection, Paris, where she positioned herself 'within the dualities out of which she formed the narratives of her identity: European/Mexican, nature/culture, body/body politic' (Ibid.). Like other painters, Kahlo was interested in writing herself within art history by cross-

referring to her lineage. Thus, in her *Self-Portrait with a Velvet Dress* (1926), private collection, Mexico, which was painted in reference to Italian Renaissance and Mannerist painters, she looked like a late fifteenth century aristocrat evoking Botticelli's *Birth of Venus* (c. 1485), Uffizi, Florence (Zamudio-Taylor in Carpenter 2008: 19). This practice, which I have already discussed in relation to Vigée Le Brun, was to be subsequently adopted, as I will show in Chapter 3, by a number of women artists including Orlan, who literally remodelled her body according to points of reference about female beauty created throughout the history of art. Finally, in *Roots* (1943), Kahlo's blood is seen coursing through a vine to feed a deserted earth, to which she is returning. Here, the 'self' is no longer separable from that of the languages, cultures, and environments which formed her identity.

Artists always used mirrors to generate a sense of immersion, though rarely in the context of self-portraiture. Yayoy Kusama, who had been engaged in self-documentation as well as in sculptural and collage accumulations known as 'self-obliterations', in acknowledging that she used her own 'complexities and fears as subjects' (Kusama 2011: 93), indicated that she developed self-obliterations as a way to signal her disappearance into the artwork. Thus, as Jo Applin suggests, in her *I'm Here, but Nothing* (2000), which could be seen as a 'self-obliteration', an instance of 'Kusama's "self" experienced as "nothing"' asserts itself at the same time as an 'I am here' (in Morris 2012: 191), presenting her 'self' in the act of becoming absent. Kusama's play on her absence/presence in the work started, over time, to include the public. Thus, her *Narcissus Garden* (1966) in which she created a sea of 1,500 polished plastic balls in the Giardini at the Venice Biennale, the balls, which she later offered for sale, reflected the viewers as well as the environment around them (see also Yakamura 2015). Likewise, her infinity Mirror Rooms, which are cube-shaped rooms that are clad by mirrored panels lit by lights or chandeliers suspended on the ceiling, reflect the image of the viewer infinitely, so that they are brought face to face with their own disappearance inside Kusama's obliterating 'self'.

Enter the viewer: the case of Pistoletto

Arte Povera artist Michelangelo Pistoletto started to work with mirrors in the late 1960s. In his *quadri specchianti*, or mirror paintings (or pictures), cut-out painted paper images of people were applied to sheets or steel. Angela Vattese notes that they attempted to overcome 'the simplest autobiographical approach contained in the question "who am I?", to leave room for a vaster, more ambitious research: "what is the relationship between (any) being and the world surrounding it/him?"' (2000: 13). The relationship between the image painted in the mirror and the reflected viewer redefined these works' temporality as a performative work. In fact, prior to these works, in the late 1950s, Pistoletto had created a series of full-figure and life-size self-portraits. It is known that at that point in time Pistoletto had been interested in the background of these works as a way to make a statement about space and time, and had experimented with different colours, levels of light, and materials to render the difference between the self-portrait and the background. In 1960 he painted more self-portraits presenting himself inexpressively at full size, under the over-arching title *Il presente* (*The present*). This phase marked a growing interest in capturing the present, and so a presence, within the work.

In *Il presente – Uomo visto di schiena* (*The Present – Man Seen from the Back*, 1961), a man is seen looking away from the viewer. For Vattese, 'The figure could be said to

Figure 1.11 Michelangelo Pistoletto, *The Present – Man Seen from the Back*, 1961. Acrylic and plastic paint on canvas, 200 x 150 cm. Collection Fondazione Pistoletto, Biella. Photo: Enrico Amici.

represent "being" and the images in the mirror "becoming"' (2000: 13). Pistoletto's comments about this work described the moment he realised that the reflective quality of the painting could constitute a gateway for the viewer to mirror her or himself within the work:

> In 1961, on a black background that had been varnished to the point that it reflected, I began to paint my face. I saw it come toward me, detaching itself from the space of an environment in which all things moved, and I was astonished. I realized that I no longer had to look at myself in another mirror, that I could copy myself while looking at myself directly in the canvas. In the next painting I turned the figure around, because the painted eyes were still artificial, whereas those of the reflection could be as real as those of the figure that now was on the surface of the painting looking into the painting. In fact, being now turned in same direction as I was, it possessed my eyes.
>
> (Pistoletto 1979)

This realisation marked a crucial moment in the development of the mirroring paintings. At this point, for Pistoletto, 'the true protagonist' of the work became, in his words,

> the relationship of instantaneousness that was created between the spectator, his own reflection, and the painted figure, in an ever-present movement that concentrated the past and the figure in itself to such an extent as to cause one to call their very existence into doubt: it was the dimension of time itself.
>
> (Pistoletto 1966)

This focus on temporality, the present, and so also presence, and the interest in liveness and instantaneousness, coincided with Pistoletto's growing interest in happenings and performance which culminated with the founding of the group Zoo in 1967. With Zoo, Pistoletto produced a number of public actions and happenings with his family and friends, often involving individuals from a range of communities in Italy and abroad. In these happenings or actions, while there still was a distinction between performers and audience, everybody was participating in or was implicated within the event (Pistoletto 1969: 16).

Uomo in piedi (*Standing Man*, 1962–1982) is another early example of a *quadro spec-chiante*. This work comprises a mirror surface hanging slightly above the floor level, measuring two and a half metres in height, on which a life-sized image of a man wearing a dark grey suit, standing while facing away from the viewer, is attached. Viewers can see themselves and their environment reflected in the mirror painting. Like Pistoletto's other mirror paintings or, to better reflect the original Italian expression *quadri specchianti*, mirror*ing* paintings, *Standing Man* facilitates the temporary co-habitation between contrasting spatio-temporal co-ordinates. This produces a clash between the static, eternally present, space–time of the image superimposed on the mirror, and the dynamic, constantly mutating, present space–time of the viewer.

For Pistoletto, the mirror paintings entailed a performative dimension and 'could not live without an audience' because 'they were created and re-created according to the movement and to the interventions they reproduced' (in Pistoletto Foundation n.d.). There was a clash between the spatio-temporal dimensions implicated by these 'participants' in the work, since, as the anonymous author of Tate's acquisition file noted, 'the figure could be said to represent "being" and the images in the mirror "becoming"' (Anon 1982). Likewise, Germano Celant suggests that the mirror works bring the past (that of the artist) into the present (that of the viewer). Additionally, for him, because of the use of photography, the work 'aims to underline the non-subjective character of the image which pertains to the universe of appearance and reproduction' (in Gianelli and Celant 2000: 256). So, there is a clash between the reproducibility of the image and the ephemerality of performance and of life itself.

It is known that most of these works now have a historical resonance, in that participants look younger or appear to be wearing clothes that are out of fashion. In the oldest mirror painting the discrepancy between the image and the reflection is bigger and so 'for the museum spectators now reflected in that painting, they are no longer just figures, but figures from a period that no longer exists' (Vattese 2000: 13). For Vattese, these works are in fact both past and future oriented. Thus, she notes, 'If when they first appeared these figures were already a memory, this remains in the present and is projected into the future: the mirror contains the potential for everything that will happen in front of it in future times' (Ibid.). But whereas the past is captured by the mirror, the present is caught in a present progressive tense, that of the mirror*ing* painting, indicating that something is continuing, moving into the future through the mirror.

After *Il presente – uomo visto di schiena* (*The Present – Man Seen from the Back*, 1961), Pistoletto developed a number of techniques for the background of his figures, including an actual mirror, and finally settled on a steel sheet. He then started to use photos, usually of himself or, more commonly, friends, including other arte povera artists, as well as customers. These were initially mostly static and facing away from gallery viewers, though over time he developed mirror paintings portraying figures in motion, positioned facing both towards the background of the work or towards the viewers themselves.

In reviewing Pistoletto's exhibition at the Museum of Modern Art in Oxford in 2000, Catherine Wood notes that the subtitle of the exhibition 'I am the Other' suggests that the

> extent to which that seemingly obdurate part of identity – one's 'image' – can never be known or possessed by the person to whom it belongs. One can only ever see oneself as 'other', and never from all the angles at which one is seen.
>
> (1999: 2089)

For Pistoletto, the aim of his mirroring paintings was in fact

> to take art to the edges of life in order to test the whole system in which both moved. After this, you have to make a choice. Either you return to the system of doubling and conflicts in a monstrous act of regression, or you get out of the system with a revolution. You either take life to art, as Pollock did, or you take art to life, but no longer in the form of a metaphor.
>
> (2000: 94)

Subsequently, self-portraiture moved increasingly within the realm of performance and the preferred technology for capturing the 'self' became the camera.

2 The photographic self-portrait

Svetlana Alpers, quoting James Ackerman (1977), notes that while 'Italian picture frames were once designed like window surrounds', during the seventeenth century in the Netherlands they started to resemble 'the frames placed on mirrors' (1983: 42). Hence, while Italian artworks could be described as being framed to look like views onto a different world, Dutch seventeenth century artworks started to be framed as if they were reflections of the world of the viewer. The impression gained was that artists were not so much depicting a world out there but rather they were representing the viewer's world back to them. The term representation in fact implies the construction of a present, a 'now', that is presented back to the viewer. As the etymology of the term representation relates to the practice of gifting, which, as Marcel Mauss shows, must produce a reciprocal act (2011), representation implies not only the artist's own act of presencing, but also the artist's positioning of the viewer in relation to it. In the rerepresentation of a self-portrait, the present time of the work, the artist's presence within the work, and the viewer's presence at the time of the reception of the work, are therefore all displaced from each other and yet also implicated within each other.

As Alpers points out, photographs, broadly speaking, share some common characteristics with Dutch seventeenth century artworks, such as the use of immediacy and arbitrary framing (1983: 43). Immediacy implies the communication of a close proximity to the 'now' that is represented, and arbitrary framing indicates that the framing for the capture of immediacy is random and subjective. In some of the Dutch paintings discussed in Chapter 1, as well as in some of the photographic works discussed in this chapter, immediacy and arbitrary framing are seen collapsing into one another, as if to suggest that the present, the now, what is immediate (in time), can only be captured in the rendering of the subject through framing (in space). Roland Barthes's analysis of the *punctum* in photography sheds further light into why this may be the case. For Barthes the *punctum* is a 'detail' (2000: 43) that has 'a power of expansion' (45), indicating not so much 'what is no longer', what is in the past, but rather 'what has been' (85), what was and yet still is, in other words, what persists in the present. The *punctum*, he suggests, therefore brings on a 'perverse confusion between two concepts: the Real and the Live' (79). What Barthes calls the 'Real' is rooted in the fact that the photograph portrays a past occurrence and what he calls 'Live' coincides with this occurrence's manifestation in the present. Both a reference to a past and to what remains, the photograph, for Barthes, constitutes 'a certificate of presence' (87) as well as 'an act of catastrophe' representing, and so making present again to the viewer, what is no longer (96). The collusion between the Real and the Live, between the immediacy of an occurrence and the arbitrary framing that contains the subject's presence within this occurrence is at the heart of many of the photographic works discussed in this chapter.

DOI: 10.4324/9780429468483-3

It is generally assumed that the photograph shows something that actually took place, and that therefore what is represented would have occurred even without the artist capturing it (Scruton 1981). In this respect the photograph, even more so than painting, is often treated as a document, evidence to the truth and authenticity of the occurrence represented in the image. However, photographs are often fabricated through montage or filtering. Yves Klein's *Leap into the Void* (1960), in which Klein appears to be jumping out from a building, is a great example of this form of work which, as suggested by Philip Auslander, purely exists as documentation (1997). The collusion between the Real and the Live that Barthes identifies thus exposes an uncanny paradox that characterises these kinds of photographic works in which the Real in the image never occurred in the way that is shown and yet the Live manifests itself in the present time of the viewer as if the event actually took place.

In a study of a photographic self-portrait of the philosopher Theodor W. Adorno, *Self in mirror* (1964), which shows the philosopher sitting on a small chair facing a mirror, the camera being positioned behind him in the mirror reflection, Gerhard Richter notes that

> the viewing subject is spatially positioned where the referential object must be for its image to be reflectable by the mirror's surface: the absent referent who bears the name of Adorno is located outside the realm of the image precisely where the viewer is now positioned.
>
> (2002: 1)

The subject here becomes 'the image of an object' in that, as Richter suggests, we 'are not looking at Adorno, at a picture of Adorno, or even a picture of a picture of Adorno, but at a *scene* in which the very *act of creating* the picture of a picture of Adorno is self-reflexively arrested' (Ibid., original emphasis). A second image shot by the photographer Stefan Moses, who also inspired the first image, *Portrait of Adorno's Self-Portrait* (1964), shows Adorno from a slightly different angle so that it is now possible to see him on the left side of the image being reflected in the mirror on the right which also shows the cut off hand of the photographer, hence the use of both the terms portrait and self-portrait (2002: 7). The use of the camera, as well as the mirror, shows the subject (Adorno), in the case of the first image, in the process of producing an image in which he appears as an object, while in the case of the second image, the subject (now Moses) is seen in the process of creating the image of Adorno producing an image in which he appears as an object. This complex interplay between the subject as agent or performer and the subject as object or image, or, to use Barthes's terms, the Real and the Live, is at the heart of the rendering of the 'self' in photographic self-portraiture.

This chapter focuses on a number of artists whose works show them staging often multiple and hybrid identities directly for the camera. Many of these works were created, in the words of Tate curator Catherine Wood, to take place 'within a new reality: inside the space of the image itself' in the sense that, still in her words, these works entailed a performance which 'was not only primarily aimed at the camera's eye instead of live audiences, but also it imagined the world within the photograph's frame as a space to inhabit: an alternative order of fictional space in two dimensions' (in Giannachi and Westerman 2017: 2). This means that even when these works are not fully theatrical or even performative, they entail aspects of both these forms as they are literally staged for the camera. This chapter shows how these artists often problematised the production of

this 'alternative order' by making visible the process at the heart of the creation of the image. While some works included in this chapter are explicit self-portraits, others are less evidently so, though they all engage with notions and practices of 'self', or 'selves', creation.

The origin of the photographic self-portrait

The first photographic self-portrait is likely to have been Robert Cornelius's 1939 image of himself. Cornelius was aware that he was producing 'the first light picture ever taken' and wrote this text himself on the back of this very early self-portrait (in Meehan 2008: 24). The image shows his head and shoulders, arms crossed, facing the camera. Cornelius commented on the image: 'You will notice the figure is not in the centre of the plate' (in Ibid.). In fact, Cornelius had to run in front of the camera after preparing it to capture the image, resulting in a self-portrait which does not only show his self-portrait but also tracks the actions he carried out to produce the image. This blurred and off-centre self-portrait, Sean Meehan suggests, never aimed to reproduce the likeness of a painted self-portrait, but rather conveyed a 'mediated immediacy' so that 'photography *itself*, like the actual photographer in this case, is part of the representation' (25, original emphasis). In other words, this work is just as much a statement about photography as it is a self-portrait.

That the photograph could at once produce an image and show its staged origin was the subject of much discussion in the early days of photography. Thus, Oliver Wendell Holmes, for example, notes in 'The Stereoscope and the Stereograph' (1859) that the photograph operates as a '*mirror with a memory*' in that whereas the mirror represents 'an image of its subject matter, seemingly giving us the subject in the image', the photograph does not forget the subject when removed from view (in Meehan 2008: 27, original emphasis). In this sense the image is a representation of an external form as well as an optical appearance and an impression obtained by a camera. This is because, as Holmes suggests, the photograph can make 'a sheet of paper reflect images like a mirror and hold them like a picture' (1859: 738). This characteristic of the photograph, which can both reflect and frame, produces an uncanny paradox whereby the event photographed both *is* and *is not* the same event as the one that is in the photograph.

Another early self-portrait was Hippolyte Bayard's *Self-Portrait as a Drowned Man* (1840). Compared with Cornelius's work, this image is overtly theatrical, showing Bayard's corpse, 'unclaimed by anyone' (Lerner 2014: 218), laying at the morgue surrounded by a series of objects. Bayard had recently pioneered a photographic process which had been ignored by the press in favour of a similar process developed by Louis-Jacques-Mandè Daguerre. The reverse of the image describes the work as an act of protest:

> The corpse which you see here is that of M. Bayard, inventor of the process that you have just seen, or the marvellous results of which you are soon going to see. To my knowledge, this ingenious and indefatigable researcher has been working for about three years to perfect his invention. The Academy, the King, and all those who have seen his pictures, that he himself found imperfect, have admired them as you do at this moment. This has brought him much honour but has not yielded him a single farthing. The government, having given too much to M. Daguerre, said it could do nothing for M. Bayard and the unhappy man drowned himself. [...] H.B. 18 October 1840.
>
> (in Batchen 1999: 167 and 171)

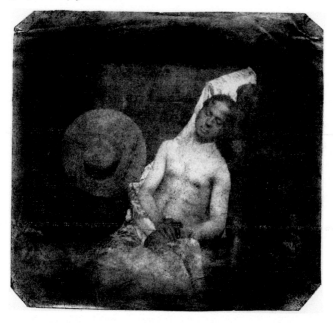

Figure 2.1 Hippolyte Bayard, *Self-Portrait as a Drowned Man*, 1840, paper direct positive, 18.7 × 19.3 cm. Collection Société française de photographie (coll. SFP), 2008. frSFP_0024im_0269.

Bayard's descriptions suggest, as Jillian Lerner (2014: 222–3) and François Brunet (2009: 16 and 28) note, that the work existed as an event and a text before it existed as an image. However, as in the case of Klein's subsequent *Leap into the Void*, the image does not show an event that actually occurred. Bayard never took his life. As Michal Sapir points out, the image therefore acts as a testimony to the non-authenticity of the text accompanying it, since the latter could not have been written on the back of the print if the author had actually been dead (1994: 623). Rather, the props that appear in the work (the hat, vase, garment, and statuette) were arranged next to the corpse so as to provide a clue to the identity of the victim (Lerner 2014: 222–3), rendering them a 'signature' of sorts (223), and so marking the beginning of the use of photography as a 'technology of the self' (231).

At the turn of the nineteenth century, philosophers and scientists became interested in exploring photography as a way to frame and document emotions. Thus Charles Darwin, for instance, commissioned Oscar Rejlander's *Souvenirs of O.G, Rejlander* (1870–1) and *Self-Portraits Showing Anger, Surprise, Apology, Shrugging, Disgust, Child Screaming, Held from Behind, Determination and Indignation* (1871), which saw Rejlander express a wide range of emotions that Darwin then used in *The Expression of the Emotions in Man and Animals* (1872). Rejlander's photographs may also be read in reference to the tradition of the *tronie*, which can be described as 'exaggerated character studies in Golden Age Dutch painting' that were meant to represent 'universal emotions', often using people as models (Prodger 2018: 164). Rejlander was familiar with Rembrandt's works, and it is possible that his expression studies relate to specific paintings by him (Ibid.), offering an early example of the use of the camera for the interpretation of emotions as well as for the staging of roles and characters, thus possibly constituting a precursor to the work of Cindy Sherman analysed later in this chapter.

Just as artists in the past had represented themselves with palettes and mirrors, photographers started to pose with their cameras, as was the case, for example, for Imogen Cunningham's *Self-portrait with Camera* (1920s), Germaine Krull's *Self-Portrait with Cigarette and Camera* (1925), and Margaret Bourke-White's *Self-Portrait with Camera* (c. 1933) (Borzello 1998: 118). Famously, Man Ray's *Self-Portrait with Camera* (1930), sees him manipulating a camera, drawing attention to his role as a photographer and the consequent staging of the event. At this point in time some artists also started to experiment with different reflective surfaces. Thus, the street photographer Vivian Maier, for example, took self-portraits in which her image is reflected in several nearby buildings, showing the subject's reflection pervading surrounding environments.

Interestingly, some of the earliest photographic explorations of gender identity stem from this period. Frances Benjamin Johnson's *Self-Portrait* (1890) showing her dressed as a man with a fake moustache holding a bicycle and her *Self-Portrait (as New Woman)* (1896) 'elbow out, mannish cap on her head, tankard in one hand and cigarette in the other' could be said to prefigure 'gender explorations of the 1970s' (Borzello 1998: 115). Additionally, artists became increasingly interested in citing well-known painterly self-portraits from the past, often to write themselves within a given history of art and as a display of technique. Thus, Ilse Bing's *Self-Portrait with Leica* (1931), for example, could be described as a reference to Gumpp's *Self-Portrait* (1646), Galleria degli Uffizi, Firenze, in that the photograph presents two images of Bing, so that 'on the left, we see a reflection of her profile in a mirror; on the right, we see her frontal self-portrait', yet both images are reflections in a mirror (Wilson 2012: 59). These early photographic self-portraits illustrate a distinctive characteristic of the genre. This, as Craig Owens suggests, reverses the action seen in the work, by presenting the subject 'as an object in order to be a subject' (1985: 212, 215), and so showing that the photographic self-portrait is a self-representation of the subject as an image, where the image as an object documents the presence of the subject as such.

An artist who made a number of experimental autobiographical self-portraits often using both mirrors and photography was Marcel Duchamp. Duchamp was interested in Frederick E. Ives's parallax stereogram and Gabriel Lippman's lens system which

Figure 2.2 Marcel Duchamp, *Five-Way Portrait of Marcel Duchamp* (*Portrait multiple de Marcel Duchamp*), Broadway Photo Shop, New York City, 21 June 1917. Private Collection, New York; Courtesy Francis M. Naumann Fine Art, New York. © Association Marcel Duchamp/ADAGP, Paris and DACS, London 2021.

produced 'changeable photographs' that allowed matching images to be viewed from different sides, showing, as in *Portrait multiple de Marcel Duchamp* (*Five-Way Portrait of Marcel Duchamp*) (1917) that he could represent different profiles and so also perspectives of himself. The work, created through the use of a hinged mirror, has been described as being indicative of his later use of 'characters' in self-portraiture (McManus in Goodyear and McManus 2009: 136–7). The dialectic between the photographed image and the image's reflections leaves the viewer excluded from the gazes of the reflections of the artist who, instead, is seen from a range of perspectives. The hinged-mirror technique, often used to photograph criminals, as well as to make high art portrait photography, rendered the role of the photographer more mechanical, something which Duchamp appeared to find attractive since at the time he sought to 'mechanomorph his portrayals of the human figure' (McManus 2008: 125).

Famously, Duchamp created a series of works featuring his female alter ego Rose (or after 1921 Rrose) Sélavy (McManus in Goodyear and McManus 2009: 60). These works seem to be best described as documentations of a series of appearances, of which at least one was documented by May Ray, showing Duchamp in women's clothes carrying out, as he called it, a 'readymadish action' (in Tomkins and the Editors of Time-Life Books 1966: 79). In the image Duchamp is seen as the fashionable woman represented on the label of a perfume bottle, 'Belle Haleine Eau de Voilette' which appeared for *New York Dada* as a possible spoof of Coco Chanel's perfume brand (McManus in Goodyear and McManus 2009: 146). Rose also coined puns and signed readymades of her own in 1920 and 1921, making subsequent appearances in works by other artists such as Mark Tansey's *The Enunciation* (1992), Museum of Fine Arts Boston, where Duchamp is seen sitting in a train compartment while catching a glimpse of Rrose Sélavy sitting in a passing train, heading in the opposite direction. Finally, Rrose signed numerous letters, and artworks, funded a fabric-dyeing business, a fashion shop, and authored journal essays (Mileaf in Goodyear and McManus 2009: 50).

Duchamp's experiments with photography, film, and optics, drawing from Etienne-Jules Marey and Eadweard Muybridge's work time, came together in the work on Rrose whose images, deliberately in the plural, point to a multiple personality fabricated through signs (McManus in Goodyear and McManus 2009: 70–1). For McManus, Rrose rubbed up 'against contemporary images of celebrities and fashion models populating the pages of *Vanity Fair* magazine' (152), whose portrayals 'weaver between those of consumer and product to be consumed' (72). The representation of the self as a readymade alter ego was to become a popular strategy among artists in subsequent years.

Over time, artists started to use mirrors, cameras as well as painting in their works, to create hybrid and often serial self-portraits. Andy Warhol's self-portraits, for example, offering what has been described as a 'contradictory balance between up-close intimacy and calculated artifice' (Rosenblum in Elger 2005: 21), were often made from photographic negatives, a technique producing 'the eerie effect of remembering something that was once there but has vanished forever' (26). Having introduced the sequential character to self-portraiture so that 'everybody can find his or her *own* Warhol' (Wäspe in Elger 2005: 73, original emphasis), Warhol often used 'his own image as a field of experimentation' (Ibid.), especially in his Pop self-portraits which were based on photos taken in photo booths (Ibid.). Quite a few of these photographic self-portraits were placed in the *Time Capsules* (1975), a serial work consisting of 610 standard-sized cardboard boxes, each containing around 200 objects, that documented the life of the artist. These boxes, collected over twelve years, and containing materials spanning between 1960 and

1987, included ephemera as diverse as dinner invitations, personal correspondence, toe-nail clippings, unused condoms, unseen artworks, dead bees, business records, photos, garbage, bills, and personal mementos such as Warhol's hospital bracelet from the 1968 shooting, fan letters, a pair of shoes that once belonged to the actor Clark Gable, silverware from an Air France flight, cans of soup, soiled clothing, raw pizza dough, some of his mother's clothes, and a letter from Alfred Barr, the first Director of the Museum of Modern Art (MoMA), turning down his offer to donate one of his shoe drawings to the New York museum. Warhol's Pop self-portraits were not only to play a major role in the subsequent development of the culture of the selfie but also offer the basis of self-representation as a broader canvas for aesthetic experimentation.

The production of the subject in the work of Claude Cahun

When Claude Cahun was in her early thirties, she wrote 'Héroïnes' in Paris, fifteen mono-logues by women drawn from the Bible, Greek mythology, Western literature, and popular culture (Conley in Downie 2006: 24). The stories intended to represent these women as human beings rather than purely as heroines (Ibid.). Here, Cahun showed a fascination, like other Surrealist artists, with the defamiliarization of well-known images through the exploration of the idea that these heroines could have been self-consciously performing roles (Ibid.). An interest in subverting preconceived notions of femininity was to play a key function in her own self-portraits where mirrors and cameras were not so much used to reflect as to problematise and destabilise an increasingly transient notion of 'self'.

Cahun, born Lucy Schwob, adopted a number of pseudonyms over the course of her life, including Claude Courlis and Daniel Douglas, literally turning her body, as Peter Weibel suggests, 'into a stage for imagined others' (2016: 48). These self-portraits were shot by her partner Marcel Moore whose shadow is often seen in the artworks as a kind of 'indexical trace of the photograph's making' (Doy 2007: 38). While Cahun's *Autoportraits* from the 1920s still show her in abstract environments, works produced in the 1930s increasingly show her in every-day life environments often seemingly caught by surprise by an imaginary onlooker (Kline in Chadwick 1998: 75). Thus *Autoportrait* (1928), San Francisco Museum of Modern Art, shows what Katy Kline describes as the

Figure 2.3 Claude Cahun, *Self-Portrait (Reflected in Mirror)*, c. 1928, photograph, 18 x 24 cm, © Jersey Heritage Collections Trust.

'three-quarter-length view of the artist in a masculine tailored jacket' facing the viewer whilst being reflected in a mirror. Looking as if 'startled and slightly uneasy' (69), Cahun is seen staring at the viewer, her reflection in the mirror facing away from the viewer in a diametrically opposite direction. This double representation makes it difficult for the viewer to look at both images of Cahun at the same time. Similarly, in *Que me veux-tu?* (*What do you want of me?*) (1928), private collection Paris, Cahun presents herself as an androgynous two-headed creature, whose heads are not the mirror image of each other, one looking at the other in a slightly startled way, as if asking the question in the title of the work. As Kline notes, the broken eye contact between the two heads implies 'the impossibility of any answer' to the question (Kline in Chadwick 1998: 73). Here, the always already multiple self is both the subject and the object of the question but the viewer can no longer construct them into a unity.

Of this period are also a series of self-portraits showing Cahun engaged in performative movements which are likely to have been inspired by Rudolph von Laban's 'alphabet' (Latimer in Downie 2006: 62). Cahun was generally interested in theatre and was often photographed wearing masks (Doy 2007: 37ff). Thus, in her *Têtes de Cristal*, British Museum, London (1936) part of her face is positioned between a number of masks on display at the British Museum, the photograph taken frontally from the other side of the cabinet, as if to imply that she too was part of that display. Cahun was, in all likelihood, familiar with the work of Havelock Ellis and his idea of sex as mutable (Knafo 2014: 45). Her *Self-Portrait (Full Length Masked Figure in Cloak with Masks)* (c.1928), for example, was described as 'an intriguing visualisation' showing that 'she was made up of multiple selves' (Howgate 2017: 99). In fact, Cahun, who was probably also aware of Duchamp's Rrose Selavy (Ibid.), often presented herself as a set of male figures (a sailor, a mime, a wrestler, a body builder, a Buddah, etc.). In her double self-portraits she reversed 'the concept of the "self-object" coined by the father of self-psychology, Heinz Kohut, as one connoting the narcissistic use of an Other to function as part of the self structure' (1971 and Knafo 2014: 48). This rendered her self-portraits acts of '*self-othering*' (49, original emphasis) in which, in an act of hospitality, she represented herself as one or more others. Her *Self-Pride* (1920–30) shows a photomontage, a representation of what has been described as an 'oedipal drama, set in a triangle, containing mother, father, and child, all attached to each other in a grotesque symbiosis' (39). As Liz Rideal suggests, these works have usually been read as exploring 'the visual language which has historically constructed "woman" as object and other' (2001: 21).

Cahun's *Autoportrait* (1939) significantly altered the genre of the self-portrait by establishing, in Amelia Jones's words, 'an exaggerated mode of performative *self-imagining*' (2002: 948, added emphasis) which transformed 'at once, the conception of the self-portrait and the very notion of the subject' (947). Showing Cahun lying still, her eyes shut as if asleep, surrounded by nature, her right hand pulling what looks like a cable, possibly that of the camera, *Autoportrait* establishes a self-portrait that, like a film still, made no attempt to connect to the viewer but signalled, by drawing attention to the cable, that we are witnessing an act of self-representation, an act of presencing, an instance of self-documentation. The viewer here becomes a voyeur, a witness to a private moment. While, for Jones, the self-portrait constituted a form of representation based primarily on external traits, the self-images produced by Cahun externalize how artists saw themselves or thought others saw them *as an image*. Thus, the photographic self-portrait becomes in Cahun's case not only a 'technology of the self' (Lerner 2014: 231) but also a '*technology of embodiment*' (Jones 2002: 950, original emphasis). Crucially, for

Jones the photograph in fact 'not only *mediates* but *produces* subjectivities in the contemporary world' (Ibid., original emphases). Hereafter the photograph, to put it with Katherine Hayles, becomes 'so entwined with the production of identity that it can no longer meaningfully be separated from the human subject' (1999: xiii). It is in the image, in the act of presencing that occurs in the representation of the subject as an other, that Cahun constructs her identity as always already multiple.

The intermedial self-portrait in the work of Ana Mendieta

Ana Mendieta used photography and video to document her performance work, a strategy she learnt from other artists and, while at Iowa, from her teacher and lover Hans Breder, who urged all his students to develop a three-step working process: 'concept development, execution, and documentation' (Viso 2008: 22). Breder understood these documentations to be 'photo documents of ephemeral events' reflecting 'the process of abstraction that occurs in the photography' (in Breder and Rapaport 2011: 20). The documentations were in fact part of his broader vision for intermedial practice which, he claimed, was akin to 'a consciousness-based process, a time-based nomadic enactment' within which 'boundaries are blurred or displaced' so that '[t]he new image/text requires a reorientation in intertextual space/time' (21).

For Breder, who took several of the photographs of Mendieta's early performance work, documentation formed part of this 'consciousness-based process' of 'reorientation in intertextual space/time' that was at the heart of his intermedial work (21), which he described as 'what happens at borders' (20). Mendieta's *Untitled (Self-Portrait with Blood)* (1973) is a photograph of the artist's face dripping with blood which Elisabeth Manchester suggests, recalls 'the imagery of martyrdom central to Roman Catholic iconography' (2009d). The image is a print from a 35mm slide (Fischer 2002: 54–6). Manchester notes that the work is part of a series of experiments on self-portraiture, *Untitled (Facial Cosmetic Variations)* (1972) showing Mendieta's face deformed so that her body, 'like that of millions of other women', is seen as 'modified with makeup, wings, creams, nylon stockings'. Here, as in other works, the subject does not only become an object, it also becomes, in Manchester's words, 'immediately plural' (2009d) and, as in the case of Parmigianino's hand, deformed by the medium.

Untitled (Blood and Feathers) (1974) is a short three-and-a-half-minute film documenting a performance that Mendieta did at Old Man's Creek, Sharon Center, Iowa City, Iowa, which shows Mendieta standing naked on a stretch of sand in front of a stream and a mud bank. The film sees her pouring blood down her chest and legs, back and arms, throwing herself into a heap of white feathers, rolling within them as if to mimic a bird (Manchester 2009a). As Olga Viso suggests, inspiration for this may have come from the writings of Carlos Castaneda which Breder was recommending to his students and which talk about self-transformation and alternative forms of being, most noticeably the act of becoming a bird (2004: 49). These acts of transformation, of becoming, are also at the heart of a number of works including her *Untitled (Silueta Series Mexico)* (1974), a colour photograph showing a view across some ruins with the silhouette of a human figure painted on the sandy ground.

Research conducted for the pre-acquisition record, prompted Manchester to note that the photograph was taken in the ruins of the 'Labyrinth' in the Palace of Six Patios at Yagul, an archaeological site in the valley of Oaxaca, Mexico. The Tate acquisitions records show Mendieta had bought blood from a butcher at a market in the city of

Oaxaca and then poured it onto the earth with the assistance of Breder 'who traced her outline on the ground before she scooped the earth around it to create a rim which would hold the blood'. This is the second of her series of *Siluetas* that Mendieta created in Mexico and the first in which she used the outline of her body, rather than her body itself. Two years later, at the Basilica of Cuilapán de Guerrero, near Oaxaca, Manchester notes, the artist created another *Silueta* based on the outline of her body using twigs (Manchester 2009b). *Untitled (Silueta Series, Mexico)* (1976) is a colour photograph in which a human figure made of interwoven twigs can be seen at the centre of an alcove set in the wall of a building. As Manchester suggests, Mendieta in this case based the figure on her own body before fixing it in the niche of a building located in the church and monastery complex of Cuilapán de Guerrero, near the city of Oaxaca in Mexico. This sixteenth century Basilica constructed by Dominican friars during the era of the Spanish colonisation of Mexico, Manchester notes, was the site of several untitled works from Mendieta's *Silueta* series in 1973, 1974, and 1976 (2009b and 2009c).

As had been the case in Frieda Kahlo's work, the relationship between nature and the body was at the heart of the way she represented herself in her art. In a set of statements she wrote about her work in 1981, Mendieta explained:

> I have been carrying out a dialogue between the landscape and the female body (based on my own silhouette). I believe this has been a direct result of my having been torn from my homeland (Cuba) during my adolescence. I am overwhelmed by the feeling of having been cast from the womb (nature). My art is the way I re-establish the bonds that unite me to the universe. It is a return to the maternal source.
>
> (in Barreras del Rio and Perreault 1988: 10)

> Through my earth/body sculptures I become one with the earth [...] I become an extension of nature and nature becomes an extension of my body. This obsessive act of reasserting my ties with the earth is really the reactivation of primaeval beliefs [... in] an omnipresent female force, the after-image of being encompassed within the womb
>
> (in Ibid.)[1]

When talking about being torn from her homeland, Mendieta was referring to the fact that she and her sister Raquelin had been forced to flee their home in the island of Cuba in 1961 at the age of 12. Once they arrived in the United States, they had spent their adolescence among religious institutions and foster families in Iowa. They had been part of a protection programme for relatives of those who supported the anti-communist movement in Cuba known as Operation Peter Pan in which their father had been involved.

From 1973 until 1980 Mendieta created well over a hundred *Siluetas* in Mexico and Iowa, including films and images, whose figures, Manchester notes, 'appear either with their arms raised in the manner of the Minoan snake goddess – as in Tate's two *Silueta* images – or with them held close to the body' (2009c). In some siluetas the body is present, like in *Creek* (1974), San Felipe, Mexico, which sees Mendieta floating in a river, facing the water, as if embracing nature. In others the artist's body is absent. Some siluetas are barely perceptible, like those in the documentation of a 1977 work in which the silueta appears as an island in the river, a form in the snow, a snow trace on a tree, a

Figure 2.4 Ana Mendieta. *Untitled: Silueta Series, Mexico, 1973/1991 from Silueta Works in Mexico, 1973–77*. Galerie Lelong. Copyright ARS, NY, and DACS, London.

trace on a broken tree trunk, grass in a lagoon, mud in a river bank. The shape some-times resembles that of a heart, the same heart that Mendieta used as a signature in her letters to Breder as a substitute to the letter 'n' in her given name or a drawing around her name (see Hachmeister 2010). So, perhaps unsurprisingly, she wrote:

> [f]or the past twelve years I have been working out in nature, exploring the relationship between myself, the earth and art. I have thrown myself into the very elements that produced me, using the earth as my canvas and my soul as my tools.
>
> (Mendieta in Farris 1999: 180)

This suggests that for Mendieta the silueta, described by Jones as 'enacted *trace*' (Jones 1998: 35), was perhaps also a signature, a self-portrait of sorts.

In discussing Mendieta's work as intermedial, Adrian Heathfield suggests that what the spectator deals with within her work 'is the relation between matter and forms – per-formance, sculpture, image – each of which carries distinct durations'. For him, 'the work is constituted "somewhen" between these times' (in Rosenthal 2013: 24). Mendie-ta's work, at once performance, sculpture, image, expresses precisely the tension of how the self-portrait exists in between forms and media. So, ahead of her time, she noted, in a proposal to Bard College for *La Maja de Yerba* written in 1984:

> [m]y works do not belong to the modernist tradition, which exploits physical prop-erties and an enlarged scale of materials. Nor is it akin to the commercially histor-ical-self-conscious assertions of what is called post-modernist. My art is grounded on the primordial accumulations, the unconscious urges that animate the world, not an attempt to redeem the past, but rather in confrontation with the void, the orphan-hood, the unbaptised earth of the beginning, the time that from within the earth looks upon us.
>
> (Mendieta in Viso 2008: 293)

In talking about Mendieta's photographic documentations in the *Village Voice* in 1979 Judith Wilson suggests that for her 'the confusion of documentation, art object and art act that Ana Mendieta's work provokes is one of its most compelling features'. Whether *Siluetas*, Wilson continues, consists of her 'ritualistic process of interacting with nature, of the immediate product of this interaction, or of the records of both process and product she represents to the public, is a question that draws nearly all the major tendencies of contemporary art into play' (1980: 71). As Wilson recognizes, Mendieta was in fact not only experimenting with a range of forms, time, and space and, most crucially perhaps, going back to the terminology used by Barthes, the Real and the Live, she was also exploring what happens to the subject in-between forms. Her work was not so much a gesture of subtraction but rather an act of presencing, of tracing herself within the broader environment that had informed and, herewith, also literally formed her.

The act of becoming in the work of Francesca Woodman

Francesca Woodman was one of the first photographers to explicitly place her work within the history of photographic self-portraiture. Her *Without Title* (1975–8), Providence Rhode Island, in which her body is half hidden and only her legs can be seen, may have been created as a reference to Cahun's 1932 *Self-Portrait in a Cupboard*, while her *Without Title* (1976), Providence, Rhode Island, where she can be seen naked, her waist pressed against a sheet of glass, may have been a reference to Mendieta's *Untitled (Glass on Body Imprints)* (1972) in which a sheet of glass is used to deliberately distort and so mis-shape her body. Scholarship is torn as to whether Woodman's works, largely developed, as in the case of Mendieta's, while she was an art student and often in response to specific assignments, can be described as self-portraits. Thus, on the one hand Arthur Danto suggests that Francesca Woodman 'never shows herself as herself [...] she always shows herself as the same character – the character of a young woman in various *mis-en-scenes*' (2004: 38). On the other hand, Marco Pierini notes that 'the whole of Francesca Woodman's journey as an artist can essentially be enclosed within the category of the self-portrait' (2010: 37) and others also indicate that she rarely became '*someone* else' (Townsend in Townsend and Woodman 2006: 59, original emphasis).

In Woodman's work the mirror is not reflective of a stable self. Thus, in her *Roman Self-deceit series* (1978) she appears next to, on top of, underneath, and hidden by a mirror which no longer reflects her image but rather conceals it. As was the case of Mendieta, Woodman too appears to fade into or become part of the environment in which she can be, often barely, seen. In *From Space* (1975–6) Woodman is seen standing 'against the crumbling interior walls of a dilapidated house' and in *House #3* (1975–6) she is 'curled up in a fetal position under a window frame' (Liu 2004: 26). Woodman in fact purposely created these effects through long exposure and what she described as 'continuously fluid movement' (Ibid.). As Rosalind Krauss suggests, everything that is photographed here appears to be 'flattened to fit paper', which means the body of the artist is seen 'within, permeating' (1999: 166, original emphasis), struggling through the rendition. While there is a stillness in the photographic image that is commonly produced by pausing an action for the camera, Woodman captures the traces produced in the act of becoming other.

Woodman's unpublished *Portrait of a Reputation*, made some time between 1975 and 1979, shows a sequence documenting her progressive disappearance from the image. In the first image, Woodman's gaze is still seen meeting the camera's eye, whereas in the

Figure 2.5 Francesca Woodman. *Self-Deceit #1*, Rome, Italy, 1978. Gelatin silver print, 3 9/16 × 3 1/2 in. © 2021 Woodman Family Foundation/Artists Rights Society (ARS), New York/ DACS, London.

second image her face is already 'half-hidden, bisected by a strange band of deep shadow produced through double exposure or a manipulation at the printing stage' while on the last page her 'vanishing act is complete, her body seemingly having sunk into the plaster, leaving a residual trace of her presence as two inky hand-prints on the studio wall' (Riches 2004: 97). Here Woodman explores in Riches's words, 'the medium's proclivity for exercising subjectivity from the world' (98). This work traced a progressive 'staged absence' (Ibid.). In fact, Woodman noted that she was 'interested in the way people relate to space' and felt that 'the best way to do this is to depict their interactions to the boundaries of these spaces' through what she called 'ghost pictures' showing 'people fading into a flat plane – i.e., becoming the wall under the wallpaper or of an extension of the wall onto the floor. [...] Also video tapes – people becoming, or emerging from environment' (in Townsend and Woodman 2006: 244). These works framed the immediacy of presence, the process of defining the subject in the act of being perceived by another.

As in Cahun's case, Woodman often made the staging of her work visible. Thus, in her *Self-Portrait at 13* (1972) she photographed herself in the act of 'producing the self-portrait' (Wilson 2012: 63). Here, a shutter release cable is seen emerging right in front of the lens stretched from her hand. Woodman's face, turning away from the camera over her shoulder, means only the back of her head can be seen. For Dawn Wilson, 'posing for a self-portrait in such an unusual way throws into question one of our basic assumptions about self-portraiture: the idea that by taking herself as her own subject, the artist is willing to subject herself to scrutiny' (64). The camera here cannot catch the subject. Neither can the mirror. Thus, in *Untitled*, New York (1979–1980) Woodman bends her arms imitating 'the rounded shape of the mirror while masking her own reflection', the

birth record on the wall above her right arm offering 'a factual counterweight to this self-portrait that decidedly rejects its own mirror image' while in *Untitled*, Providence, Rhode Island (1975–1978) 'she self-consciously fashions her appearance as an image within the image' (Bronfen in Schor and Bronfen 2014: 18). In *Self-Deceit # 7*, Rome, Italy (1978), her figure being blurred by movement and the image reflected in the mirror, from the knees down, not being that of herself but of the photographer who occupies the position of the viewer.

Corey Keller illustrates that pictures of Woodman's Providence studio show that she used photographs as stationary and that pictures were often 'tacked to the walls, lined up along the mantel, or, more often, heaped in great lose drifts on the floor' so much so that, she concludes, pictures seemed to be treated more like 'objects than images' (2012: 179). Around 1980 Woodman started to experiment with architectural blueprints using slide projectors. Works were subsequently often unmounted, and, in contrast with her earlier work, they ended up 'torn and untrimmed' (180). Woodman at that time was in fact hanging her work quite unconventionally. Thus, Keller points out that 'irregularly torn from rolls of photographic paper, the large prints were pinned to the walls at dramatically varying heights – close to the ceiling, abutting the baseboards – and in such a manner that they deliberately engaged and activated the architecture of the room' (180–1). This sculptural or architectural quality, Keller continues, was further accentuated in *Swan Song*, Woods-Gerry Gallery, Rhode Island School of Design, 1978, by the placement of a large mirror at the base of one wall, 'incorporating the physical space of the installation into its own representation' (181). Woodman's face here appears obscured, and the angle is almost cartographic, offering a bird's eye view. These images, as Jennifer Blessing notes, 'document a performance for the camera' (2010: 198) in a work that was increasingly 'architectural' (202), almost as if to say that this photographic self-portrait is reclaiming, through the reflective capability of the mirror, its three-dimensionality.

The multiplication of the subject in the work of Lynn Hershman Leeson

Throughout her career, Hershman Leeson produced a number of works which she explicitly described as self-portraits, such as *Self-Portrait as Another Person* (1969), a wax head with a wig cast from her own face paired with a tape recorder asking questions of an imaginary listener: 'Tell me what you are afraid of … Who are you? Not just your name … Where are you going? Why are you here? … I want to get to know you better … Everything disappears. Time disappears.' (Hershman Leeson in Weibel 2016: 62). Like Cahun, Hershman Leeson often explored the theme of the double, as was the case of her *Expired Twins Self Portrait* (1968) and *Expired Self Portrait* from the series *Suicide Machines* (1968), sculptures made from wax, wigs, and makeup. Hershman Leeson also produced a number of postage stamps showing her face, often as a double, such as *Identity Face Stamps* (1966–72) and created video works which could be described as self-portraits, which I discuss in Chapter 4, such as *First Person Plural* (1988) and *The Electronic Diaries* (1986–98). Peter Weibel notes that, like Cahun, Hershman Leeson often explored and even rewrote 'identity through masquerade' staging reality by 'designing the subject not so much as an ontological being, or, as in Mendieta's case, the produce of nature' (2016: 51), but, perhaps following Duchamp, a construct of a 'language game' or 'social game' (48).

One of Hershman Leeson's best-known works, *Roberta Breitmore* (1972–8), saw her embracing the role of the fictitious persona of Roberta Breitmore for a period of six

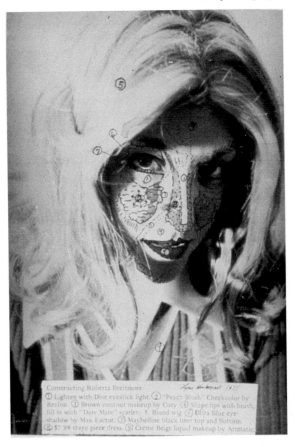

Figure 2.6 Lynn Hershman Leeson, *Roberta Construction Chart*, 1975. Print. Courtesy of Lynn Hershman Leeson.

years. Using photography and moving image and developing a graphic novel in colla-boration with Spain Rodriguez, Hershman Leeson captured various moments in Rober-ta's 'life', creating a set of documents that were then re-formed, often through collage, including text and painting, into individual artworks. These documents, originally con-ceived of as a testimony to the occurrence of the performance of *Roberta Breitmore*, together with a new set of documents produced in more recent times, became both part of, and the totality of, the still evolving artwork known as *Roberta Breitmore*.

From the works, a number of biographical factors can be deducted that may be inter-esting so as to interpret the construction of Roberta's persona. For example, from *Unti-tled from Roberta's External Transformation from Roberta (Roberta's Construction Chart)* (1975), we know that Roberta was born on 19 August 1945; she was educated at Kent State University where she majored in Art and Drama; she married Arnold Marx in 1969 and was divorced after three years; and she travelled on a Greyhound bus to San Francisco and checked into room 47 at the Hotel Dante on Columbus Avenue. At that time, Roberta was carrying $1,800, which corresponded to her entire life savings. The hotel was also the site of Hershman Leeson's artwork *The Dante Hotel* (1973), an early site-specific piece in which Hershman Leeson rented a room in a run-down hotel on

Columbus Avenue in San Francisco where visitors would encounter evidence of its inhabitation by a fictitious character.

The documents, produced over a prolonged period of time, capture Hershman Leeson's live performance which started with Roberta's arrival in San Francisco. Here, she underwent a series of external and internal transformations that can be traced through a number of documents. The *Roberta Construction Chart #1* (1973) shows how Roberta was painted by 'Dior eyestick light', blushed through '"Peach Blush" Cheekcolor by Revlon', and how her lips were shaped though '"Date Mate" scarlet'. *Untitled from Roberta's External Transformations (From Roberta's Body Language Chart)* (1978) shows that she also had a vocabulary of gestures so that, for example, she would have tried to 'avert attention' by 'avoiding your eyes' and that she sat in a stiff and tense way. One such transformation was filmed by Hershman Leeson's friend Eleanor Coppola in 1974, with whom she was working on *The Dante Hotel*, and is now often exhibited as a still document dated 1975. After checking into the Hotel Dante, Roberta tried to find a roommate by placing an advert in some local papers, including the *S.F. Progress* (1974) and, later, on *The San Diego Union and Evening Tribune* (1975). Roberta's meetings with potential roommates were documented, for example, in *Roberta and Irwin Meet for the First Time in Union Square Park* (1975). *Roberta Breitmore Blank Check* (1974) shows that she also had a financial existence, while *Untitled from Roberta's Internal Transformations, Language from Roberta (Excerpt from Roberta's Psychiatric Evaluation)* (1978) shows that she suffered from severe alienation and experienced difficulties in distinguishing dreams from reality. Finally, *Untitled from Adventure Series: Meet Mr America (Roberta Contemplating Suicide on Golden Gate Bridge)* (1978) shows that, unable to integrate in contemporary society, she contemplated suicide.

During her lifetime, *Roberta Breitmore* became a multiple as Hershman Leeson engaged three women, including the art historian Kristine Stiles, to 'be' Roberta. Hershman Leeson recalls that Stiles went out as Roberta, and Hershman Leeson as herself because 'there was a rumour about Roberta' and she wanted people to 'think that she existed' (2015). So *Untitled (Roberta's Signature in Guest Book)* (1975) is in fact Stiles's, and not Hershman Leeson's, signature. All performers wore wigs and costumes identical to the ones worn by Hershman Leeson when performing Roberta, and all underwent a series of transformations: '[e]ach had two home addresses and two jobs – one for Roberta and one for herself – and each corresponded with respondents to the advertisement and went on dates that were obsessively recorded in photographs and audiotapes' (in Tromble and Hershman Leeson 2005: xiii). Finally, Hershman Leeson ceased performing as Roberta, leaving the three hired performers on their own. In 1978 an exhibition of Roberta's artefacts entitled *Lynn Hershman Is Not Roberta Breitmore/Roberta Breitmore Is Not Lynn Hershman* was presented at the M.H. de Young Memorial Museum in San Francisco during which a Roberta look-alike contest was run that led to an additional multiplication of Robertas accompanied by a further expansion of documents. Noticeably, most studies of this artwork only refer to Hershman Leeson's performance of Roberta and rarely discuss the artwork as a multiple or a remediated artwork.

After being exorcised at the Palazzo dei Diamanti in Ferrara (1978), Roberta was remediated as the telerobotic doll *CyberRoberta* (1994–8), who was dressed identically to Roberta, and had a fictional persona that was, as in Hershman Leeson's words, 'designed as an updated Roberta' who not only navigated the internet, but was in herself a creature of the internet, a 'cyberbeing' (1996: 336). Roberta was also brought back in *Re*

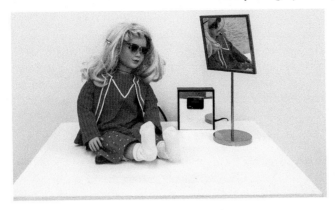

Figure 2.7 Lynn Hershman Leeson. *CyberRoberta. Telerobotic Doll*, 1994. Courtesy of Lynn
Hershman Leeson.

Constructing Roberta (2005) which shows an image of Hershman Leeson taken in recent
years alongside the text 'botox injections three to six months – Cut and Lift, pin back
xxxx Liposuction Electric Stimulation Rejouvenation *////*.' Additionally, Roberta
appeared as a bot in the Second Life remake of *The Dante Hotel*, called *Life to the
Second Power* or *Life Squared* (2007–), which turned a number of documents in the
Hershman Leeson archive about the homonymous artwork now hosted at Stanford Uni-
versity Libraries into a mixed reality experience where visitors could explore digital
reproductions of fragments of the original archive under Roberta's guidance in Second
Life (Giannachi and Kaye 2011).

Apart from the re-mediations and 'reincarnations', such as *Lamp Test* (2005), among
others, there are a number of less known documents, including birthday cards, which
form the 'Anonymous Social Constructions' series, e.g., cards from Hilary and Bill Clin-
ton (1992), Nancy and Ronald Regan (1992), and Richard Nixon (1992), a set of comics
about Roberta by Spain Rodriguez (1975), and essays such as Roger Penrose's extract on
black holes and a list of artworks by Arturo Schwartz, including 'The Alchemical' (1978).
When asked why Roberta keeps on reappearing in her artwork, Hershman Leeson com-
mented: Roberta

> just comes back in different forms every now and then. For *CybeRoberta*, it was 20
> years later as a surveillance system, which she originally was, but used the technol-
> ogy of that time; for *Life Squared* as an effort for immortality in digital space. She
> also came back 30 years later and appeared in a plastic surgeon's office.
> (E-mail to Gabriella Giannachi dated 30/11/2015, private archive)

In a letter to Sandra Philips at the Photography Department at SFMOMA dated 1/2/1988
Hershman Leeson mentions sending along part of a book she was writing about her
'ARTLIFE' called '"Retrospective notes: Roberta Breitmore 1971–78, San Diego, Ferrara,
Italy, San Francisco. A performance of experience in real time and real life" by Lynn
Hershman', stating: 'to objectify as a portrait the experience of living in San Francisco I
constructed an 'Alternative personality', separate from mine, that existed as an objectified
manipulation of circumstance'. Then she continued: 'to me she was my own flipped
effigy; my physical reverse, my psychological fears'. Over time, she continued, 'Roberta's

life infected mine' (File on Lynn Hershman Leeson SFMOMA). Thus *Roberta Breitmore*, which did not start as a self-portrait, and for which Hershman Leeson had deliberately produced an alter ego, or 'flipped effigy', so that people would not confuse her and Roberta, uncannily, ended up affecting her life so much so that Roberta and all her multiples could be seen as having an agency that Hershman Leeson, over a prolonged period of time, has continued to attend to.

Identity transfer in the work of VALIE EXPORT

VALIE EXPORT produced the triptych *Identity Transfer 1–3* (1968) soon after creating her artistic identity as 'VALIE EXPORT' by using the name of an Austrian cigarette brand (VALIE EXPORT 2000: 26). The work was photographed by Viennese photographer Werner H. Mraz, who documented several of the artist's actions in the late 1960s, and was not exhibited until the 1990s, when the images were printed in an edition of three plus one artist's proof. In 1973 VALIE EXPORT created a second *Identity Transfer* series differentiated from the first through the use of roman numerals. VALIE EXPORT's poses in *1 and 3* are identical though her head changes so that 'in the first picture it tilts to the right and she has a sad expression, while in the third she holds her head straight up and stares ahead with a faint smile'. In the second *Identity Transfer* picture VALIE EXPORT smiles at the viewer. For VALIE EXPORT these, like other works, are 'self-portraits in different characters [...] in which I communicate my identity' (quoted in Stiles, in Iles, Stiles and Indiana 1999: 24).

VALIE EXPORT'S subsequent work *Action Pants: Genital Panic* (1969) was a set of six identical posters produced to advertise an action that had occurred at a cinema in Munich in 1968. The black and white photographs, *Action Pants: Genital Panic*, taken by the photographer Peter Hassmann in Vienna in 1969, were not a documentation of the action. VALIE EXPORT had them subsequently screen-printed as a poster in a large edition of unknown size and had intended to flypost it in public spaces and on the streets. As Jones explains, the project as a whole was 'to turn fetishism violently around, to enact the female body as a site of agency and potential violence' (2010: 294). Different accounts of the original action were offered over the years by the artist. In a 1979 interview with Ruth Askey published in *High Performance*, VALIE EXPORT described the action as having taken place in a pornographic film theatre. In this version of the story, the artist, wearing trousers from which a triangle had been removed at the crotch, carried a machine gun and offered her sex to the audience while pointing the gun at people's heads (Askey 1981: 80). VALIE EXPORT said: 'I was dressed in a sweater and pants with the crotch completely cut away. I carried a machine gun. Between films I told the audience that they had come to this particular theater to see sexual films' (Ibid.: 15). Manchester notes, however, that although the latter testimony fulfils the promise of the image in the poster, this version of events was subsequently emphatically denied by the artist (2007). Thus, twenty years later VALIE EXPORT stated: 'I never went in a cinema in which pornographic movies are shown, and NEVER with a gun in my hand' (Stiles in Iles, et al. 1999: 17–33). In a more recent interview with Devin Fore, VALIE EXPORT pointed out that she had been invited to a film screening at an experimental cinema and upon entering the cinema, wearing the pants, she said '*Was Sie sonst auf der Leinwand sehen, sehen Sie hier in der Realität*' (in Fore 2012) ('You will see here in reality what you usually see on the screen'), while walking between the rows of seated viewers, her exposed genitalia being at face-level. This deliberate confusion poses a challenge for anyone attempting to

trace the authenticity of the image to an original event. Thus, the Tate acquisition file noted:

> it is extremely important to the artist to retain some of their 'poster' status and to counteract any misunderstanding of the image as a unique work which is why they are only sold as a group. For EXPORT in fact the number six is in keeping with her original concept of seriality and reproduction.
>
> (Manchester 2006)

A subsequent re-enactment of the work by Marina Abramović at the Guggenheim in 2005 sheds further light into the relationship between the work in the Tate collection and the original action that had occurred one year later. When asked to comment about Abramović's re-enactment, VALIE EXPORT said:

> I wore the action pants in a cinema. It never occurred to me to sit down in a gallery or museum as if I were an artwork. That wasn't my intention at all. Even the photo series [Action Pants: Genital Panic, 1969] in which I posed with a machine gun was shot only later and was not part of the original performance. These photographs became iconic, but that was just incidental. In fact, it was important to me that they not be elevated to the status of icons, because iconography always strives for conclusiveness. I wanted something multilayered, not something conclusive. The big difference between the two performances, then, is that I wore the action pants in a cinema, while Marina put herself on display in a museum. It's a completely different context.
>
> (in Fore 2012)

By juxtaposing the accounts of the original performance, the image in the VALIE EXPORT poster, the Tate work, and the documentation of the Abramović performance, it is clear that Abramović restaged the image in the poster, rather than the performance. Mechtid Widrichm, in writing about Abramović's re-enactment in 2008, also comes to this conclusion in pointing out that the composition of VALIE EXPORT's work 'makes the images resemble movie posters, while the grainy structure seems to relate them to documentary photographs. Overall, the photos function less like film stills than as posed publicity photos in their distillation of the idea of the action' (2008: 56). Widrichm, who indicates that the original action may have never taken place (65), draws attention to the fact that the image has the composition of a film poster but the grainy structure of a documentation. In either case, the veracity of the event is what is in doubt here. Hence, as Wood suggests, Abramović's performance at MoMA 'conflates two major paradigms that define a Western idea of the artist's "self-performance" in the post-war period: the presentation of the authentic self via the body as a real, vulnerable, physical and emotional presence' (Barthes's notion of the Real) 'and the idea of presenting oneself as a mediated image' (2018: 33) (Barthes's notion of the Live). What appears to be challenged here is the authenticity of self-re-mediation, raising questions about what happens to *self*-representation during the re-enactment of someone else's performance that allegedly never took place.

Constructing the self as an other: the case of Cindy Sherman

Known for assuming multiple roles, such as those of the photographer, model, makeup artist, hairdresser, stylist, and wardrobe mistress, among others, Cindy Sherman's work

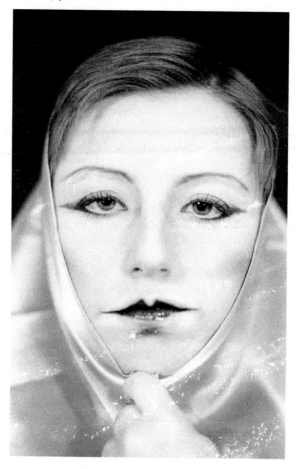

Figure 2.8 Cindy Sherman, *Untitled*, 1975/2004. Gelatin silver print, 7 × 4 3/8 inches, 17.8 × 11.1 cm. Brooklyn Museum. Gift of Linda S. Ferber, 2005.10. Courtesy of Metro Gallery.

explored the construction of roles, types, personas, and characters, including that of the artist. Her *Untitled*, 1975/2004, Brooklyn Museum, produced while she was still a student at the State University of New York, Buffalo, shows her referencing Claude Cahun. Likewise, her *Untitled*, 1983, used for the 1983 *Art News* cover, sees her sat in a chair in her studio 'enacting the role of the "artist" and recalling figures such as Andy Warhol, Joseph Beuys, and Gilbert & George, whose personas [sic] loom large in her work' (Respini 2012: 13). As Eva Respini suggests, identity in Sherman's work is in fact not fixed but rather 'malleable and fluid' (Ibid.) and while the characters represented in her work are not autobiographical, Sherman suggested that they did engage in these works with notions of the self. Thus in talking about the cut-outs, also known as *The Play of Selves* (1976), described as 'elaborate paper dolls' that she would assemble into 'narrative tableaux' (Sherman in Frankel 2003: 6), with characters including a leading actress, a leading man, a director, and generic characters from a 'Hollywood murder mystery', Sherman noted: 'I'd dress as different female and male characters, pose, photograph myself, print the photo at the scale it was to be in the tableau, cut out the figure, and use

it in little scenarios' (in Ibid.: 6) in which the selves would form a play. The figures were then meant to be used in a film script narrating the story of a young woman and her various alter-egos. These tableaus, which were to play a significant role in subsequent works, show how Sherman started to use herself as malleable material to shape and perform an increasingly wide range of recognisable identities. Of the same year is also *Untitled (Murder Mystery People)*, 1976, in which she wrote an eighty-two-scene play involving thirteen characters, all performed by her in the style of a 1940s crime drama. Moreover, also in 1975, she started to document her transformations. Thus, for example, *Untitled # 479* is a set of twenty-three prints in which she can be seen, from top left to bottom right, putting make-up on and changing her appearance to result in a character resembling a femme fatale smoking a cigarette, while looking confidently at the viewer, her mouth slightly open.

Sherman came to photography as a way to record her performance work in the mid 1970s. Among her best-known works are a series of film stills, *Untitled Film Stills*, a series of sixty-nine black and white photographs made between 1977 and 1980, in which she embraced, often ironically, the roles and postures of film celebrities caught in the middle of some unspecified storyline. Although the title refers to film, the films themselves were never shot and the viewer is left wondering what the story behind the image could be. As Krauss suggests, there is no 'original', they are 'a copy *without* an original' (1999: 102, original emphasis). Here there is

> no free-standing character, so to speak, but only a concatenation of signifiers so that the persona is released – conceived, embodied, established – by the very act of cutting out the signifiers, making 'her' a pure function of framing, lighting, distance, camera angle, and so forth.
>
> (110)

Sherman often referred to these women as types rather than roles, stating that for example #13 was 'more of a Bardot type than a Bardot copy' while others were inspired by Jean Moreau, Simone Signoret, Sophia Loren, Anna Magnani (Sherman in Frankel 2003: 8). For example, *Untitled A–D* (1975), present identity as performative, based on role and play, to introduce 'tropes, figures' (Owens 1980: 77). In developing the first six *Film Stills* Sherman 'purposely caused reticulation in the negatives, a grainy effect that results when one chemical bath is very different in temperature from the preceding one' so that the pictures were deliberately manipulated to 'look technically poor' (Respini 2012: 20). Furthermore, additional details, such as a phonebook placed in a hallway in #4 or a 'picture within a picture' in #33 show the images were 'constructed' (Ibid.) and the use of frames in #2, #14, #56, and #81 indicates that the viewer was encouraged to become a kind of voyeur (Mulvay 1975: 6–18).

Untitled A, B, C and D (1975) were developed while Sherman was studying art at State University College in Buffalo, New York (1972–6). Manchester draws attention to the fact that Sherman selected five images from the series and labelled them A to E 'arbitrarily' (2001). The images were then enlarged and reprinted in editions of ten. Sherman noted:

> these images were from a series of head shots that I made to show the process of turning one character into another. At the time I was merely interested in the use of make-up on a face as paint used on a blank canvas. [...] I unintentionally shot them

with a very narrow depth of field, leaving only certain parts of the face in focus, which gives some features [a] malleable quality.

(in Beudert and Rainbird 1975)

Sherman, who said she had scenarios in her mind (in Chadwick 1998: 23), indicated that she didn't think of the portraits as being about her but rather 'it may be about me not wanting to be me and wanting to be all these other characters. Or at least try them on' (Reaves 2009: 21). Constructed like clothes 'in the image of representation' (van Alphen in Woodall 1997: 244), these images do not so much represent characters as simulacra of imagined selves.

Sherman's subsequent work, *Bus Riders* (1976–2000), consists of fifteen black and white photographs produced shortly after graduating from Buffalo, reprinted in 2000 in editions of twenty. The artist here wears different outfits and uses props like a wig, glasses, a cigarette, a briefcase. One rider is male, three are androgynous, and five are black. The background, a white wall, is the same in each image. Interestingly, it was noted, '[t]he same electric socket appears in each photograph, points are marked on the floor by scraps of masking tape and snaking across the floor, with no attempt being made to hide it, is the shutter release cable of her camera' (Wilson 2001: 33). Again, the work does not hide its production, showing cables and the pump of the camera's shutter release, as well as the masking tape on the floor marking the position of the sitter, which could be seen 'as an exploration of portraiture and the mechanics of its staging' (Manchester 2000). The characters, which seem to be taken from everyday life and could be described as 'enacted social studies' (Schor 2012: 69), were, however, originally conceived of as forming part of a cut-out, as is shown in a sketch and a page from Sherman's notebook titled 'Exhibition plan and draft for *Bus Riders*, 1976'. The page reveals that Sherman had intended for a much larger number of white and black, male and female characters to be positioned alongside each other in a continuum (70). This suggests that the documentary quality of these works is in fact due to the fact that the images, like those in *The Play of Selves*, had not originally been created as independent works. Most of the images, however, did not survive, and this selection, alongside the page in the notebook and some negatives, is all that is left.

While still at Buffalo, Sherman made some works which can be more explicitly classified as self-portraits. Here she combined painting (on her face) with photographic portraiture, assuming the personae of three female characters of different ages and one male. Variations in hairstyle and the use of hats in two of the photographs are the only props used (Manchester 2001). These include *Self-Performance* (1973) twelve images in which she transformed from male to female, and a number of self-portraits as other artists. These self-portraits, often using false noses, breasts, and skull caps, show different expressions, ages, and disguises, which inspired subsequent works from the late 1980s and 1990s known as history portraits. In these, she referred to paintings from the Renaissance, Baroque, Rococo, and the Neoclassical period, alluding to the work of painters like Caravaggio, Raphael, among others. Thus, in *Untitled # 224* after Caravaggio's *Young Sick Bacchus* (1593–4), also known as *Self Portrait as Bacchus*, she re-appropriated the original work and so to some extent she became both Caravaggio (as a subject, through the act of painting) and Bacchus (as an object, through the image). The deliberately unconvincing and explicitly theatrical prosthetics create a parody of the veracity of the historic re-enactment exposing the theatricality of the photographic self-portrait and so making visible the fabricated nature of our self-representations.

Self-portrait in a mask: the case of Gillian Wearing

Like some of the other artists discussed in this chapter Gillian Wearing was inspired by Cahun, especially in her use of the mask. Thus, in commenting on her *Self-Portrait (Head between Hands)* (c. 1920), she noted: 'it's almost like she's in a Greek play, and she's put the head on. You can almost detach it from the body. Because the hands look real, the body looks real – but the face doesn't' (in Howgate 2017: 24). As in Sherman's case, the idea of literally wearing other people's identities became a defining feature of her practice.

So, for instance, Wearing's *Me as Cahun Holding a Mask of My Face* (2012) refers to Cahun's iconic self-portrait from 1927 which sees her dressed as a comic bodybuilder, two nipples drawn on her fat chest, staring directly at the viewer, with the English text 'I am in training, don't kiss me' written on her chest. Here Wearing holds a mask of her own face suspended from a thin stick while on her face she wears a mask of Cahun representing herself 'both as an artist and as Cahun' (Howgate 2017: 16).

Wearing considers her early self-portraits as a 'precursor to the "selfie"' (in Howgate 2017: 17) and she often used photographs to reconstruct her 'self' in a past period of time. Her *Self-Portrait at 17 Years Old* (2003) from her *Family Album Series*, for example, is a reconstruction of a photo booth self-portrait from that period. In an interview with Marianne Torp, she elaborated how she worked these from old images:

> I can't even remember taking the image of myself in a portrait booth that I later redid in *Self-Portrait at 17 Years Old*. The photo is the record, but either side of that

Figure 2.9 Gillian Wearing, *Me as Cahun Holding a Mask of My Face*, 2012, framed bromide print, 157.3 × 129 × 3.3 cm. © Gillian Wearing, courtesy Maureen Paley, London, Tanya Bonakdar Gallery, New York/Los Angeles, Regen Projects, Los Angeles.

record is a blank. So I have to think of other moments around that age. The images I chose to recreate of my parents were taken before I was born. So I took what they told me about themselves. My mother, I believe, had a romantic notion of love and life. But her life did not go according to her dream and likewise the photo is a mirage.

(27)

Self-Portrait of Me Now in Mask (2011) brings a temporal dimension to the work (Wearing 2012: 9). Described as a 'classic self-portrait' (10), Wearing's face is a silicone mask which was made from a cast of her own face. Likewise, her *Me as an Artist in 1984* (2014) was created 30 years after the staged event in which we see her surrounded by objects pertaining to her art. For this Wearing took about 250 Polaroid images between 1988 and 2005 documenting her aging. She commented:

> I wasn't thinking of the context in which I was photographing myself; I was just taking the photographs to see how I looked or if I could change or adapt my look. After a few years I realised those photographs had become a document; it was about all those incremental changes that happen in your face or attitude.
>
> (in Howgate 2017: 43)

Wearing, who pointed out that she 'was looking at myself as though I was studying someone else', discovered while studying the Polaroids that she needed to find out 'who this person was', feeling also that there was a wider trend emerging at that time. Thus, she commented: 'there is a similarity in my posing and the poses of a lot of young women you now find on Instagram and Twitter, etc' (in Ibid.: 44). The Polaroids were subsequently curated as a display in 2016 at ADAA, Park Avenue Armory, New York, as part of the *My Polaroid Years* exhibition in which Wearing used her own Polaroids as fields of study to rediscover and re-enact her 'self'.

Wearing created a series of self-portraits in which she appeared as members of her own family. These include *Self-Portrait as My Mother, Jean Gregory* (2003); *Self-Portrait as My Father, Brian Wearing* (2003); *Self-Portrait as My Grandmother, Nancy Wearing* (2006); *Self-Portrait as My Grandfather, George Gregory* (2006); *Self-Portrait as My Sister, Jane Wearing* (2003); *Self-Portrait as My Brother, Richard Wearing* (2003); and *Self-Portrait at Three Years Old* (2004). In these works, the eyes are always Wearing's, so that, in her own words, she could be 'returning the gaze' (in Howgate 2017: 162). In fact, Wearing wanted the characters to 'look as real as possible' but at the same time she wanted 'to have certain parts of the disguise visible'. Thus, all the characters wear masks, but the cut-outs around the eyes are left visible to draw attention to the process. The mask had an imprint of Wearing's face inside so that, in her words: 'there are two faces on the mask, so even before I wear it as my own face I am already in there'. For Wearing the mask is the technique through which she can become another. So, she commented: 'unlike in Photoshopping and retouching, wearing someone else's face or body brings out a much stronger performative element in me. That's the thing, with all these works, it's not just about wearing a mask but about becoming someone else, too, acting out' (in Ibid.: 163). The performative processes of creating these works were thoroughly documented (Wearing 2012: 184–197) and so illustrate, for example, how Wearing struggled to embrace her brother's position of the torso or tilt her head like her uncle in *Self-Portrait as My Uncle Bryan Gregory* (2003).

Like Sherman, Wearing also represented herself as other artists in staged works described as 'self-dramatisations' (Schwenk in Wearing 2012: 36) and entitled *Me as Arbus* (2008); *Me as Mapplethorpe* (2009); and *Me as Warhol in Drag with Scar* (2010). These works, like the self-portraits as members of her family, draw from performance and so in *Me as Warhol*, for example, she replicates the pose in Richard Avedon's portrait of 1969 in which he displays the scars from his operation following an attempt on his life whereas in the *Me as Mapplethorpe* piece she replicates a self-portrait of 1988, an image which 'both creates a sense of presence and conveys the impossibility of halting time' as in fact Wearing's eyes can be seen behind the Mapplethorpe mask, which is deliberately not a precise fit, 'destroying any pictorial illusion and replacing it with the knowledge that the picture is by definition a projection and that ultimately no one is going to be taken in here' (Schwenk in Wearing 2012: 35). For Wearing these works are 'self-portraits with masks' rather than 'portraits of other people' (in Bogh and Fabricius 2017: 24), showing how the performative process and the use of the camera to capture this process, which started from an image and ended up as an image, were instrumental not only in constructing the other as an uncanny and yet familiar self but also, again, in constructing the self in terms of its lineage, not so much as an inter-text but rather an inter-image, where the artist's self-portrait can only be seen as the self-portrait as an other.

Self-portrait as power: Zanele Muholi

In writing about South African photography, Tamar Garb suggests that early photography showed black people in terms of three categories of representation: ethnography, portraiture, and documentary (2011: 11). Zanele Muholi's work, Raél Jero Salley (2012) notes, confronts the colonial and anthropological stereotyping described through these categories by making visible feminist and LGBT rights campaigners in post-apartheid South Africa. This work finds a precedent, Salley continues, in Santu Mofokeng's *The Black Photo Album / Look at Me: 1890–1950* (2012) which shows a collection of family photographs sourced by the artist, including images that urban black working middle class families had commissioned and that had been subsequently left behind, showing these families' social and economic aspirations and desire for recognition. Muholi's work, like Mofokeng's, is in sharp contrast to the dehumanising colonial use of a number of historic archives (Giannachi 2016: 96ff) and instead makes visible communities and individuals who thus far have been far too often completely excluded or erased from history.

Muholi's work addresses the viewer, problematising their place and role in the past and future production of cultural history. As Candice Jansen suggests, 'Muholi's queer practice undercuts hetero-colonial-apartheid genealogies of time', subverting 'oppressive visual norms' and asking of the viewer that they 'reimagine South African identities' (in Allen and Nakamori 2020: 19). Muholi's work *Mirror* (2005), for example, shows an indistinct shadow in front of a mirror in which a woman bent downwards is reflected while taking a photo between her legs of the subject, covering her vagina with her right hand. The mirror, Elvira Dyangani points out, is the 'vanishing point of the camera, and the space where the light that will make the photograph possible is captured' constituting a 'trompe l'oeil [...] with the capacity to challenge both the beholder and the discipline of photography itself' (Ibid.: 117). Muholi's work is not only a statement on identity, on photography, on art itself, it is also a transformative attempt to make visible the history of LGBT communities.

Figure 2.10 Zanele Muholi, *Phila I, Parktown*, 2016. Silver gelatin print. Image and paper size: 80 × 53.5cm. Edition of 8 + 2AP. © Zanele Muholi. Courtesy of Stevenson Cape Town/ Johannesburg/Amsterdam and Yancey Richardson, New York.

Muholi's *Somnyama Ngonyama* (isiZulu for *Hail the Dark Lioness*, 2012–) is a series of self-portraits that Muholi took over a period of time. In these works, Muholi are looking straight at the viewer, who becomes immediately implicated within the work. Using materials and objects sourced from their surroundings that refer to stories of exclusion and violence, and the history of black people more widely, Muholi manipulate these objects (e.g., latex gloves, electrical cords, rudder tyres, among others) to become hair accessories, hats, and necklaces. These works, which are all in black and white and in which the contrast of the images was often modified in post-production, have titles in isiZulu, Muholi's language, and make visible the history of political, social and economic injustice. Thus, for Dyangani the act of making visible a long history of suppression is captured by Muholi's disappearance into the absolute blackness of the image, which shows how black here becomes an 'insurgency itself; selfhood' (in Allen and Nakamori 2020: 119). Each image makes visible a history of suppression, and in each image Muholi are both the supressed other and themselves. Thus, Muholi's *The Bester, Mayotte* (2015) is dedicated to Muholi's mother Bester Muholi who lived the majority of her life working as a domestic helper in apartheid South Africa, raising the children of privileged South

Africans while her own children were home. Here, Muholi use the objects Bester Muholi would have used at work to transform their mother's clothing into a royal attire. Likewise, *Basizeni XI, Cassihaus, North Carolina* (2016) is a reference to 'necklacing', a brutal form of execution in which rubber tyres are placed around a victim's chest and legs filled with gasoline and set alight; *Phila I, Parktown* (2016–) sees Muholi's head and chest covered by inflated dark latex gloves while in *MaID III, Philadelphia* (2018) they are wearing a rope on their head which could well have been used for hanging.

With these self-portraits Muholi challenge the reading of their image as victim. Instead, theirs, is an image of resistance, showing the re-production of the past in the present as an act of power. Thus, Muholi state: 'my practice as a visual activist looks at black resistance—existence as well as insistence' to make place for black LGBTQI people 'in the visual archive'. In *Somnyama Ngonyama* they used 'my own face so that people will always remember just how important our black faces are when confronted by them [...] I needed it to be my own portraiture. I didn't want to expose another person to this pain' (in Mussai 2018: 176–177). The selves-portrait here, just like the archive it creates, becomes a transformational field in which the punctum of the image, to use Barthes's

Figure 2.11 Zanele Muholi, *MaID III, Philadelphia*, 2018. Silver gelatin print. Image and paper size: 90 × 60cm. Edition of 8 + 2AP. Courtesy of Stevenson Cape Town/Johannesburg/Amsterdam and Yancey Richardson, New York. © Zanele Muholi.

term, the 'what has been' (2000: 43), gives presence not only to Muholi but also the untold histories of black people who are implicated within the image by the objects that caused their suffering and death. Thus, the punctum, the presence of the past in the image, documents the absence, the exclusion of the person and the people, and yet, at the same time, it re-presences them in the self-portrait as a new history yet to be written. The viewer then, by looking, becomes implicated in these histories, their own 'self-positioning' challenged by them, as a witness of the suppression and suffering that took and still is taking place.

Note

1 These two extracts were drawn by the authors from two different texts by Mendieta.

3 Sculpting the self

Sculptural self-portraits, by which I mean self-portraits created through sculpture, as well as works documenting or illustrating an act of sculpting, the reshaping of a body, or moulding of an object through an action produced by a body, are less common than other kinds of self-portraits, but nevertheless highly significant in art history. Spanning a period of over 4,000 years, this chapter does not intend to offer a comprehensive analysis of the field but rather to show how sculptural self-portraits, and so, implicitly, the technologies used for them, have played a significant role in configuring what is meant by 'self'. The chapter comprises a number of early examples of sculptural self-portraiture aimed at illustrating how artists used sculptural self-portraits to position themselves in relation to religious, political, and cultural figures, and the world views they represented. The chapter then moves on to show how after the Renaissance, artists continued to represent themselves, often as other artists, drawing attention to their cultural lineage and establishing the self-referentiality of the genre. In line with painterly self-portraits, artists regularly employed sculptural self-portraiture to illustrate or document physical and mental illness, sometimes, literally, by penetrating the body, or capturing the effects of an illness over time. This chapter also looks specifically at medical self-portraits analysing a number of examples from different periods in history to trace the evolution of the genre.

The origin of the sculptural self-portrait

One of the earliest sculpted self-portraits is located in the tomb of Ptah-hotep near Sakkara. Ptah-hotep was an ancient Egyptian vizier and author of some of the earliest books in history. The artist, who created the work in 2650 BC, represented, quite innovatively for this period, a series of actions (Goldscheider 1937: 10). Thus, the sculpture shows a number of stone masons turning towards each other, and a cow keeping an eye on her calf. On the left of the limestone relief, squatting in a boat, we can see the artist drinking from a pitcher, his name carved above him, Ni-ankh-Ptah (Ibid.: 11). Over a thousand years later another self-portrait was created by Bak, or Bek, who was the chief sculptor of the Egyptian pharaoh Akhenaten. Bak represented himself with his wife Taheri (c. 1353–1336 BC), Egyptian Museum Berlin, as a courtier and family man. The stela shows his large naked belly, which, as James Hall points out, intends to draw attention to his wealth and status (2014: 13). Bak also appears in a relief showing an inscription stating that he was taught art by Akhenaten himself (Ibid.), an indication that Bak associated his practice to the most powerful of pharaohs.

A thousand years later, another example of sculptural self-portraiture was created by Phidias in 438 BC, this time in Greece (Goldscheider 1937: 12). Phidias sculpted Athena's

DOI: 10.4324/9780429468483-4

shield in gold and ivory for the inside of the Parthenon. Athena can be seen here holding a figure of a winged victory, her helmet ornated with sphinxes and winged horses, as well as a spear and a shield representing a relief showing a battle between the Greeks and the Amazons. In this work, Plutarch tells us in *Life of Pericles*, the artist can be seen as a 'bald-headed man, with domed brow and wrinkled features' about to pick up a boulder (in Goldscheider 1937: 14). These early works by Ni-ankh-Ptah, Bak, and Phidias not only constitute some of the earliest known attempts at self-representation in art, but also show how the artists were creating self-portraits so as to position themselves within specific political, religious, and cultural lineages.

During the Middle Ages, a number of sculptural self-portraits were created specifically within religious buildings. One of the earliest examples is Volvinus's self-representation on the golden altar in the Church of Sant'Ambrogio in Milan (824–59) in which the artist can be seen receiving the blessing of the saint. Other artists who sculpted images of themselves within the architectures they built famously include Peter Parler, one of the most influential craftsmen of the Middle Ages who built Charles Bridge in Prague and created one of the first busted self-portraits in art history in the late fourteenth century, which is displayed on the wall of St Vitus Cathedral in Prague alongside busts of members of the imperial family, archbishops of Prague, building directors, and master-builders. These early examples of self-portraiture in art were not entirely independent and served the purpose of positioning the artist in relation to local dignitaries and/or religious leaders.

Sculptural self-portraiture gained in independence and status during the early Renaissance. Thus, for example, Florentine artist Lorenzo Ghiberti sculpted himself in the Baptistry of St John, at the North Gate (1403–24 ca.), as well as on the gilded bronze doors of what Michelangelo likened to the Gates of Paradise, Florence's Baptistery of San Giovanni, Museo dell'Opera del Duomo (1425–52). Whereas the earlier self-portrait on the Baptistry of St John, showing Ghiberti in a turban and buttoned up shirt, conforms to representations of artists that can be seen in a number of contemporary paintings, in the second self-portrait, on the Gates of Paradise, Ghiberti appears as a well-to-do man who does not need to wear working clothes but is instead fashioning a tunic with lace. Here, Ghiberti appears to be emerging from a circular opening, or cornice, usually used for gods and emperors, next to his son, who was also a sculptor, featuring on the other door leaning towards him, so as to indicate the relation between them (Fabbri in Verdon 2014: 129), drawing attention to their newly established position in culture and society.

Self-portraiture became increasingly popular during the Renaissance and artists started to position their work not only in relation to dignitaries and/or religious leaders but also in relation to each other. Thus, Leon Battista Alberti, for example, signed a bronze self-portrait plaquette (1435) which is known to have influenced subsequent work by Pisanello in the 1440s (Hall 2014: 45). In this work, one of the earliest, if not the earliest, independent self-portrait, Alberti portrays himself in what looks like a cameo, wearing a classical cloak, knotted at the front, showing also his emblem, a winged eye, and his initials. Another important sculptural self-portrait of this era was realised by the German stone sculptor Adam Kraft who sculpted himself on his knees, holding mallet and a chisel, the instruments of his trade, whilst bearing the towering structure of the Sakramentshaus on his shoulders, at the St Lorenz Church in Nuremberg (1493–6). In the sculpture, which is more complex and modern than many of those created by his predecessors, Kraft is bending on one knee looking upwards, seemingly not feeling the weight of the building on his shoulders. Ahead of his time, this sculptural self-portrait is very realistic and places the artist at the centre of the work, very close to the world of the viewer.

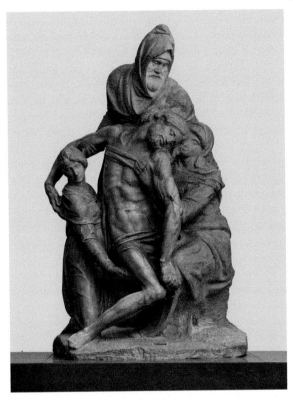

Figure 3.1 Michelangelo, *The Deposition* (*Bandini Pietà* or *The Lamentation over the Dead Christ*), 1547–55. Museo dell'Opera del Duomo, Florence.

Michelangelo, who famously painted himself on the skin of Bartholomew in the *Last Judgement* (1536–41), as well as, possibly, in the *Crucifixion of Saint Peter* (approx. 1545–50) in the Vatican's Pauline Chapel, which shows him as one of the three horsemen in the picture wearing a blue turban of lapis lazuli blue (Day 2009), created one of the most debated and mysterious sculptural self-portraits in the history of art, namely *The Deposition* (*Bandini Pietà* or *The Lamentation over the Dead Christ*) (1547–55), Museo dell'Opera del Duomo, Florence. Michelangelo started to carve the composition at the age of 72 from a single piece of stone. Most critics suggest that he represented himself in this work as Nicodemus, holding the body of Christ, just taken from the cross, next to Mary Magdalene and the Virgin Mary (Wasserman 2003: 18; Kristof 1989). In fact, Michelangelo's image of himself has a clear similarity to Daniele da Volterra's *Portrait of Michelangelo* (ca. 1550), Teyler Museum, Haarlem (Kristof 1989: 163), so there is little dispute as to whether the image is a self-portrait, but the question is why Michelangelo used the figure of Nicodemus for this purpose and why the composition is incomplete. Critics have offered many explanations, including the fact that Nicodemus was appropriate for portraits and self-portraits because he was himself a sculptor (see for example Kristof 1989: 170) and so, by convention, the use of Nicodemus indicated that a self-portrait was being presented within the work.

While the flayed skin in the *Last Judgement* may allude to the legend of the flaying of Marsyas which was popular among Neoplatonists (Wind 1958: 142–7), we know from

Saint John's gospel that Nicodemus was a powerful Pharisee, and a member of the San-hedrin, the Jewish ruling council. Three episodes involve Nicodemus in the life of Jesus. In the first one Nicodemus is said to have gone to Jesus by night, so as not to be seen, to hear his preaching; in the second one he reminded his colleagues in the Sanhedrin that the law asked of a person, including in this instance Jesus, to be heard before they were judged; and in the third one, he went to Jesus's Crucifixion to assist in preparing the body for his burial. Nicodemus and Joseph of Arimathea then wrapped Jesus in strips of linen with 100 pounds of myrrh and aloes, according to Jewish customs (John 19:38–42). It is possible that it is what happened in the first encounter between Jesus and Nicodemus which inspired Michelangelo's approach to the work. When Nicodemus went to see Jesus by night Jesus taught him that nobody could see the Kingdom of God unless they were 'born again', something which he struggled to understand: 'Nicode'mus saith unto him, How can a man be born when he is old? can he enter the second time into his mother's womb, and be born?' (3:4). Subsequently, Nicodemus was reproached by Jesus who explained to him the role of Baptism in this process: 'That which is born of the flesh is flesh; and that which is born of the Spirit is spirit' (3:8).

The fact that Nicodemus is the predominant figure of this composition could be read as an indication of the artist's affinity for the reformist movement (Shrimplin-Evangelidis 1989: 64). But several critics have disagreed with this analysis and suggested other reasons especially in view of Michelangelo's sudden outburst against the composition in 1555 when he attempted, at nearly eighty years of age, to destroy the work he is said to have created for his own grave, only to be restrained by his servant Urbino (see Wasserman 2003). Among the reasons that have been given for his gesture, is a possible sexualised reading of the image due to the crossing of Christ's leg over Maria's lap, the so-called 'slung leg hypothesis', which is presented, in Leo Steinberg's historiographic reading, as a clear and 'an unmistakable symbol of sexual union' (1968: 343). However, other critics are unsympathetic with this explanation (Wasserman 2003).

The actual composition of the group may be indicative of the complexity of what Miche-langelo was trying to convey. Jesus is in physical contact with each member of the group. He is being held up by Mary Magdalene, who is touching Nicodemus's leg. He is also embraced by Mary, whose left arm is not visible, and the force of her gesture has turned his shoulder and arm. Finally, he is being pulled up by Nicodemus, whose left arm is holding Mary. Jack Wasserman notes how in most other Depositions or Entombments, for example Donatello's and Titian's, the figure of Nicodemus does not touch Jesus while in Michelangelo's compo-sition there is 'a virtual symbiosis, practically a fusion of the two male figures, to the extent that the eye has a certain difficulty distinguishing where Christ ends and Michelangelo begins' (2003: 137). For Wasserman, this suggests a 'communion' of sorts through which the ageing figure of the artist is able to live because of the sacrifice of Jesus (138). While it is not for this chapter to resolve or even take position in this fascinating debate, it must be noted that already at this point the sculptural self-portrait had become a complex artistic platform not only for portraying the artist's position within a given art historical, theological, and philosophical history, but also for unlocking complex hypotheses about the power of art in defining what constitutes the 'self'.

The medical self-portrait

There are numerous examples in the history of art of works, including drawings, sculp-tures, and photos, in which artists depict or document themselves experiencing physical

or mental illness. This sub-category of self-portraits, which I have called here 'medical self-portraits', has been very influential on contemporary self-portraiture in drawing attention to the mortality of the subject. Both an attempt to create a self-representation and a document, medical self-portraits constitute a key step towards building an understanding of the self as part of a malleable, vulnerable, and finally mortal body. Among one of the earliest medical self-portraits is the drawing by Dürer, discussed in Chapter 1, *The Sick Dürer* (1471–1528), Kunsthalle Bremen, in which the artist can be seen pointing his right finger to an area circled near the stomach possibly to show a doctor where his pain was (White 1981: 17–8). Later examples include Franz Xaver Messerschmidt's *Character Heads Series* (1785) which featured a dismal gloomy man and a man in distress, and Francisco de Goya's *Self-Portrait with Dr Arrieta* (1820), Minneapolis Institute of Arts, Minnesota, in which the artist is seen while being looked after by the doctor who had saved the painter's life the year before. While these self-portraits are crucial in establishing the early history of the genre, I will dedicate this section primarily to works created at the turn of the twentieth century to show how, in moving from painterly self-portraits to sculptural and performative self-portraits, artists started to shift their attention from representation to presence and from the body as image to the body as an environment.

One of the earliest self-portraits showing a mental health breakdown was Edvard Munch's *Self-Portrait in Hell* (1903) which was created in response to a personal crisis and shows Munch's naked body against an abstract background painted with expressive strokes and strong colours, spanning from yellow to orange, brown and black. The artist's head, painted in a dark red/brown colour, is positioned in front of what looks like a black cloud of smoke. A dark red brush stroke cuts across his neck as if the artist had been wounded there. Around the same time, Munch, who painted many self-portraits over the years, also painted *On the Operating Table* (1902–3), which reprised Rembrandt's *The Anatomy Lesson of Doctor Nicolaes Tulp* (1632), except that here the body on the slab in Munch's painting is not dead. While in Rembrandt's work Dr Nicolaes Tulp is seen during an anatomy lesson as he is explaining the musculature of the arm to a group of doctors who most probably paid commissions to be included in the

Figure 3.2 Edvard Munch, *On the Operating Table*, 1902–3. Courtesy of the Munch Museum.

work, the face of the criminal party shaded, suggesting an *umbra mortis*, or shadow of death (Harvey 2007), in Munch's work, the naked and isolated body is facing the opposite direction, and the patient is Munch himself, who appears to be bleeding out (Ibid.), a consequence of an injury to his finger. Three faceless doctors are seen emerging from the distance, seemingly disengaged from the scene, while an almost faceless nurse appears to be removing a bowl of blood and a group of onlookers stare at the scene from behind two closed windows. The perspective of the work is such that the viewer is closest to Munch and his injury, though the blood does not appear to be on his body. Of all, Munch is the only person with a recognisable face.

There are numerous other medical self-portraits, including Ernst Ludwig Kirchner's *Self-Portrait as a Soldier* (1915) at Oberlin Ohio's Allen Memorial Art Museum, in which he depicted himself with an amputated hand, considered a 'sort of war memorial to the causalities among the German painters' (Gasser 1963: 267) and Joan Miro's *Self-Portrait* (1938) at the New Canaan, Conn. James Th. Soby collection, where the artist's 'face is in the process of changing before our eyes into beast and plant, stone and star' (Ibid.: 299). Vincent Van Gogh, of course, famously used self-portraiture as a documentation of his psychological state, with works such as *Self-Portrait with Bandaged Ear* (1989), The Courtauld Gallery, London, showing the artist shortly after he returned home from hospital where he had been treated for mutilating his ear. Likewise, Frieda Kahlo created a large number of self-portraits in which she visualised her physical and psychological pain following a bus accident in 1925, after which she received thirty-two operations that left her in physical agony. Thus, in her work *Self-Portrait 'The Frame'* (1937–8) she appears in the centre of a panel against a blue/purple field with yellow marigolds in her hair which signify the Day of the Dead in Mexican culture, making it seem as if she was looking at the viewer from beyond the grave. In *Broken Column* (1944), Museo Dolores Olmedo, she visualises her pain by painting her broken, split, spine as a column, with nails holding the body together to what looks like a white hospital sheet. The column, on the verge of collapsing, goes from her chin to her loin, no longer able to hold her upright. *The Two Fridas* (1939), Museo de Arte Modern, Mexico City, which followed Diego Rivera's request for divorce, shows her using dual images to 'portray two opposing forces: living and dying' (Grimberg 1998: 97). Here, two Frida Kahlos sit side by side on a bench holding hands, each heart being linked by one artery to the other. While the Kahlo on the right, dressed as a Tehuana, holds in her left hand a miniature portrait of Rivera as a child, the second Kahlo, the one on the left in a white lace dress, 'is dying since she is not loved by Rivera' trying to stop 'the slow bleeding from the artery despite the efforts of a Kelly clamp' (98).

Photographers too have been known for creating what could be described as medical self-portraits. Thus, Nan Goldin, for example, in *Self-Portrait Battered in Hotel, Berlin* (1984) holds her camera at chest height, showing her injured face. The work documents her physical assault by her then lover, marking also the end of their relationship. The work then reappeared in her more recent *All By Myself* (1995–6) alongside a text explaining the context of the battering. Some of the most interesting works in this field are photographic, almost diaristic, accounts of the artists' bodies changing over time. Thus, Tee Corinne's *A Self-Portrait Dialogue with Time and Circumstance* (1967–92), for example, consists of multiple images of the photographer taken over a twenty-five-year period which reveal 'the multiple and disparate nature of a self in time, rather than a chronological progression or narrative of the completion of the "person"' (Meskimmon 1996: 76). Similarly, Eleanor Antin's *Carving a Traditional Sculpture* (1972) consists of

172 photographs depicting her naked body changing over a five-week diet. In *Notes on Transformation* Antin (1974) describes that she considered autobiography as

> a particular type of transformation, in which the subject chooses a specific, as yet unarticulated image and proceeds to progressively define the self with increasing refinement which, in turn, both clarifies and makes precise the original image, while at the same time transforming the subject.
>
> (69)

By positioning her body within the history of 'carved' sculpture, Antin thus forced 'a connection between subtraction (dieting) and the classical ideals of the artist "revealing" beauty' (Fortenberry and Morrill 2015: 59), only that here the emphasis is on the documentation. In more recent times, Faith Ringgold's *Change Faith Ringgold's Over 100 Pounds Weight Loss Performance Story Quilt* (1986) documented the artist's loss of weight during a period of a year while Hannah Wilke documented the progression of her terminal cancer. Thus, *June 15, 1992/January 30, 1993: #1* from *Intra-Venus Series* (1992–3), published posthumously, documents the illness ravaging through her body following chemotherapy and a bone marrow transplant.

Several artists regularly documented mental illness, sometimes as a form of therapy. This was the case of Jo Spence who indicated that while she was in therapy and tried to '"speak" to various interior parts' of herself, she 'begun to make connections with this earlier practice [capturing sitters as they tried out 'new "selves" for the camera'] and seek for a way of portraying 'psychic images of myself' (Spence 1988: 27). In 1979 Spence exhibited *Beyond the Family Album* as part of *Three Perspectives on Photography* at the Hayward Gallery in London, producing a work that she felt constituted an investigation of her family, class 'and what it meant to be a woman' (82). The project begun by the artist examining photos of herself and then creating photographic self-portraits in which she focused on 'different ways of "seeing" myself' (93) by literally reversing the process through which she 'had been constructed as a woman', deconstructing herself visually 'in an attempt to identify the process by which I had been "put together"' (82). Noting that she had 'only ever been bits and pieces, symptoms and faults. Never an organic whole' (93), Spence started to piece the fragments together by taking documentary pictures whose purpose was 'to try to give an indication of what actually "happened"', knowing that this would produce very different images from 'a traditional portrait which is usually especially lit, posed and decontextualised' (94). In playing for the camera, she acknowledged that she begun to conceive of herself 'as a set of signals or signs, all of which "meant" something to the viewer (including myself), which I could begin to control more' (95). Finally, in *The Picture of Health* (1982–) she documented her breast cancer, her operations, and treatment exploring how she felt about her 'powerlessness as a patient', and about how she was 'being managed and "processed" within a state institution' (156). As in the case of Munch's *On the Operating Table*, the photos here too were taken from the patient's point of view, creating empathy between the viewer and the artist seen as patient. Subsequently, Spence entered what she called photo-therapy as a 'way of examining one's social and psychic construction' (175), literally using photographic self-portraiture as a strategy for reconstructing her identity.

While artists have tended to use medical self-portraits as a form of documentation of their illness, on occasion they also used technological research to draw attention to the materiality, the flesh and blood, of the 'self'. Thus, in *Self* (1991–) Marc Quinn reconstructs his

'self' by using his own blood. Here, the viewer faces a life-sized cast of Quinn's own head, immersed in frozen silicone, created from ten pints of his blood. The refrigeration equipment ensuring that the work remained stable slowly destroyed it (Pointon 2013: 210), which means the work has to be reiterated every five years. Quinn continued to experiment with self-portraiture in *You Take My Breath Away* (1992) which consists of a thin layer of latex upon which his body is cast, his features barely recognisable, reminiscent of 'a carcass hanging on meat hooks', perhaps in reference to Michelangelo's self-portrait on the skin of Saint Bartholomew. The rubber in this case 'acts as an imprint which has Quinn's features on the outside. Here issues of the internal being are shown as being physically externalised. The skin symbolises the boundaries between external reality and the inner life of the self' (Thomas 2004: iii). The work was exhibited at the same time as *I Need an Axe to Break the Ice* (1992) which showed a cast of the artist's head inflated, by Quinn's breath, within a glass sphere mounted on a 'sputnik-like stand' (Thorp in Allan 1998: n.p.) and *Template for My Future Plastic Surgery* (1992) in which Quinn 'speculates on his future life and the notion of being eternally young through the replacement of parts of his body' (Ibid.). These works, capturing the passing of time, and ephemerality of life itself, draw attention to the 'self' not so much (or not only) as a social or cultural construct but also as an ephemeral presence in space and time. Thus, in an interview with Tim Marlow, Quinn indicated that when he was working on *Self*, he wanted to make art that 'was about life and being alive' and 'wanted something that was more alive than a normal sculpture, that was dependent, that could only exist in certain conditions and was completely made of "myself"' (Quinn 2009: 25). Here the object, the self-portrait, and the artist, the subject, started to coincide with one another. As the inside became the outside, the self-portrait became quite literally *alive*.

Sculpted action: Arte Povera's Giuseppe Penone and Gilberto Zorio

The term Arte Povera was famously coined by art critic Germano Celant to define a form that existed not so much as an object, but rather as an environment formed by everyday materials and processes. In the two texts presenting the 1967 Arte Povera exhibitions held in Genova and Bologna Celant talks about the significance of 'being there', mentioning the 'pure presence' and 'physical presence' of the artist (2011: 198, my translation). Arte Povera, however, was not so much interested in exploring the ontology of the presence of the artist, and instead focussed on the process involved and traces left in artistic creation. Thus, Celant notes that while in the early 1960s the art scene was defined by action painting and the historical avant-gardes, with galleries like Sperone in Turin privileging pop and minimal art, after 1968, anti-minimal and antipop became more prominent and artists started to look into working with 'poor' materials while at the same time documenting these acts of 'transformation, destruction and reconstruction' in 'time as well as space' (in Celant, Fuchs and Bertoni 1988: 10–11). Thus, with Arte Povera, attention shifted from the object to the process, from being to 'doing' (Barilli 1970), and, herewith, from sculpture to sculpting (carving, cutting, etc.).

Transformative processes were at the heart of some of the works by Gilberto Zorio and Giuseppe Penone. Zorio's *Broken Board* (1967), for example, consisted of a cracked wood board with a fluorescent orange rubber tube. The creation of the work involved an action, that of cracking the board, which the viewer could see the consequence of. For Zorio 'every human being is a container of minerals and water, their veins, or lungs and organs being an extraordinary chemical laboratory made of tubes and alembics' (Zorio in Celant, Fuchs, and Bertoni 1988: 15). Zorio in fact was interested in showing how

materials changed through alchemic processes and rituals. For example, in his *Self-Portrait* (1972) he used leather, which he had imprinted with his face, upon which stars, a recurrent symbol in his work, mark the position of his eyes (in Celant et al. 1988: 19). When the lights are switched off, the fluorescent stars light up (Guralnik in Eccher and Ferrari 1996: 213), turning the leather into a mask in which the artist appears as energy. Likewise, in *Terracotta Circle* (1969) the diameter of the circle of terracotta that constitutes the work was created by the artist moving around himself over a period of time with his arms spun open. Here, the shape of the circle documents the action at the heart of the creation of the work. For Jean Christophe Ammann, the energy emanated by creating the terracotta circle defines a change in form that had to do with an 'aspect of matter', with 'the possibility of planning past, present and future' (in Eccher and Ferrari 1996: 178). What is at stake here is not the subject as a being or presence, or as a representation, but rather as a trace of the action or energy left behind by the process of creation. In other words, the artist informs, literally, the environment produced by their actions – the artwork comprises (and is a trace of) a wider ecology and the environment that is formed by it.

Penone's *Breath* (1978) is a clay object which was modelled on the shape the artist imagined his breath would take during exhalation. The top of the form, which, as an

Figure 3.3 Giuseppe Penone, *Soffio* (*Breath*), 1978, fired clay 148 × 72 × 65 cm. Private collection. Photo © Archivio Penone.

object, looks like an amphora, is in the shape of Penone's mouth, and the impression on the side is that of his leg, leaning forward, the pattern of his jeans visible upon close inspection. *Breath* is one of six: the first three were made in Turin, the latter three at a pottery in Castellamonte, a small family-run establishment near Penone's birthplace, Garessio, located between the Ligurian Alps and Piedmont. *Breath* could be described as the evocation of an action carried out by a subject, the artist, now absent. Both an artwork and a document, *Breath* is related to a number of other works that were created after Penone came across an ancient terracotta vase in 1975 on which he had found the potter's fingerprints. Penone then recorded and traced these prints and made a 'topographical' map of them. He subsequently merged the potter's skin with his own, reproducing the marks of both fingerprints in the work. Ugo Castagnotto recognises, '[a]n imprint made by the potter, in negative, in 3D "means" a movement of the hand; a specific gesture' (in Penone 1977: 79). Thus, the work showed not only the history of actions carried out for its creation but also the lineage of this history. For Ammann, therefore just '[a]s the tree, conscious of a new branch, searches for a new balance, so the artist, who reproducing them absorbs the marks of the potter, will become conscious of the potter and the potter's doing' (in Ibid.: 75–6). Hence, Ammann suggests that in this work Penone 'gets away from the object to return to it through the object's "shady side" of its historicity.' (76). The same can be said for *Breath*. Here, to 'look' at the object is to see the traces of the actions conducted by the artist in the process of its creation. The artwork thus traces an anterior time when it did not exist as an object but the action that produced the object was already being carried out by the artist.

In a related work, *Breath Bronze and Tree* (1978) we see a tree branch reach out of a bronze *Breath* (Celant 1989: 99). Penone's comments on the work may help towards building an understanding of *Breath 5*. He noted:

> [w]e systematically breathe in dust and earth … I tried to realise a form as if I breathed against my body, especially to indicate that it is an emanation of the breath, to give a sense of measure, as if one was breathing against one's own body, so that air takes that shape. At the top of the sculpture there is the inside of the mouth, as if to indicate an emanation of the breath.
>
> (Penone in Celant 1989: 96)

The photographic documentation, *Breaths*, taken in Garessio in 1977, adds a mythological dimension by showing a wood in mist or fog, juxtaposed with a text on Prometheus who created humans with lime and water which Athena gave life to by breathing onto them. Penone commented:

> [t]he movement created by the potter tends to facilitate in the clay the formation of a vortex, a typically fluid form, instantly filled by the air that the potter, through the speed of their actions, closes within their vortex. The emission of breath is the equivalent of the air that introduces itself in the vortex created by the potter and is equivalent to language.
>
> (91)

For him, this sculpture is created in the act of breathing: '[t]he breath is sculpture. [...] Every breath has within itself the beginnings of fecundation, it is an element that penetrates another body and the emission of the breath, the murmur, bears witness to it with its form' (Penone in Gianelli and Celant 2000: 238).

In 1993 Tate acquired *Study for 'Breath of Clay'* (1978), part of a series of drawings titled *Breath of Clay*, realised through coffee, graphite and ink on paper. These document Penone's thinking for the realisation of the *Breath* series and show how he studied, in the words of Elisabeth Manchester, 'the form his exhaled breath would take' so that it could be 'transformed' 'into a kind of container for his body' (Manchester 1978). The use of coffee, Manchester suggests, indicates the collapse of boundaries between art and life which is typical of the Arte Povera movement (Ibid.). Penone carried out further studies of the work, including one in the 'style of Leonardo showing currents of air blown from the mouth like waves, another showing studies of human lips, pursed as if to blow' (Ibid.). Interestingly, photographs were included in one of the exhibition catalogues showing Penone taking a bronze cast of such a shape out of his mouth, to demonstrate what the opening represents (Anon 1984: 43). Through this, Penone documented the act of sculpting and, as Manchester suggests, captured a process of trans-formation, the going beyond, through, or across forms so that the human subject is seen in the act of imprinting its presence within their environment.

Breath is distinctively a work about capturing an ecological process in its environ-mental impact in space and in time. For Penone, these works are about interpenetration, and so '[e]ach breath has in itself the beginning of fertilisation, it is an element that penetrates another body and letting out the breath, the puff of air, attests to it with its form' (Penone in Maraniello and Watkins 2009: 208). *Breath* then must be viewed in the context in which the work is placed. So, in the museum where viewers occupy the spatial dimension of the work, its walls and floors, visitors must be visible in the space and time of the work. In a letter to the Art Historian and Tate Director Alan Bowness and written shortly after Tate's acquisition of *Breath 5*, Penone wrote:

> I would like to bring to your attention that the work published in the catalogue on page 18 appears to reduce my work in respect to the piece. The reason for this is the elimination of the relationship between the work and the space, therefore the actual dimension of the piece is not visible.

Penone, who then proceeded in asking Bowness not to use this image anymore (1983), had herewith noted that the image's background had been blanked out. As a con-sequence, it looked as if the work was floating, out of time and space. What he asked of Bowness was that the documentation of the work, illustrating the position of the work in the gallery, should show the work in the time and space of the viewer who must be included in the environment of the work. Traces here, of the work's inception, of its relationship to a legacy of crafts spanning over the centuries, are what prompts visitors to link two different sets of space/times, that of the making of the object in which the artist is present as a subject and that of its exhibition in which the artist's presence has become part of the environment of the viewer.

In *Unrolling one's skin* (1970) Penone traced his body with hundreds of photographs by laying a small piece of glass on his skin. In this work, he moulded his thorax and right foot in plaster and obtained 'a real reproduction' of his body in that 'through this pro-cedure you can see on the plaster form some torn hairs in the same place – in the same skin pore – as before on my body'. He subsequently projected the slide on the plaster form so that 'the image of my body is reconstructed, as it was before the described operation' (Penone 1977: 77). Here, Penone showed that for him 'Skin is the limit, border, reality of a division, the extreme point that can add, subtract, divide, multiply

Figure 3.4 Giuseppe Penone, *Rovesciare i propri occhi* (*To Reverse One's Eyes*), 1970, mirroring contact lenses. Documentation of the action by the artist. Photo © Archivio Penone.

and cancel what surrounds us, the extreme point that can physically wrap enormous extension, contained and container' (in Celant 1989: 60). Likewise, in *To Reverse One's Eyes* (1970) Penone wore contact lenses that covered his eyes so that he became blind though, as the documentation of the work shows (Penone 1977: 77), viewers, including the documenting photographer, could see themselves reflected in them. Here the contact lenses become, 'contact-zones', a kind of artificial skin connecting 'the exterior world reflected in them with the interior world of the artist', though the work 'is there before the author himself sees it' (Ammann in Penone 1977: 75). But these contact-zones, as Penone indicated, did not augment or extend the body, rather they confined it, turning his eyes into a mirror. Thus, when the eyes are covered by the lenses, they reflect into space the images they gather, and so 'one's seeing faculty is postponed in time and one trusts in the possibility of seeing in the future the images one's eyes have gathered in the past' (Penone 1977: 77). In this sense, with Penone's work, the self is never separate from the environment formed by the factors that produce it and in which it is experienced.

Entering the body: the case of Antony Gormley

In an interview with Ralph Rugoff and Jacky Klein, Antony Gormley indicated that just as his peers were using found objects, he was interested in using his own body 'as my found object' (in Vidler, Stewart and Mitchell 2007: 40), pointing out that he intended to investigate his body 'from the inside, exploring it as a place rather than an object' (Vidler et al. 2007: 43). Gormley also noted that herewith he was treating his own existence 'as a subject, instrument and material' (in Wickham and Salter 2017: 60), indicating that while in his earlier works, the 'moulds were empty, void and often sealed', in the later works he 'went on to making massive solids from the inside of the moulds' (Ibid.), denoting a change in the position of the sculpture, now carved inside out.

In *Event Horizon* (2007) the figures that can be seen against the sky were cast from his own body. Gormley suggested that these figures were not so much statues as sculptures, 'indexical copies' of his body marking the 'the registration of a particular time of a particular body which, in their displacement of air, indicate the space of "any" body; a

Figure 3.5 Antony Gormley, *Event Horizon*, 2007. 27 fibreglass and 4 cast iron figures, each 189 × 53 × 29 cm. Installation view, Hayward Gallery, London, 2007. A Hayward Gallery commission. Photograph by Richard Bryant. Courtesy Antony Gormley Studio.

human space within space at large' (Gormley n.d.). In his earlier work *Another Place* (1997) Gormley created 'a sense of diversity in unity' among the 100 cast-iron figures exhibited on Crosby Beach, and while it was the same body this was captured 'at different moments' in time (in Wickham and Salter 2017: 45). The moulds used for this work had in fact been made over a ten-year period. For Gormley, presenting large numbers of similar figures or figures in time had been not only 'a way of acknowledging that these bodies are made in the age of mechanical production' but also evidence that there is 'a sense in which the figure gets emptied through repetition: the more you reproduce it, the less the aura, the less inherent content it has' (in Ibid.). In this work the body and the architecture in the environment started to fold into one another (in Ibid.: 47). Thus, in an interview with Ernst Gombrich, he points out that he was 'realising, materialising perhaps for the first time, the space within the body' (in Hutchinson et al. 2000: 10). In both *Event Horizon* and *Another Place*, the body, or bodies, are represented as sculptures capturing being in space and time. Hence, he notes,

> each piece comes from a unique event in time. The process is simply the vehicle by which that event is captured, but it's very important to me that it's my body. The whole project is to make the work from the inside rather than to manipulate it from the outside.
>
> (Ibid.: 18)

Gormley's *Model* (2012) reimagined the body as an inhabitable architectural form. Visitors enter the work which consists of a 'lying body, 32 meters long, in the form of a building made of twenty-four individual cells, with three of them open at the top' (Gormley in Holborn 2015: 200), through the right foot. The darkness produces an immediate disorientation as it is hard to distinguish the shape of the environment and whether one is standing in front of a wall that is a closure or an opening. The only way one can proceed is by feeling one's way through, thus activating all senses. The journey terminates in the head, which is a large space 2.8 × 4.5 × 3.4 meters that is completely dark. Again, the only way of orienting oneself is to either follow others or try to retrace one's footsteps. Here, for Gormley, 'the idea of the work is to provide a proprioceptive environment for thinking about being in one's own body by being in this enlarged one' (Ibid.). In this work viewers are simultaneously looking at and being within the

Figure 3.6 Antony Gormley, *Model*, 2012. Weathering steel, 502 × 3240 × 1360 cm. Installation White Cube. Bermondsey, London, England. Photograph by Benjamin Westoby. Courtesy Antony Gormley Studio.

sculpture, orienting themselves on the basis of the stimuli that are produced by other visitors, who are also moving around the sculpture, a reminder of the interconnectedness of the subject to her or his environment and to the other beings that are located within it.

Sculpting the body: the case of Orlan

Since 1990, the French performance artist Orlan has undergone a series of surgical operations entitled *The Reincarnation of St Orlan* aimed at reconstructing her body according to somatic and symbolic characteristics from the history of art. Thus, Orlan modelled her forehead on Leonardo's Mona Lisa; her chin on Botticelli's Venus; her nose on an unattributed sculpture of Diana by l'Ecole de Fontainbleau; her mouth on Gustave Moreau's Europa; and her eyes on François Pascal Simon Gérard's Psyche (Ince 2000: 6). Orlan indicated that she selected Diana because of her insubordinate and aggressive character, and because she had leadership skills, whereas Mona Lisa was chosen because she represents an emblem of beauty and because 'there is some "man" under this woman', while Psyche was preferred because she 'is the antipode of Diana, invoking all that is fragile and vulnerable in us', Venus was picked because she embodies 'carnal beauty', and Europa because of her adventurous character and her capacity to look 'toward the horizon' (Orlan in Phelan and Lane 1998: 320).

When curator Hans-Ulrich Obrist asked Orlan what she meant by a 'self-sculptural principle', a phrase she had previously used in relation to her work *ORLAN Gives Birth to Her Self* (part of *Body Sculptures*) (1964), she replied by saying that the work 'involved the idea of giving birth to oneself but at the same time that birth was a split, a cloning, a play on identity and otherness' (in Donger, Shepherd and Orlan 2010: 184). This suggests that Orlan intended to reshape herself as a kind of *selves*-portrait, whose identity encompassed references to other women from the history of art. In fact, Orlan referred to her work 'as classical self-portraiture, even if initially it is conceived with the aid of computers' (in Wilson et al 1996: 88). In this context, Paul Virilio notes that Orlan's self-portraits could be read as a continuation of Rembrandt's self-portraiture, a form of 'self-transfiguration' (in Donger et al. 2010:191), in that Orlan's face forms not so much 'an

Figure 3.7 Orlan, *Reading after the Operation, 7th Surgery-Performance, Titled Omnipresence,* New York, 1993. Cibrachrome in Diasec mount, 65 × 43. © Orlan.

object or a subject', but a 'journey' (Ibid.: 192). For Orlan, every operation in fact constituted 'a rite of passage' (1997: 39), in which her skin was 'treated as a fabric to be cut, shaped and stitched into a new look' (Botting and Wilson in Zylinska 2002: 152). The emphasis here was therefore not so much on the self-portrait as the object of self-fashioning but on what happens while being, literally, in-between forms.

The first six surgeries of *The Reincarnation of St Orlan* took place in France and Belgium and Orlan's seventh operation, 'Omnipresence' (1993), was broadcast via satellite to thirteen galleries around the world, including the Sandra Gering Gallery in New York, the Centre Pompidou in Paris, Toronto's McLuhan Centre, and the Multimedia Centre at Banff. Sue-Ellen Case describes the piece as follows:

> [u]nder local anesthetic, with a woman surgeon, Orlan read aloud from a psychoanalytic text by Eugénie Lemoine Luccioni which posits, among other things, a notion of the body as obsolete. Orlan read before the knife cut into her face and two silicone implants were injected above her eyebrows to duplicate the Mona Lisa brow.
>
> (Case 1995: 117)

The title of the operation, 'Omnipresence', alludes both to Orlan's simultaneous presence, via the medium, in a multiplicity of locations, realising therefore also what she referred to as cloning (in Donger et al. 2010: 184). The operations brought to attention the difficulty critics faced in describing what is beneath or beyond Orlan's face:

> [d]uring her operation Orlan's face begins to detach itself from her head. We are shocked at the destruction of our normal narcissistic fantasy that the face 'represents' something. Gradually the 'face' becomes pure exteriority. It no longer projects the illusion of depth. It becomes a mask without any relation of representation. [...] Orlan uses her head quite literally to demonstrate an axiom of at least one strand of feminist thought: *there is nothing behind the mask.*
>
> (Adams in McCorquodale 1996: 59, original emphasis)

The process behind Orlan's operations thus revealed an oscillation between 'disfiguration and refiguration' (Orlan in Phelan and Lane 1998: 319), the former consisting of the cutting, and the latter of the sculpting of her body, happening against a backdrop of diverse readings and including the documentation of the audience's response to the work. But what is caught in this documentation is not some form of essence, a stable self, rather, what happens in between the 'dis-' and 're-' figuration of these *selves*.

The site of Orlan's operations, her operating 'theatre', functioned as a set, indicating that the public was witnessing some sort of live staged event: '[s]urgeon, attendants, and observers [...] wear futuristic designer surgical gowns, as does Orlan' (Augsburg in Phelan and Lane 1998: 305). However, as Tanya Augsburg points out, 'although the performance was "live" since it unfolded in "real time", its "liveness" was not immediate but mediatized' (289). The work was in fact usually exhibited as a documentation formed by a series of panels, forty-one in total, featuring Orlan at the top, and the image drawn from in the surgery at the bottom, capturing salient moments of the rituals involved in the operations. Orlan noted: '[m]y body has become a site of public debate that poses crucial questions for our time' (Orlan in Phelan and Lane 1998: 319). Orlan's *selves*-portrait is therefore formed by the documentation of her operations, also including the reception of her work, and even parts of her body such as, at the Sydney Biennial in 1992, vials containing samples of her liquefied flesh and blood drained during the operations (Rose 1993), alongside any point of reference that these operations utilised in the 'dis-' and 're-' figuration of Orlan.

In more recent years (1990), Orlan posed for a portrait photograph in which she wore the wig and make-up of the Bride of Frankenstein, from the 1935 film based on Mary Shelley's *Frankenstein* novel of 1818. Kate Ince describes the work as follows:

> [w]ith pale face, full lips, a fixed robotic stare and an electric white weave standing out against the piled-high frame of hair, the portrait is a close copy of the image presented by Elsa Lanchester in the 1935 classic film *The Bride of Frankenstein*.
>
> (Ince 2000: 82)

Here, Orlan modelled her image on a fiction and, as Julie Clarke suggests, '[w]ith her newly constructed chin leaning provocatively on her gloved hands, Orlan's pose draws our attention to contemporary constructions of the ideal and admired woman through the technologies of photography and film' (Clarke in Zylinska 2002: 40). In this work, Orlan therefore brought 'closer together singular and collective stories' (Orlan in Donger et al. 2010: 114), using technology to present herself as a construction of 'what we are, what we can be, what we want to be' (in Donger et al. 2010: 118).

Subsequently, Orlan was involved in a number of acts of transformation that led to the production of eleven computer-generated images known as *Refiguration Self-hybridation* (1998–2007) in which Orlan's head was digitally hybridised with the head-sculptures, bone-structures, decorative prostheses and make-up of Pre-columbian and, subsequently, African sculptures, masks, and ritual images. These hybridations illustrate her attempt to further build on, but also, again, de-form and indeed even un-form her-*selves* as a series of hybrid intercultural layers, in which she is either 'colonised or *coloniser*' (Cala-Lesina, 2011: 189, original emphasis). In recent years Orlan also started to experiment with bioart in *Harlequin Coat* (2007) in which she arranged a series of petri dishes in diamond-shaped vertical panels in the form of a harlequinesque human, over which a video was projected. The petri dishes contain Orlan's dead cells which were then filled with

Figure 3.8 Orlan, *Disfiguration–Refiguration, Precolumbian Self-Hybridization No. 35*, 1998, 150 × 100 cm, Cibachrome. © Orlan.

cells from African origin and a marsupial dunnart, rendering her not only as an inter-cultural hybrid but also as semi-animal. As Philip Auslander suggests, Orlan has, over time, come to represent some sort of 'living palimpsest' (1997: 131) documenting the process of transformation through which she has, over the years, become 'other' (O'Bryan 2005: 84). This process rendered Orlan a 'place where neither the original body nor a final body (evoking identity) is defined, and the maximum number of possible future identities exist' (86–7). Orlan's controversial *selves*-portraits thus consist primarily of the process of 'dis-' and 're-' figuration of her 'self' as a series of intercultural, inter-medial and interrelational 'selves', an assemblage of multiple identities seen in the often uncomfortable act of becoming one another.

Stelarc's cybernetic body sculptures

The performance artist Stelarc was described by Mark Dery as the 'foremost exponent of cybernetic body art' (in Bell and Kennedy 2000: 577). Already in his early suspension works, Stelarc had in fact augmented himself by using the skin as an interface between the 'inside' and the 'outside' of his body. But whereas in the suspension works, strings were used to challenge gravity and extend his body, the wires used in his subsequent *live* cybernetic performances augmented the body through prosthetic extensions and the internet.

In *Event for Amplified Body/Laser Eyes and Third Hand* (1986) Stelarc used fibre optics and lenses to demonstrate how his sensory and motor systems could be augmented through technology. The latter is an interactive performance 'that controls, counterpoints, and *choreographs* the motions of the virtual arm, a robot manipulator and an electronic third hand' (Stelarc 1997: 247, original emphasis). Stelarc describes the distinction between the different types of movement involved in this work as follows:

[t]here are four kinds of movements in my performances: the improvised movement of the body, the movement of the robot hand, which is controlled by sensors in my stomach and leg muscles, the programmed movement of the artificial arm, and the movement of my left arm when it's involuntarily agitated by an electric current. It's the interaction of these voluntary, involuntary, and computerised movements that I find interesting.

(Stelarc in Virilio 1996: 110)

In *Host/Body Coupled Gestures Event* (1992) viewers could also see projections forming a counterpart to Stelarc's movements:

[s]ensors on the head and limbs allow the body to switch images from cameras positioned above the body, on the robot manipulator and from a miniature camera attached to the left arm – with the Virtual Arm being the other video default image. A relationship between body posture and images is established, with body movements determining the flow of images on the large screen – displayed either *singly*, *superimposed* or in *split-image* configurations.

(Stelarc 1997: 247, original emphases)

Thus, viewers of *Event for Amplified Body/Laser Eyes and Third Hand* not only saw a variety of more or less choreographed and voluntary as well as involuntary movements, but they also saw how these related and responded to the images on the screen.

These early works are not only about manipulation and control they are also political debates. Thus, Stelarc commented: 'I see these performances as architectures of operational awareness [in which] ethical, feminist or political considerations are allowed to unfold' (Stelarc 2002b). Stelarc is here both in control of the complex technological operation he exhibits, and also, paradoxically, he is being controlled by it. As in Stelarc's own words:

in the internet performances even though half of my body was being remotely prompted by people in other places or by internet data, I was actually actuating and controlling my third hand. So the third hand was a kind of counterpoint. People were being in control of my body but I was in control of my third hand and pretty much nothing else. And also the third hand sounds were amplified so I would actuate the third hand as a means by which I could compose the complexity of the sounds-cape that was being heard, and sound in a sense is the real virtual medium in that it immerses. I used sound not only to register a movement but also to allow an audience to inhabit the physical body of the performer.

(Stelarc 2002b)

This representation of the artist as controlling and controlled, subject and object, manifested itself also performatively as an interplay of presence and absence in which 'Stelarc's gaze became simultaneously active/passive' (Armstrong in Keidan 1996: 24).

For Stelarc the body is a relational entity: '[w]e mostly operate as absent bodies. That is because A BODY IS DESIGNED TO INTERFACE WITH ITS ENVIRONMENT' (Stelarc in Bell and Kennedy 2000: 562, original emphasis). In Stelarc's work the body thus becomes an interface, 'A SITE BOTH FOR INPUT AND OUTPUT' (Stelarc in Ibid.: 567, original emphasis). Just as the outside interferes with the inside of Stelarc's body, the inside is projected outside to become part of the 'technology' of the performance itself. As in Orlan's work, the distinction between private and public, inside and outside is dissolved. Thus, Dery describes this dynamic as follows:

> [a] welter of *thrrrups*, squeals, creaks and *cricks*, most of them originating from Stelarc's body, whooshes around the performance space. The artist's heartbeat, amplified by means of an ECG (electrocardiograph) monitor, marks time with a muffled, metronimic thump. The opening and closing of heart valves, the slap and slosh of blood are captured by Doppler ultrasonic sound transducers, enabling Stelarc to 'play' his body.
>
> (Dery 1996: 155, original emphases)

In *Ping Body* (1996) and *Parasite* (1997) this possibility of 'play' was taken a step further in that the artist's body was directly connected to and activated by the internet. In *Ping Body*, described by Stelarc as 'an Internet Actuated and Uploaded Performance' (in V2 1997: 27), the body became, as in Stelarc's own words, 'a barometer of internet activity' (2002b). In this piece Stelarc had in fact linked his neuromuscular system to the internet. The frequency and intensity of the pings drove his enhanced body and his neuromuscular spasms beyond his conscious control. In *Ping Body* the relationship with the Internet is in fact 'flipped – instead of the Internet being constructed by the input from people, the Internet constructs the activity of one body' (Stelarc in V2 1997: 27). For Brian Massumi, Stelarc appears here both as 'a subject and an object *for itself*-self-referentially'; in that 'the self' here includes 'other individual human body-selves, computers, telephone lines, electromagnetism, and any number of heterogeneous elements, forces, objects, and organs' in so far as 'the body–self has been plugged into an extended network. As fractal subject–object, the body *is the* network – a *self-network*' (in Smith 2005: 179, original emphasis). Interested in ideas about 'access and actuation, of hosting and of multiple agency' (Stelarc in Zylinska 2002: 120), Stelarc thus reversed the usual relationship between the user and the net by reducing the body to the status of a networked subject–object. In *Parasite* too, a search engine was constructed which selected and analysed images from the net and displayed them in Stelarc's video headset. The real time images were then projected onto the body which was actuated proportionally to the incoming file sizes. Here, Stelarc points out, 'the internet is experienced more like a kind of external nervous system that optically stimulates and electrically activates the body' (2002b). Thus, in this piece, as Stelarc suggested, 'the cyborged body enters a symbiotic/parasitic relationship with information' (2002a).

Similar dynamics were explored in *Telepolis* (1995) where visitors to the Pompidou Centre in Paris, the Media Lab in Helsinki and the Doors of Perception Conference in Amsterdam were able to 'remotely access and actuate' Stelarc's body in Luxemburg by using a touchscreen interfaced muscle stimulation system (Stelarc in V2 1997: 23). Although the visitors thought that they were just activating Stelarc's limbs, 'they were inadvertently composing the sounds that were heard and the images of the body they were seeing' (Stelarc in V2, 1997: 23), hence authoring not only the performance of

Stelarc, but also the very environment in which this took place. Again, it was the skin that acted as a gateway between inside and outside. And so, as suggested by Mark Poster, in these works it soon became clear that '[o]ur skins no longer demarcate a line between inner and outer except in the limited sense of the body's endurance. What is generated within the body as information is hooked into global networks' (in Zylinska 2002: 28). The skin, thus representing the 'interface of the body with technology' (Stelarc 2002b), became how the body was extended and thus augmented to include a networked environment.

In *Fractal Flesh* (1995) Stelarc interacted with the net through an interface-operating STIMBOD software, a touch-screen muscle stimulation system that allows his body to be moved from a remote source (Clarke in Zylinska 2002: 49). This produced, in Stelarc's words: 'a body whose authenticity is grounded not in its individuality, but rather in the MULTIPLICITY of remote agents' (Stelarc 2002a). In this piece, which created 'intimacy without proximity' (Stelarc, 2002b) the viewer, as Marina Gzinic suggests, became 'a parasite via the internet [which is] safely hosted within Stelarc's body' (Grzinic 2002: 99). For Stelarc, like for Orlan (Orlan in McCorquodale 1996: 91), the body became 'obsolete' (Stelarc in Bell and Kennedy 2000: 562) precisely because it can only survive through technology, by being a cyborg (Stelarc 2002b). In this sense the body in not only a 'melding of the organic and the machinic, or the engineering of a union between separate organic systems' (Gray, Mentor and Figueroa-Sarriera in Gray 1995: 2) or even 'a self-regulating human–machine system' (Featherstone and Burrows 1995: 2), it is also an interface for manipulation and control, it is where the self is re-written not only as an other, but also by others.

For Stelarc the conventional relation between the body and technology is reversed: for him, the body is empty, hollow, a mere interface with or even container of technology. In this sense, in his work the body often operates as a host for technology: 'ONCE A CONTAINER, TECHNOLOGY NOW BECOMES A COMPONENT OF THE BODY' (Stelarc in Bell and Kennedy 2000: 563, original emphasis). Stelarc did not only modify his body, but he also went within it: 'I went within myself' (Stelarc in McCarthy 1983: 15). Thus, in *Stomach Sculpture* (1993–6) he inserted 'an art work into the body' (Stelarc in Bell and Kennedy 2000: 565). As the hollow body becomes 'a host' to the work (Stelarc in Ibid.: 565), there are no distinctions 'between public, private and physiological spaces' (Stelarc 2002b). For Stelarc, in *Stomach Sculpture* one in fact 'no longer looks at art, nor

Figure 3.9 Stelarc, *Stomach Sculpture*. Fifth Australian Sculpture Triennial, National Gallery of Victoria. Photographer: Anthony Figallo.

Figure 3.10 Stelarc, *Ear on Arm*. London, Los Angeles, Melbourne 2006. Photographer: Nina Sellars.

performs art, but contains art' (Stelarc 2002a). In a reversal of the conventional understanding and use of the body in art, Stelarc, through the use of nanotechnology, thus brought the work of art, and subsequently the viewer, inside his body.

Finally, in *Extra Ear* (1997–), Stelarc aimed to turn his body into a host for an extra ear which originally was to be positioned next to his own ear as a form of sculptural self-augmentation. Stelarc wrote: 'the ear would speak to anyone who would get close to it. Perhaps, the ultimate aim would be for the Extra Ear to whisper sweet nothings to the other ear' (Stelarc 2002a). As the ear is the organ of balance (Ibid.), the creation of an extra ear was meant to unbalance both the relationship between the viewer and the work of art, and the relationship between the human body and technology, 'a symptom of excess rather than a sign of lack' (Stelarc in 2002b). After 2003, Stelarc reinterpreted *Extra Ear* as *Extra Ear ¼ Scale* with the help of Tissue Culture Art Project (TC&A). Using human cells as a ¼ scale replica of Stelarc's ear, an ear was built that constituted a 'reconizable human part' meant to be attached to the body. The work was presented as a 'partial life', raising questions about 'notions of the wholeness of the body' (Stelarc 2005), and about what partial life would mean in this context not only from an aesthetic but also from an ethical point of view. His *Ear on Arm* thus marked a crucial step for Stelarc, who felt that finally his body could 'project its physical presence elsewhere' and so 'become a nexus or a node of collaborating agents' (2006).

Stelarc placed *Extra Ear ¼ Scale* next to an interactive video installation *Prosthetic Head*, realised with TC&A, a 3D avatar head that resembled the artist and that had real

time lip-synching, speech synthesis, and facial expressions such as head nods, tilts and turns, changing eye gaze etc. The head was meant to 'speak to the person who interrogates it' and was able to detect the colour of the visitor's clothing and analyse some basic behaviour so as to make the conversation more personalised (Stelarc 2003). As the conversation database grew, the prosthetic head became increasingly autonomous (Ibid.). *Prosthetic Head* led to the creation of *Partial Head*, a semi-living self-portrait, which consisted of a scan of Stelarc's face alongside a humanoid skull resulting in a 'third face' formed by the human face's digital transplantation over the skull. The data was used here to print a scaffold of ABSi thermal plastic using a 3D printer which was seeded with living cells supported by a custom-engineered bioreactor/incubator and circulatory system that immersed the head in nutrient and kept it at human temperature (Stelarc 2019). With this work, Stelarc rendered himself as a cyborg, a post-human semi-living entity. His self-portrait was not only live, it was *alive*.

4 Video self-portraits

The birth of video art can be traced back to the early 1960s when Nam June Paik and Rolf Vostell started to manipulate and experiment with television images. At this stage, because of the impossibility of editing, artists steered away from filmic conventions such as montage and, instead, focussed on closed-circuit systems and instant feedback (Westgeest 2016: 20). But early in the 1970s videos started to be created which were not mere documentations of live performances and were developed specifically for the medium. For Kathrin Becker this became the moment in which

> alongside the use of the video camera for the artist's self-observation, closed circuit installations and feedback systems started to enable the shift of the conceptual focus of video works to the beholder, who then became the subject *and* object of his or her own perception.
>
> (in Babias, Becker and Goltz 2013: 45)

Video has been described by Rosalind Krauss as 'a medium for narcissism' (1976: 50), offering radically different possibilities by comparison with film. Thus, in *Centers* (1971), she notes, Vito Acconci uses the video monitor as a mirror so that

> as we look at the artist sighting along his outstretched arm and forefinger towards the center of the screen we are watching, what we see is a sustained tautology: a line of sight that begins at Acconci's plane of vision and ends at the eyes of his projected double.
>
> (1976: 50)

Likewise, she notes, in his *Air Time* (1973) he sits between the video camera and a mirror which he faces and for 35 minutes he addresses his own reflection using the terms 'I' and 'you' which could be understood to refer to him and a lover as well as to him and his self-reflection (53–4). For Krauss these works, in which 'the agency of reflection is a mode of appropriation' (56), erase the difference between the artist as subject and object. Unlike other art forms, video has offered a unique opportunity to explore self-perception at the moment of its occurrence. In this sense, as Krauss shows, many video art works focus on the subject's presence not so much as an ontological given but rather as a performative process that can only be captured through its perception by others.

So if in experimental film-based self-portraits film makers tended to explore what makes a film a film, so much so that in *The Man with the Movie Camera* (1973) David Crosswaite placed himself and the camera in front of a mirror and played 'with the size

DOI: 10.4324/9780429468483-5

of the shot, focus, aperture, depth of field and therefore with light, framing and composition' (Tinel-Temple in Tinel-Temple, Busetta and Monteiro 2019: 98–9), in video, artists also often experimented with the intrinsic properties of the video camera and monitor, exploring the perception of their presence and its dependence on the relation between the performer and/or the viewer in space/time. Interestingly, artists often used mirrors as well as the camera and the monitor, hence combining the effects afforded by both technologies. In *Light Dissolves* (1977) Nan Hoover uses the camera to reveal series of fragments of different parts of her body. Two years later, in 1979, she stated in an interview that at the time she was interested in capturing 'parts of herself' (1979) and was 'stimulated' by video because of the 'possibility of controlling the composition, the movement, the special use of light and the subtle greys, which are all so important in video' (Ibid.). In this sense, Hoover regarded herself as 'an object' that she herself could move (Ibid.). Her work with video in fact often explored her movement in time, frequently by paying direct reference to painterly works from the canon of self-portraiture. Hence, in her later *Self-Portrait* (2004) she referenced Parmigianino's *Self-Portrait in a Convex Mirror* (1524). In Parmigianino's work the focus is on the hand, and here too Hoover's face is hidden by the rim of the hat and the camera focusses primarily on her hand (Leach 2010).

Video artists used the medium not only for self-representation but also to explore self-awareness and self-perception. Thus, in an interview with John Hanhardt, Bill Viola notes that he did not think it was possible to talk about video without bringing in notions of self-awareness and self-knowledge, because the whole idea of media is the creation of an artificial system that literally – technologically, symbolically – reflects the life field (in Galansino and Perov 2017: 131). His *Nine Attempts to Achieve Immortality* (1996) was a black and white video projection in which he could be seen holding his breath for as long as possible while staring at the camera. His subsequent *Self-Portrait Submerged* (2013) was a colour high-definition video mounted on a wall at the Vasari Corridor at the Galleria degli Uffizi in Florence, where the museum historically had placed its historic collection of self-portraits. Here Viola is again underwater, his eyes shut, holding his breath. As time goes by, the movement of the water animates Viola's body, which can be seen gently but also somewhat ominously fluctuating. Water is used here to 'convey the invisible, the ineffable, the transitory' (Perov in Clayton and Perov 2019: 37). In water lives are in fact seen as 'suspended, floating in a simultaneous state of being and of non-being' symbolising 'death and renewal' (Ibid.). Likewise, in his earlier *The Reflecting Pool* (1977) a man, Viola, emerged from a forest and stood before a pool of water. When he leapt up, the figure froze mid-air and slowly disappeared until all the viewers saw were the reflections of what happened in the water. Finally, the figure reappeared 'naked and reborn' (in Galansino and Perov 2017: 38), which shows that there are two parallel movements of time in the work, one in the pool and the other in the forest above it (Ibid.). These works show how Viola used the medium to explore on camera what ultimately distinguishes presence from absence, being from not-being, life from death.

Over time, artists started to exhibit video self-portraits outside of museum spaces, often using them as a comment on the power of media in shaping individual identity and society at large. Pipilotti Rist, for example, used video for a number of self-portraits, most famously *Open My Glade (Flatten)* (2000–17), first shown, as part of *Midnight Moment*, a monthly presentation by the Times Square Advertising Coalition and Times Square Arts, broadcast on the NBC Astrovision by Panasonic board overlooking the

square in between various adverts (see Phelan et al 2001). The work, which in many ways evokes Ana Mendieta's *Untitled* (1972), is a video projection of the artist showing her face and hands tightly pressed against a glass surface near the entrance to the New Museum moving from side to side, her face distorted by the glass confining her and separating her from the viewer. Here Rist makes an explicit comment on how media frame and so implicitly entrap their subjects, and how it is impossible to escape the *dispositif* of power they maintain over the subject. Hence *Open My Glade (Flatten)* consisted of an exploration of the mediatisation of the 'self-portrait', and herewith also the 'self', showing that the subject is no longer perceivable outside of the technology of its representation.

Self-perception in the work of Dan Graham

At the heart of many of Dan Graham's works is an exploration of self-perception, which is often articulated relationally, between audiences and performers. For this purpose, Graham preferred to use video over film in that he thought that video, unlike film, does not tend to detach the audience from the world caught on camera by constructing a separate reality, but rather allowed him to include the audience within it (in Buchloh 1979: 69). For Graham, video thus constituted the ideal platform to explore how the relationship between the audience and the performer could prompt and sustain self-perception, allowing him to capture interactions between himself and his audience, often by showing himself and his audience at the moment in which they perceived their own and/or each other's presence.

For Graham, many of these explorations originated from the desire to respond to 1960s modernist art which, he thought, considered the present as 'immediacy – as pure phenomenological consciousness without the contamination of historical or other a priori meaning'. This focus on immediacy, he thought, led artists to believe that 'the world could be experienced as pure presence, self-sufficient and without memory' (in Martin 2006: 54). Instead, Graham's video time-delay installations aimed to challenge this 'notion of phenomenological immediacy', foregrounding what he called 'an awareness of the presence of the viewer's own perceptual process', which aimed to cast doubt about self-perception by showing, in his words, 'the impossibility of locating a pure present tense' (in Alberro 1999: 144). Graham's investigation into perception thus led to an exploration of the interdependence between a perceiving subject and a perceived object as if to suggest that self-perception can only occur through the involvement and/or engagement of an other.

In a letter to Benjamin H.D., Graham noted that he 'had the idea of the reciprocal interdependence of perceiver (spectator) and the perceived art–object/or the artist as performer who might in the case of Nauman present himself as or in place of this "object"' (in Buchloh in Kitnick 2011: 16). Here, Graham was most likely referring to works such as Bruce Nauman's *Self-Portrait as a Fountain Get Out of My Mind, Get Out of This Room* (1966–7), in which the artist is seen, shirtless, spewing out an arc of water as the fountain, the found object of Duchamp's homonymous 1917 work. Thus, in this case, 'the idea of the self as a work of art is taken quite literally: the body of the artist becomes a sculpture' (Noack in Brietwieser 2001: 26). For Graham, 'this work of Nauman's is in the present in the presence of the spectator'. Here Nauman in fact acts, 'as both the artist and material, both perceiver (as he perceives himself in order to execute the piece) and perceived, and both exterior and interior surface' (Graham 1978a: 65). Graham, instead,

was more interested in the relationality of self-perception, and the role played by others and by the medium in this process.

Graham's early work *TV Camera/Monitor Performance* (1970) consisted of a stage facing the audience with a TV monitor positioned at the back of the room pointed towards the middle of the stage. Graham, lying on stage with his feet facing the audience, rolled parallel to the left and right edges of the stage, directing a TV camera at the monitor's image, resulting, in his words, in a 'pattern on the monitor of image – within – image – within – image – feedback'. Here, for Graham, 'the monitor image represents a "subjective" view' from inside of his '"mind's eye"'. The audience looking to the rear of the monitor could therefore, in his words, 'observe the view from within my "subjective" view (within my body's feedback system), while a member of the audience looking to the front can observe my body from an external vantage – as an outside object.' For him, the monitor's view, which also shows the audience, is placed directly between the camera and the monitor, literally 'observing the performer's process of orientation' (in Buchloh 1979: 2). The construction of the interdependence between the perceiving subject and object of perception through the video camera produced a self-referential environment, showing that the subject could only perceive her- or himself from within the world of the medium, but also that this world was tautological in that the exact moment of self-perception could not be identified. Hence the performer's presence could not be perceived in the 'present' moment but rather had to be perceived through a medium and/or the presence of another.

In his subsequent work, *Past Future Split Attention* (1972), Graham explored how self-perception occurs in time. A video work producing a continuous sequence, *Past Future Split Attention* shows two people who know each other and are in the same space. One of the two is seen predicting the other person's behaviour, while the second recollects the first person's past behaviour. Both describe themselves in a continuously evolving present, which manifests itself only in relation to information they give about their recalled past and predicted future. Thus, for Graham, here, 'a simultaneous – but doubled attention – of the first performer's "self" in relation to the other (object) – the other's impressions – must be maintained by each performer' (1978b). Interestingly, Graham's construction of the 'present' echoes Francisco Varela's writings about the perception of time, which were inspired by Edmund Husserl's analysis of the subjectivity of temporal perception and his vision of time as a flow. For Varela, time is in fact not formed by a succession of measurable successive now points, but rather by three separate phases: 'now', 'retention', and 'protention'. Retention is described as belonging to the past even though it is happening in the 'now', whereas protention is 'the expectation or the construction of the future' (Varela 1999). In *Past Future Split Attention* the performers' perception of themselves can therefore only occur in a present that, however, presents itself as past- and future-facing, leaving the subject with the impossibility of perceiving their presence in the present moment.

Graham's subsequent work explored whether intentionality could affect behaviour. In line with his wider body of work, *Intention Intentionality Sequence* (1972), first performed at the Lisson Gallery in London in 1972, was divided into a number of stages. In the first stage Graham faced the audience to form, in his words, 'a mental set of total self-concentration, isolated from awareness of audience as I verbalise intentions' (Graham 1978b). In the second stage, he looked directly at the audience observing and describing what appeared in front of him. Here, speaking directly to the audience in the present tense, he noted that his intention was 'to do a piece that has to do with my intention'.

Thus, he stated: 'I sense that the word, **intention**, can be broken down or used in two different ways. One way is subjective, and the other is objective' (1978b, original emphasis). Claiming to have been influenced by Gregory Bateson's *The Ecology of Mind* (1972) as well as Husserl's phenomenology through Jean-Paul Sartre's *Being and Nothingness* (1966[1943]) (in Huber 1997: 6–8), Graham indicated he had aimed to explore in this work how the subjective intention expressed what he saw, while his 'intention – intentionality' was everything he saw in the world, including the attitude to his movements, appearing as his 'behaviour' (Graham 1978b). The piece, which could be seen as a precursor to *Performer / Audience / Mirror* (1977), included the audience as a 'cause and effect relationship' so that, ultimately, he and the audience would be 'in the same position' in responding to and anticipating each other (1978b).

Graham often used video as a 'conductor of images' between one viewer and another, between a viewer and himself, or his own after-image, or between different spaces and the temporalities they constructed (Rorimer in Graham 1981: 10). To further mediate between them, Graham also used mirrors. For him, mirrors constitute 'metaphors for the Western concept of the "self"' (in Buchloh 2012: 67). Thus, in *Present Continuous Past(s)* (1974) he utilised two mirrors, covering adjacent walls, and a video camera and monitors set into the walls across and near the mirrors. Here, the mirrors 'reflect present time' (Alberro 1999: 39) in the act of becoming multiple past times. While the camera in fact recorded visitors as they entered the space, their action was reflected in the mirror opposite, replaying the images after an eight second delay. Graham described the piece as follows:

A person viewing the monitor sees both the image of himself, 8 seconds ago, and what was reflected on the mirror from the monitor, 8 seconds ago of himself which is 16 seconds in the past as the camera view of 8 seconds prior was playing back on the monitor 8 seconds ago and this was reflected on the mirror along with the then present reflection of the viewer. An infinite regress of time continuums within time continuums (always separated by 8 second intervals) within time continuums is created.

(in Buchloh 1979: 7)

Present Continuous Past(s) depends entirely on the presence of the viewer. As noted by Anne Rorimer, 'the spectator *of* the work is the spectator *in* the work, both an object in it and the subject of it' (in Graham 1981: 12, emphasis in original). The video monitor operates here as the medium which, through its built-in time delay mechanism, 'permits the viewer to see himself as he looked (in an active and passive sense) eight seconds prior to his looking at/seeing himself in the mirror' (Ibid.). Being perceived as an object thus becomes the condition of the act of perception which is at the heart of the work. Here in fact, as Friedrich Heuback indicates, perception is not only 'an (active) function of the subject but also an essential condition of subjectivity [...] the subject reaches himself not by perceiving but by being perceived, or rather by seeing that he is being observed: as an object' (in Graham 1981: 12). In this work, '*esse est percepi*' – 'to be is to be perceived' (see Berkeley 1710).

Graham's best-known work, *Performer / Audience / Mirror* (1977), could be described as an exploration of perception and real time informational 'feedback' in a more performative, theatrical context. In the video of the work Graham is seen standing in front of a mirror reflecting the audience which at the beginning of the piece is positioned in front of him. The work is divided in four stages lasting five minutes each (Rorimer in Graham 1981: 9). In the first stage, Graham described his own behaviour uninterruptedly and very

Figure 4.1 Dan Graham *Performer / Audience / Mirror*, 1975. Single channel black and white video with sound, 22 minutes 52 seconds. Pictured: Second Performance at PS1 NY, 1977.

quickly as a form of self-reflection; in the second stage he described the audience's behaviour; in the third stage he turned round and faced the mirror, describing his own behaviour again but this time mediated through the mirror; and in the final stage he again described the audience by looking at them in the mirror. The cameraman can be seen reflected in the mirror too, rendering mediatisation part of the process of self-perception. It is worth noting that when the work was shown at De Appel in 1977, the title was *Audience / Performer / Mirror*, indicating an emphasis on the reversal of the relationship between the performer and the audience in relation to the original title. Hence, to some extent, *Performer / Audience / Mirror* could be described as an immanent re-enactment of itself. Arguably, *Performer / Audience / Mirror* was in fact experimenting with an extended present time, that was not immanence, and that fell between the protentional and retentional dimensions of self-perception, so much so that each attempt to perceive one's presence was only a trace or shadow of an action initiated in the past.

In *Performer / Audience / Mirror*, as Rorimer suggests, spectators are not only witnessing an event, but they are also implicated within it (in Graham and Rorimer 1981: 10). For Graham, spectators see themselves here 'objectively' while being 'subjectively' perceived by the performer (in Zippay 1991), though there is a delay, he suggests, in that 'the audience sees itself reflected by the mirror instantaneously, while the performer's comments are slightly delayed and follow a continuous flow of time (since they are verbal)' (de Duve in Brouwer 2001: 58). This slight delay (and its consequent displacement) is crucial. Thus, he continues: 'The slightly

delayed verbal description by the performer overlaps/undercuts the present (fully present) mirror view an audience member has of himself or herself and of the collective audience' (ibid.). This operation, as Chrissi Iles notes, not only involves 'the audience in the performance directly', but also adds 'the role of object to the observer' (Iles in Simpson and Iles 2009: 69) who is then, as in the title, performing, spectating, and being mirrored, re-enacting them-selves as the object of the performance. For Graham, *Performer / Audience / Mirror* is formed by its own delays in that 'the audience sees itself reflected by the mirror instantaneously, while the performer's comments are slightly delayed and follow a continuous flow of time (since they are verbal)'. The latter then 'overlaps/undercuts the present (fully present) mirror view an audience member has of himself or herself and of the collective audience' (de Duve in Brouver 2001: 58). However, in the second stage this is further complicated as

> members of the audience (because they can see and be seen on the mirror by other members of the audience) attempt to influence (through eye contact, gestures etc.) the behaviour of other audience members, which thereby influences the performer's description (of the audience's behaviour).
>
> (Ibid.: 177)

This feedback loop is at the heart of the work. Hence Graham described his own actions in the work as follows:

> I face the audience. I begin continuously describing myself – my external features – although looking in the direction of the audience. I do this for eight minutes. Now I observe and phenomenologically describe the audience's external appearance for eight minutes. I cease this and begin again to describe the audience's responses ... The pattern of alternating self-description/description of the audience continues until I decide to end the piece.
>
> (Ibid.: 49)

In this version of the piece, divided in three equally long parts, Graham uses the terms 'observe' and 'phenomenologically describe'. This pairing of observation and description through phenomenology, the study of structures of consciousness, suggests Graham describes what happens as it happens moving from a first-person narrative to a second-person re-enactment. Here, as Thierry de Duve notes, the performer and the audience are 'coupled into a loop by the experimental apparatus [*Dispositif*], such that each of them is both subject and observer, together or alternately, in an uncontrollable oscillation' (Ibid.: 49). Graham indicated that when he looked at the audience and described himself he tried to see himself at first 'reflected in their responses' and subsequently 'more influenced or "contaminated"' by his 'impressions of the reactions of the audience' (Ibid.), so much so that at the end of the performance, in his words, 'the audience's projected definition of me helps to define themselves as a group and my projected definition of the audience tends to define my sense of myself' (Ibid.). These dynamics were rendered more complex when the mirror was used, in his words again, as

> members of the audience (because they can see and be seen on the mirror by other members of the audience) attempt to influence (through eye contact, gestures etc.) the behaviour of other audience members, which thereby influences the performer's description (of the audience's behaviour).
>
> (Ibid.: 177)

Hence ultimately in this work, Graham combined two ideas of time, the Renaissance perspective and the present time, and both were reflected in the mirror at the same time in a 'continuous free flow' (in Simpson and Iles 2009: 169) which was captured by the camera. This complex layering of different temporal conceptualisations not only illustrates the relational nature of self-perception, but also shows that whereas '*here*' is 'by definition the place where *I am*', in this work Graham constructed the I am being '*there*' – in other words, the performer is elsewhere, a 'projection whose "place" is the audience, and viceversa' (de Duve in Kitnick 2011: 63, original emphasis). Capturing the relational but also performative quality of the process of self-perception, Graham's work thus shows how the self is ultimately only perceivable from the medium/place (space/time) of an other.

Presence and absence in the work of Gary Hill

Gary Hill's works are an exploration of the constitution of presence, both that of the performer and that of their viewers, in and over time. As Hill noted in an interview with Christine van Assche, it is in fact *time* rather than the act of *seeing*, as the etymology of the term video would suggest, that plays a crucial factor in his work because for him video's 'intrinsic principle' is feedback, and so for Hill the use of time in video is not linear but rather a folding 'movement that is bound up in thinking' (Hill and van Assche 1993: 150). Hence, in Hill's work, video often embodies 'a reflexive space of difference through the simultaneous production of presence *and* distance' (151). It is through coming into appearance and distancing that the subject's presence turns into absence, and vice versa, and it is this transformative instant that the work captures not to create unity but rather to evidence its fragmentation.

Tall Ships (1992), shown at the 1993 Whitney Biennial, was a 90-foot long corridor space upon which sixteen black and white images of people were projected. These were of people of different ethnic origin, gender, and age. The only light in the installation came from the figures themselves. At first the figures appeared far away, but as the visitor triggered a sensor by walking into the corridor, they walked forward towards them, so much so that visitors became participants in this work, which seemed to respond to them, playing on their self-awareness. For Hill, the work was in fact not so much about interactivity or interculturalism but about encountering others: 'it's simply the idea of a person coming up to you and asking: "Who are you?" by kind of mirroring you and at the same time illuminating a space of possibility for that very question to arise' (in Quasha and Stein 1993: 44).

The choice of the specific medium, video, was crucial for Hill's exploration of self-representation in time. Thus, for example, he described his *Commentary* (1980) as 'something of a "manifesto in jest" against television'. Here Hill performs as 'a sit-in viewer looking slightly up at the screen making simple gestures into the camera' which is treated as if it was a mirror. Covering his face, Hill can be seen reaching out to the camera, obstructing his head with a light, literally capturing himself in the moment of becoming an other. In his own words, in this work here Hill plays 'both sides of the screen – performer and viewer attempting to "connect" either way', so that, in this sense, this work operates as 'a commentary on commentary' (Hill in Quasha and Stein 2009: 573). Here, Hill visualises the impossibility of self-perception by literally splitting the two terms, self and perception, on two sides of the screen.

For his subsequent work, *Crux* (1983–7), Hill strapped four small cameras with microphones to his wrists and ankles, with a fifth camera and microphone positioned in

front of his body, so that it could capture his own face. He then went on a walk on a rough terrain on a ruined castle on an island on the Hudson River. The installation shows five monitors positioned in the form of a cross so that the artist's body becomes a composite image produced by the monitors. Four face forward and one faces backwards. For Hill his body here in fact 'films its own absence, metaphorically pinning or nailing its extremities to the cross with the camera's "objective" view (did)embodying the "video"' (2000: 203). His movement, in his own words, was 'awkward', showing a 'distinct sense of separation' from the environment around him which curiously resembles what we would experience nowadays in VR. Thus, he continues, 'I am "nailed", as it were, to a continuously changing ground and sky by the cameras, which have fixed frames focussed on my extremities' (Quasha and Stein 2009: 468). Hill's presence in this work is continuously displaced from his environment. So, Hill, breathing heavily, moving forward through rustling leaves, is captured in the act of becoming the object he will be in the eyes of the viewer. He is no longer in his space and time. He is already elsewhere. In this sense, as Lynne Cooke suggests, the image the subject/performer sees on the mirror is in fact not a mirror image but 'an image of the "right-side-round", that is, not the image known to him- or herself through reflection, but the image as seen by others' (Quasha and Stein 2009: 164). Hill is captured as being longer here and already *there*, in the world of the medium.

Similar strategies were used in his subsequent piece *Crossbow* (1999) in which Hill, sat at a table in front of a notebook, paper, a pencil, water and a musical instrument, strapped three cameras to his body and recorded himself in a sequence of performing actions. Two cameras were mounted in his arms and positioned so as to record his hands from the back and another camera was placed on his body so as to record the back of his neck and parts of his head. The third display was mounted between the other two, showing a simultaneous but fragmented representation of himself (see Hill 2020). For Robert Morgan *Crossbow* is in fact 'dependent on the context of seeing as an activity of time-consciousness' (2000: 7). Again, the subject cannot here be perceived in its totality.

Figure 4.2 Gary Hill. *Crossbow*, 1999. Three-channel video/sound installation. Courtesy Gary Hill.

Their presence remains only perceivable in relation to what is always already absent, not there.

Incidence of Catastrophe (1987–8) is a single channel colour which, in George Quasha's words, literally '"takes place" inside the act of reading a text by Maurice Blanchot, *Thomas the Obscure*' (in Quasha and Stein 2009: 479). The work is loosely based on the first part of Blanchot's text which is about Thomas's annihilation and transcendence of his own experience. Here, Thomas is alone in a seaside resort, experiencing a series of adventures, 'each one landing him further into an ontological abyss in which perception and the impossibility of perception, being and its negation, intelligibility and its absurdity, language and its inversions or antitype possess, obsess, absorb, disgorge, fill, and empty him' (Quasha and Stein 2009: 156). Eventually Thomas experiences the annihilation of his own presence which manifests itself to him as an absence, a 'double' which is 'conjured in the place of his own being' (Quasha and Stein 2009: 156).

Throughout the piece, Hill is seen in multiple postures which are reminiscent of episodes in the book. Thus, Hill commented:

> In *Thomas* the differentiation of the space of the book from that of the author and of the reader collapses, and this creates a state of incredible vertigo; your position is constantly being challenged in terms of where you fit into the narrative as a reader. All you can do is *hold* the book, *feel* the pages, *see* the words as pure things being there, generating a cocoon around you
>
> (in Quasha and Stein 2009: 480, original emphases).

This annihilation is rendered physically in that at the end of *Incidence of Catastrophe* the artist's body is seen curled up.

Many of Hill's works focus on the impossibility of capturing the subject in the present moment and the displacement that is consequently produced by this. In *Conundrum* (1995–8) a prone clothed man appears to be trying to get up repeatedly across six monitors mounted horizontally on a wall. Each screen displays the same image but there is a delay based on a mathematical structure so that each image is seen at a different point in time. Likewise, *Up Against Down* (2008) consists of a series of projected images showing various parts of Hill's body pressing against a black space. The delay is 'equal to the time it takes for the image to pass across a single screen' (Hill 2020: 167). In *Namesake* (1999) two video images are projected on opposite walls. On one side the image is saying the name Gary and on the other image the back of a head can be seen. The artist repeats the name as if the name could become the person seen (Quasha and Stein 2009: 586).

Hill's 1998 *Switchblade*, which could be described as a medical self-portrait, focusses on the memory of the body by showing a series of scars and marks on the body that resulted from accidents, operations, and other interventions, through one projected and one monitored image placed on the floor. The images originate from real time views of the body which are then edited together in a single stream, as if to suggest that here at least the subject can be produced during editorial process. In his *Self* (2016) a set of objects is displayed on a wall, each fitted with a tube and soft rubber eyepiece through which visitors can look into the tubes. The objects are called Self A, B, C, D, E, and F. For Hill, there is a 'conflicting realisation that the very intimacy of self (not the face that the gaze looks onto but the hair, flesh, and cloth that clothes it wherein the gaze is rather absorbed) is rendered as mere texture and that which we identify as "self", our face and

its expression, has disappeared' (Hill 2020: 173). All that can be seen are parts, of a neck, lips, the head, and cheeks which here remain separate. Thus, as Yun Hee Kyeong notes, in this work 'the unified totality of the self becomes decentralized and gradually vanishes' (in Hill 2020: 184). The self in *Self* is no longer a subject, but rather it is formed by its irreconcilable and ultimately un-editable fragments that can no longer be composed into a unity.

Environmental presence: the case of Joan Jonas

Trained as a sculptor in the 1960s, Jonas started, after the 1970s, to use video, images, fairy tales, sculpture, dance, and performance to develop highly personal complex visual landscapes, scattered with objects, often out of size, as well as her own drawings. Describing her own presence as that of another material, 'or an object that moved very stiffly, like a puppet or a figure in a medieval painting', Jonas claimed that she 'gave up making sculpture' when she 'walked into the space' (in Rush 1999: 42). This action of 'walking in' could be described as an act of self-representation (an act of presence). Thus Johann-Karl Schmidt suggests that Joan Jonas moved from sculpture to *living sculpture* (2001: 10, original emphasis), and the media often used to position this living sculpture in time and across audiences are, respectively, video and the mirror.

Jonas has often made clear how her work is concerned with her own life, representing environments that have been familiar to her to audiences which are re-positioned within the work so they too become part of it. Her practice tends to be autobiographical, based on the aesthetic of the 'portrait in the broadest sense' in that 'whether performing herself as an artist before her own camera or giving directions to collaborators, produces self-portraits as an interpreter of her own statements' (Schmidt 2001: 11). The autobiographical elements are often represented at multiple levels. Thus, in her work Jonas is often both image and live performer, both a 'witness and a narrator' (Ibid.: 12). In line with the use of mirrors in painterly self-portraits, the medium is often used here to implicate the audience. Hence in her early works *Mirror Piece I and II* (1969–70) Jonas explored gaze, reflection, and representation, by using mirrors to bring, in her own words, 'the audience into the picture' (Jonas 2020). In the original staging of *Mirror Piece I* at New York University's Loeb Student Center, the piece was interpreted by a group of mostly women performers who moved in 'slow choreographed patterns while holding oblong mirrors in front of their bodies' (Mount Holyoke College Art Museum 2019). These reflected the audience as well as the environment in which they were sat. Two men periodically lifted and carried the women horizontally, by feet and neck, towards different places (Ibid.). In the original staging of *Mirror Piece II* at New York's Emanuel-El YMHA the performers carried even heavier mirrors and glass which slowed 'the pace of their movements', thus 'creating a sense of risk and vulnerability to their bodies' (Ibid.). While in *Mirror Piece I and II* the mirror integrates the audience into the work, though always partially and only sporadically, in *Mirror Check* (1970) the performer, Jonas, is seen inspecting her own naked body with a hand mirror. Here the spectators became voyeurs since only the performer could see what is in the mirror. In both cases, the mirror operated as a medium for reflection which, however, only returned a partial and ephemeral fragment of the reflected environment, drawing attention to the limitations of technology and so also of culture in capturing the physical world and the plants, animals, and other life forms that inhabit it.

Jonas subsequently used both mirrors and videos to bring the audience into the work. Thus, she claims: 'video is a device extending the boundaries of my interior dialogue to

include the audience. The perception is of a double reality: me as an image and me as a performer' (in Martin 2006: 62). For her, video became a 'layering device' (Jonas 2018). Through video, she started 'to perform for the camera' and create 'alternative personas' which are seen to coexist. Thus, the live video footage often consisted of close-ups of objects, characters, actions which were sometimes carried out 'to a monitor or a projection' so that the audience would simultaneously see 'the live action with a close-up or a detail of the poetic narrative' (in Ibid.). Jonas's use of video in *Organic Honey's Visual Telepathy* (1972) was an extension of her earlier use of mirrors as tools for reflecting herself and her audiences. Thus, she claims: 'I attempted to fashion a dialogue between my different disguises and the fantasies they suggested. I always kept in touch with myself through the monitor. I was never separated from my own exposure' (in MoMA 2016). In *Vertical Roll* (1972) she carried out a series of movements both as herself and her alter-ego, 'Organic Honey'. Here she used video to play created fragmentation in the work:

> In a belly dancer's costume I jumped in and out of the bar of the vertical roll like frames in a film going by. This out of synch disfunction of the television – the rolling pictures – presented on the screen parts of my body, never a whole.
>
> (Jonas in Schmidt 2001: 64)

Constructing, in her words, a 'theater of female identity by deconstructing representations of the female body and the technology of video' Jonas made use here of an interrupted electronic signal which she called 'Vertical roll', 'dislocating space, re-framing and fracturing the image' and disrupting the image 'by exposing the medium's materiality' (Hanley 1993, 69).

In 1994 Jonas converted her 1972 pieces *Organic Honey's Visual Telepathy*, *Organic Honey Vertical Roll*, and *Vertical Roll* into an installation entitled *Organic Honey's Visual Telepathy / Organic Honey's Vertical Roll*, also including a video by Richard Serra with sound by Philip Glass called *Anxious Automation* (1971) in which she performed. In *Organic Honey's Visual Telepathy* a camera transmitted a live video feed of the performers' actions, allowing audiences to see the live action and video at the same time. In the 1994 version of the work, she created a hybrid piece which, however, characteristically for her, still entailed elements from the original performance. Here she used video to produce an enhanced presence, a doubling, and became, in her own words, 'my own audience' (in Schmidt 2001: 101). As suggested by Anja Zimmermann, the artist's self-mirroring and the mirroring of the viewer were placed in direct juxtaposition so that literally 'vision becomes visible' (in Schmidt 2001: 101), shifting attention from the presence of the artist to its construction in the gaze of others. In fact, the work, Jonas noted, 'evolved as I found myself continuously investigating my own image in the monitor of my video machine. Wearing the mask of a doll's face transformed me into an erotic electronic seductress' (Jonas in Schmidt 2001: 106). Here Jonas was interested in what she called 'the discrepancies between the performed activity and the constant duplicating, changing and altering of information in the video' (in Schmidt 2001: 108). This duplication was especially interesting for her in relation to her construction of a persona. Thus, she added: 'If you look at yourself in the mirror in relation to performance, or look at yourself in the camera, you have to ask that question, because you are not who you think you are. It's the double, and has to do with construct and artifice, and also with your own psychology' (Ibid.: 153). The camera movement reflected this uncertainty. Hence in an interview with Babette Mangolte, Jonas claimed that she used the monitor to frame

herself: 'for me the performance was about framing details of my image making' (Ibid.: 172). Interestingly, in the same interview, Mangolte noted that at the time she had no idea of what Jonas was going to do and just interpreted her instructions as she went along (Ibid.). At the heart of the work was the idea that the audience would be watching a performance while also watching the movement of the camera, thus detecting the 'discrepancy between the two' (in Jonas 2015: 145).

While these works are not self-portraits in the conventional sense of the work, they are autobiographic and play with notions of self, identity, and persona. Thus, in her 1971 notebook the term 'self' appears twice, once as a reference to self-portraiture (Jonas 1971). Jonas says that in the video performance *Organic Honey Visual Telepathy* 'I see my face as image, my body as image, my activity as image and objects as image' (Jonas 1973: 132). So, in a sense, the work shows Jonas in the act of becoming image, highlighting the performativity involved in this act. The coexistence of the performer and the screen show the uncanny similarities as well as, divergences between them. Hence for Jonas the process was about her own: 'theatricality' (in Crimp 1983: 137) in that her body had become 'a medium: information passes through' (Ibid.: 139). This doubling makes it possible for Jonas to be both performer *and* the image, located both within and outside of the parameters of the representation.

Jonas's subsequent piece *Volcano Saga* (1985–9), originally performed live by Jonas, and then developed, in 1994, into an installation with the same title, was based on a thirteenth-century Icelandic poem in which a woman marries four times. The protagonist, Gudrun, interpreted by Tilda Swinton, tells the seer, Gest, interpreted by Ron Vawter, about the four dreams which Gest thinks are about each of Gudrun's husbands and her lives with them. The performers looked like 'paper dolls pasted on the scenery – similar to what Jonas achieved with a projection backdrop in the original performances' (MoMA 2007). The video backdrop showed a river flowing through a black volcanic landscape intercut with images of mountains, plains, and desert-like landscapes, sheep, seals, and other animals, accompanied by a soundtrack by Alvin Lucier. Juxtaposed against the video projection was a desk, and on top of that was a map of Iceland. While most of the work consists of the narration of the saga itself, Jonas can be seen at the beginning of the video wearing a raincoat and measuring the backdrop created by the video projection in relation to the map, comparing scale and distance, while she narrates how in researching the work she went on a drive near a glacier, lost control of the car and was left hanging upside down. The images are intercut with the hands of a woman seen wringing a cloth in a bowl and scenes of the dialogue between Gudrun and Gest. In recalling the accident in the performance, Jonas recalls: 'the wind whistled and blew. Everything was moving' (Jonas in Kaye 1996: 95). This image conveys the shifting territory and subsequent displacement (from dream to reality to image to map to performance to myth) that characterises this work. Here the foundations of knowledge and so also of self-representation become, like rivers, fluid and in perpetual motion.

Re-presencing the subject: Lynn Hershman Leeson

Over the years, Lynn Hershman Leeson created a number of works exploring the construction of presence which used a wide range of technologies and often grew organically from each other. Among her video works, *Paranoid Mirror* (1995), inspired by Jan Van Eyck's painting *The Arnolfini Portrait* (1434), engaged, in Hershman Leeson's own words, with 'ideas of reflection, tracking, surveillance, and voyeurism' using 'the viewer

as a direct interface' (1995: 18). While in the original Van Eyck painting the artist appears to be reflected in the mirror, here Hershman Leeson appears as a reflection in the art collector Anne Gerber's piercing eyes which 'form a core image in the mirror' (Anon 1995: 5) as if to say that we are not only framed by technology, by the medium, but also by culture. For this work, Hershman Leeson placed a set of sensors on the gallery floor which, when stepped on by the viewer, activated a still image in a golden frame. This figure then turned around and dissolved between sequences of the viewer and/or other images, which had been captured playing in real time over a framed monitor placed outside the gallery space (Ibid.). The second screen reflected whoever was standing in front of the first screen in the gallery space, with the image of the artist remaining visible from behind the central figures. For Hershman Leeson this work intended to draw attention to manipulation and control as well as identity construction, by raising the following questions: 'are we gatherers of information manipulated by powers beyond our control? Are we sneaky voyeurs stealing other people's identities for our own use? Are we simply a mirror of what we see?' (in Anon 1995: 5), suggesting that the 'self' is constructed not only in the presence of others but also by adopting the characteristics, theatrically speaking, of others.

Hershman Leeson's *The Electronic Diaries* (1984–19) features a woman confronting her traumas (childhood abuse, weight gain, dieting, illness, and aging) through direct address to the camera. The diaries tend to be intercut with historical facts preceding and following the dates of the filming, which started just before the fall of the Berlin Wall, while the term cyberspace was about to become, in her words, a 'buzzword', documented the spread of AIDS, internal and international politics, and natural phenomena, as well as, in her own words, her 'own private apocalypse'. The *Electronic Diaries* captured the emergence on tape of what Hershman Leeson called in the *Diaries* 'separate conflicted personalities', each trying to tell her own 'truth'. Entailing tightly framed close-ups, as well as fragmentary cuts which appear to split and often multiply her image, *The Electronic Diaries* thus trace the (trans-)formation of Hershman Leeson over a period of thirty years, and, anticipating confessional technologies like vlogs and Instagram, literally edit the construction of her identity through the medium.

David James noted that in these diaries Hershman Leeson directly addresses the video camera and herewith the viewer, using the monitor as a mirror, 'in which the subject may perceive an objectified form of herself, partially reified but still in flux, and also a stage upon which she may set herself to play assumed personae' (in Tromble and Hershman Leeson 2005: 147). Thus, the conversation, for James, 'mimics the scene of psychotherapy, securing a place where the self may be encountered, and a self image constructed' (147). Only that there is no therapist, only the camera and the viewer. Yet, clearly, Hershman Leeson can be seen slipping in and out of her 'self', by moving backwards and forwards in time and by highlighting certain aspects of her personalities. The fundamental condition of *The Electronic Diaries* is then, for James, 'the instability of Hershman's self as their subject' (147). Yet what Hershman Leeson presents is not only or not so much what James calls the 'impossibility of an autonomous, uninterrupted self' (149) and the fact that there can be therefore only 'video-dependent' images of the self (149) but also that the self here is continuously edited, just like the video diaries are, and so clearly also framed by the technologies used to keep that subject (a)live.

Each of the diaries tells a different part of Hershman Leeson's own history. As the diaries move forward in time, they build on each other, forming a kind of deep map. Hence themes return, like weaves, to haunt its central character who becomes

Figure 4.3 Lynn Hershman Leeson. Still from the video *The Electronic Diary 1984–2019*. Courtesy Bridget Donahue Gallery NYC and Altman Siegal Gallery SF.

stratigraphically increasingly complex, a layering of different histories, material, discursive, imaginative, performed. Thus in 'Confessions of a Chameleon' (1986) Hershman Leeson recalls her childhood and teenage years, telling how she was abused as a child and how she ended up constructing imaginary 'characters each of which had their own life'. Here, she mentions how she married very young, and was left with no money after her husband left her unexpectedly without any explanation, which meant she had to take on different lines of work to support her daughter.

In her subsequent diary 'Binge' (1987) Hershman Leeson talks about her attempts to lose the weight she gained after her husband left her. She mentions her self-hate and increasing vulnerability, and how she started to separate herself from her 'image' of herself, covering mirrors and avoiding reflections of any kind. As she talks about her image, she can be seen multiplying on screen, as if the use of the camera could only but further extend the very 'distortion of our sense of truth and values'. Thus, 'Binge' ultimately shows that, in Hershman Leeson's words, 'we deal with things through replication, and through copying, through screens, through simulation'. Hence the binging has not only to

Figure 4.4 Lynn Hershman Leeson. Still from the video *The Electronic Diary 1984–2019*. Courtesy Bridget Donahue Gallery NYC and Altman Siegal Gallery SF.

Figure 4.5 Lynn Hershman Leeson. Still from the video *The Electronic Diary 1984–2019*. Courtesy Bridget Donahue Gallery NYC and Altman Siegal Gallery SF.

do with the consumption of an excess of food, but also with the amplification and expansion of the self, afforded by her attempts to use media for self-representation.

In 'First Person Plural' (1988) Hershman Leeson returns to her childhood abuse and the fact that she dealt with it by assuming the identities of characters whom she read about in a short story. Thus, she reveals that in her wardrobe she had the clothes of several people, confessing that 'I had no grounding for who I was. I was seeking in everything that I did to find an identity'. Here she also reflects on the fact she was born to Jewish parents who had fled Austria in the 1930s and that therefore she is not only formed by the plurality of selves that emerged throughout her own life but also by those of others, who were affected by the course of history. Hence, she notes: 'The scars are deep'. In 'Shadow's Song' (1990) Hershman Leeson reveals how she realised that she was in pain as her plane was landing. When the pain came back a few days later she went to the doctors where she was told that she had a tumour at the base of her brain which she could see as

Figure 4.6 Lynn Hershman Leeson. Still from the video *The Electronic Diary 1984–2019*. Courtesy Bridget Donahue Gallery NYC and Altman Siegal Gallery SF.

a shadow in the x-ray. Hershman Leeson describes how she felt estranged from herself: 'I looked at those x-rays as if it was somebody else. I could not see myself in it'. She then describes having a hospital appointment on the day of the earthquake in San Francisco, on 17 October 1989, when everybody was 'literally displaced', to be told, some time later, that she didn't need to have the surgery as the tumour had shrunk.

In her subsequent 'Ring Cycle' (1992) and 'Re-covered diary' (1994) Hershman Leeson shows snippets from her wedding to George Leeson, reflecting also about her daughter's own wedding and her becoming a grandmother. In talking about the diaries, Hershman Leeson concludes that 'now I don't believe that anything is true unless it has been mediated through a camera or a computer', pointing out that she had in fact been recording images of herself as evidence that she existed, showing therefore that identity and even life itself 'is the ultimate editing process'. The self is produced by life itself only that we cannot see the full story until the end.

'Cyberchild' (1998), the latest diary, begun in 1993, entails an investigation into advances in medicine, especially tissue regeneration, genetic manipulation, and 3D printing. Here, Hershman Leeson notes how in the period in which she created the diaries 'everything changed' in that the future of humanity will not only be edited through technology but also literally created by it. Thus, the diary includes an interview with Elizabeth Blackburn, Professor at the University of California, on her work on telomerase in aging, cancer, and the onset of cardiovascular disease, which shows how telomeres reflect the health status and risk for chronic diseases in humans, making telomere research crucial in a range of fields affecting human life. Hershman Leeson also describes her growing interest in bioprinters and the possibilities they offer in medical research. For this, she interviews Dr Anthony Atala, Professor in Regenerative Medicine at Wake Forest School of Medicine, who discusses with her the printing of organs for terminally ill patients. So, for example, he mentions how he could scan an area of injury and then

Figure 4.7 Lynn Hershman Leeson. Still from the video *The Electronic Diary 1984–2019*. Courtesy Bridget Donahue Gallery NYC and Altman Siegal Gallery SF.

print cells on the injured area. For him 'the genetic imprint that we have in every cell is like the keyboard in a piano. You can play many different pieces with it. But the keys are the same'. Reflecting on biomedicine more broadly, Hershman Leeson then suggests that surveillance is now 'going from the inside out'. The diary finally includes an interview to the molecular engineer, geneticist, and chemist Dr George Church, Harvard Medical School, who tells her that DNA could be considered as 'a four-dimensional sculpture that includes every part of our ecosystem' in which time 'is the fourth dimension'. This image, suggesting that DNA operates as a live archive of humanity, led Hershman Leeson to suggest that DNA 'tells about the past and the future and the evolution of life as we knew it'. In concluding her latest diary, Hershman Leeson then reveals how she converted all her archives into DNA, so they could 'simmer into its own reduction' as a 'poetic essence of this entire process'. As we are now 'the editors of our own life', her life, she notes, seems like a re-enactment or re-performance of the same issues which are 'modified by time'. Thus, Hershman Leeson ultimately shows how we re-enact, as if caught in a fold, the *self* that is already written within our DNA.

Surveillance: from wearable computers to AI

In 1945 Vannevar Bush suggested in his 'As We May Think' article published in *The Atlantic* that people could wear small cameras on their foreheads to capture their daily lives for what he called the Memex archive. Eventually his vision was adopted in the field of wearable computing. Thus, Steve Mann, Professor of Electrical and Computer Engineering in the Department of Electrical Engineering at the University of Toronto, who started to experiment with wearable computers in the 1970s, used such devices around a decade later to track his daily activities. He then founded the MIT Wearable Computer project at the MIT Media Lab in 1992 where he experimented with wearable face recognisers that could see everything the wearer saw, taking the field of wearable computing into the field of body-borne computing.

The exploration of the use of cameras to document everyday life was continued in 1998 by Microsoft analyst Gordon Bell who started to capture as many aspects of his life as possible, including emails, correspondence, documents and records, books, videos, films, conversations, and, among others, photos. In 2000 he started wearing a camera and in 2002 a health tracking arm band, capturing data for what in 2015 became known as the Microsoft MyLifeBits project. Subsequently, Microsoft designed Facetmap which was meant to visualise Bell's data. When Clive Thompson met Mary Czervinski at the Lab, she showed him how the map works: 'if you click on any blob, it instantly expands to show you everything it contains' (Thompson in Levy 2007: 104). The idea that computers can be worn, that they should become part of the human everyday dress code, was also explored by Mann, who, throughout the years, developed wireless forms of wearable computers which are almost invisible and which can be used to establish new, non-hierarchical forms of surveillance called 'sousveillance' (from the French sous, meaning 'below, under'), a term coined by him to suggest sousveillance's opposition to surveillance (from the French sur, meaning 'above'). Through wearable computers, computer systems are able to share their wearer's perspective, 'much like a second brain – or a portable assistant that is no longer carted about in a box. As it "sees" the world from our perspective, the system will learn from us, even when we are not consciously using it' (Mann 1997: 80). With Mann's wearable computers, the subject becomes enmeshed with their environment, transforming the wearer into an active receptor and transmitter of information.

Figure 4.8 Irene Fenara, *Self Portrait from Surveillance Camera*, 2019, inkjet print, 28 × 40 cm. Courtesy the artist, UNA Piacenza, ZERO … Milan.

It is clear that wearable computing could be used for self-tracking, and so for creating what has been described as a quantified self, a term first created by *Wired Magazine* editors Gary Wolf and Kevin Kelly in 2017, also described, by Deborah Lupton, as a self-tracking culture, 'regularly monitoring and recording, and often measuring, elements of an individual's behaviours or bodily functions' (2016: 2). These self-tracking practices have led to the development of lifelogging, personal informatics and personal analytics, but also creative responses such as Laurie Frick's FRICKbits data app which allows self-trackers to take back their data and turn them into art, a 'data selfie' (Frick 2015).

Some artists have performed to surveillance cameras, such as Irene Fenara who in her *Self-Portrait from Surveillance Camera* (2018) is seen moving towards a surveillance camera, her gaze resisting the invasion of the medium, before saving the images so that they are not automatically deleted 24 hours later. Likewise, Jill Magid's *Evidence Locker* (2004), consists of an archive of videos and email correspondence created through the CCTV system in Liverpool in collaboration with its employers. In this work Magid chronicled a month in Liverpool during which she choreographed and edited actions in public identifying herself with a bright read raincoat, which signalled to the police crews where she was. After the performance was complete, she retrieved the footage which she then recomposed alongside a number of video diaries on her project microsite. In her videos *Trust* (in which she was directed around blindfolded) and *Final Tour* (in which she orchestrated her own coverage) Magid transformed surveillance technology into the platform upon which to explore her identity as if to imply that we are not only seen by others but also controlled by them.

In recent years artists have started to use new technologies for self-portraiture such as AR, MR, and VR. Jonathan Yeo, for example, made a series of self-portraits of himself at OTOY, a California based graphics company pioneering sophisticated 3D scanning techniques. Capturing himself in high definition, he then worked from his facial scan in virtual reality using Google's Tilt Brush software and an HTC Vive headset to create self-portraits, with the wireless controllers acting as a palette and paintbrush (Wickham and Salter 2017: 154). The final self-portrait was then cast in bronze, becoming a statue that was then used in exhibition. Commenting on the process, Yeo stated: 'You can look

at yourself, walk all the way around yourself, light yourself as if you were another person' (Yeo in Wickham and Salter 2017: 152). This doubling up of the subject as an object evidences the aesthetic potential of the digital double which, unlike the double produced by reflection, could in years to come become part of the internet of things. Moreover, Yeo noted how the absolute precision through which the VR locked his gestures meant that one could look at the object in the VR as if it was a sculpture. 'So', he noted, 'it seemed obvious that I should export my self-portrait out of VR and into physical reality, where it could take up real space' (Yeo in Wickham and Salter 2017: 154). This use of painting to produce a self-portrait sculpture turns an action into an object and so also into a space, generating a duplication of the subject, of the self, that could be reused over time.

Artists have started using robotics and AI for self-portraiture. Ai-Da, named after the mathematician Ada Lovelace, for example, is a humanoid AI robot–performance artist which is capable of drawing people from like using camera eye and a pencil. Displayed at the Design Museum in London in 2021, the robot created a series of self-portraits by looking into a mirror with her camera eyes. In fact, the AI and algorithm programs transformed what the robot saw into co-ordinates which were then interpreted by the robotic hand to create the self-portrait. Described by its creator as the 'as an artist' and as 'art', existing in the 'unreal, real and hyper-real', communicating through telepresence and AI, Ai-Da acknowledges the potential harm of technologies 'in situations where power can be abused' (Meller 2021). In this sense, Ai-Da makes us wonder what 'self'

Figure 4.9 Ai-Da creating a self-portrait. © Aidan Meller www.ai-darobot.com.

will mean in the future and, crucially, who will in fact control it. At the talk at the Design Museum Ai-Da thus asks: 'how does someone without a self create a selfie'? (Ibid.). At the time in which data doubles are being created and exploited within the Internet of Things, Ai-Da, and Lynn Hershman Leeson before her, remind us that not only do we need to reflect about what the self may become in the context of AI, but also who controls these selves, and so what exactly will be meant by this term in the Metaverse which spans between the physical and digital world, and in which our multiple selves will be active simultaneously in different and possibly even contrasting spheres of life.

5 The selfie

The term selfie entered the Oxford English Dictionary (OED) in 2013 indicating a photograph taken of oneself with a smartphone or webcam usually in relation to social media usage. The OED suggests that the term was first used in a forum post in Australia in 2002, but became more common after 2011, when a Jennifer Lee from Oakland shared her photo on Instagram and subsequently used the hashtag #selfie (Laird 2013). While the selfie stems from self-portraiture, the principal difference between the two is that the selfie often, though not always, includes its own circulation strategy. Over time, the social dimension of the production of the selfie became so significant that Paromita Vohra, among others, suggested that the selfie could be described as a form of 'social ritual' (2015), presupposing that everybody must, to some extent, participate in the practice of selfie-creation to establish their social presence and safeguard its circulation in the digital world.

The social dimension of the selfie is inherent in the photographic genre, in that, as Nathan Jurgenson suggests, the selfie is not too different from and in fact often behaves like other forms of 'social photos'. However, the innovative quality of the selfie lies not so much in the image itself but in the 'transmission of the moment as it presents itself' (Jurgenson 2019: 23), indicating that the circulation of the image, and as Vohra points out, its associated rituals, are part of the content, while its 'experience' is what is in fact being shared (Ibid.). Arguably then, the selfie is formed by a representation of a 'self' at a particular moment in time, and by the sharing of the experience of this representation, both as an image and, by association, through the tagging and/or hashtagging of this image, as part of a wider body of images. In this sense, the selfie is a form of photographic self-portrait as well as a circulation and communication strategy aimed at constructing the subject as an image to be seen and experienced by others.

Selfies entail an epistemic value, which has not only to do with self-representation and communication, but also with the identification of a relatable subject. In other words, the selfie is constructed *in relation to* other subjects and is then reconstructed every time it is received and recirculated among new communities which may have, over the course of time, become involved in the propagation of the image through tagging and/or hashtagging. The same selfie can therefore be repurposed and become part of different and even diverse communities, which can then experience and recirculate the selfie further afield. It is therefore not so much the ontology of the selfie that matters in this context, but its relatable and epistemic value. In other words, the selfie is defined by what it *could* become in the interpretation of others. A photograph taken of oneself without a tag or hashtag may therefore still be a selfie, but produce no circulation, and so be socially invisible within the Internet of Things. In this sense selfies are both objects of and strategies for circulation and consumption.

DOI: 10.4324/9780429468483-6

Selfie-taking has become such an integral part of most people's lives that some researchers talk of a 'selfie-syndrome' which affects people who are so concerned with their own digital image on social networks that selfie-taking has become a compulsive behaviour for them (Fox and Rooney 2015). Researchers have described this phenomenon as 'selfitis', defining the behaviour of 'people who feel compelled to continually post pictures of themselves on social media' (Knapton 2017). There are different types of selfies, depending on whether sticks are used, which body parts are shown, whether video is used, or manipulation occurred (Kozinets, Gretzel and Dinhopl 2016), and whether apps such as Meitu, BeautyCam, MomentCam were utilised. There are also different forms of content, spanning from funeral selfies, selfies taken alongside luxury cars, in front of bathroom mirrors, with cats, but also extreme selfies, animated selfies, and sexualised selfies, each with their own set of codes and recognisable parameters. As data analytics and facial recognition technologies continue to develop, it is likely that selfie analysis will become more and more sophisticated.

Selfiecity is a very good example of what selfies could tell us about how we wish to appear to society. Selfiecity is a digital humanities project led by Lev Manovich, which investigates the use of selfies in five locations by looking into how people photograph themselves. The team analysed approximately 3,200 Instagram selfie photos shared in New York, Bangkok, Moscow, Berlin, and São Paolo, using a combination of theoretic, artistic, and quantitative methods, looking specifically at the demographics, age, as well as poses and expression of people who engage in self-documentation through selfies. Rich media visualisations were also used to reveal patterns, offering a novel way to visualise big data through digital media. For Alise Tifentale and Lev Manovich, the main difference between the selfie and other forms of self-portraiture is the fact that the selfie 'is at once a private act as well as a communal and public activity' (2015: 8). It is therefore not surprising that two of the most common venues in which selfies are taken are hotel rooms and bathrooms, where the subject appears to be caught in a private moment. Selfiecity also entails a 'selfiexploratory', an interactive visualisation app which allows interested parties to navigate the entire set of photos by city, gender, age and a number of face measurements and expressions, and to see, when selections are made, how the graphs update in real-time (Manovich 2015). Curiously, in the portal the images are stripped of context, and do not show the hashtags used for their circulation. The project, one of the largest collections of selfies, reveals fascinating data about how individuals construct their own image according to precise sets of rules to do with, among others, setting, positioning, mood, and facial expression.

Much has been written about narcissism and the selfie (Fox and Rooney 2015, Lee and Sung 2016), and communication and the selfie (Barry et al. 2017; Qiu et al. 2015). Less has perhaps been written about non-representational and artistic selfies. Here, I build on scholarship looking at self-portraits and selfies as forms of performance of the self (Jones 2002), describing how selfies specifically aim to capture 'the act of self-portrayal' (Levin 2014: 20) so as to engage others not only in experiencing different images of one's self (Wendt 2014) but also in decoding the performative nature of the image. To this extent, I show, artists construct environments featuring the viewer as a kind of prosumer who is both consuming and producing the selfie by hashtagging, commenting on its content, and sharing it with others.

I have already shown how artists used painterly self-portraits to frame performative acts and photographic self-portraits to render the subject as an image. Here, I show how selfies tend to turn viewers into broadcasters, and so to some extent co-producers of the

selfie's circulation. By embracing the conventions of selfie creation and sharing though social media, I also show, how selfies identify exploitable behaviours that turn users into commodities within the Internet of Things. The main case studies are Amalia Ulman's *Excellences and Perfections* (2014), a four-month performance on Instagram in which the artist fabricated a fictional persona whose stories unfolded over three episodes, and a number of works by Erica Scourti including *Facebook Diary* (2008), an example of what has been described as 'an enaction (sic) of a collectively created subjectivity' (2008), *Life in AdWords* (2012) exposing how Google uses algorithms to translate personal information into consumer profiles that advertisers pay access for, and *Dark Archives* (2016), in which Scourti uploaded her entire fifteen-year personal media archive consisting of photos, videos, and screenshots to Google photos. The chapter ends with an analysis of the work of Cached Collective which exposes how commercial companies create rich psychological profiles from the data we generate by using social media. These works not only offer a testimony of how we now frame ourselves but also show that, as Nathan Jurgenson noted, we have developed a 'documentary vision' through which we see the world as a series of potential social media posts (2011).

The origin of the selfie

The origin of the popularity of the selfie can be tracked back to snapshot photography. It is known that photography has always entailed a participatory dimension. Thus, Susan Sontag points out that photography is 'one of the principal devices for experiencing something, for giving an appearance of participation' (2008: 10), but in the selfie, participation is constantly changing during the process of transmission through social media. For Edgar Gómez Cruz, photography has, since the advent of the selfie, 'gone from being a medium for the collection of important memories to an interface for visual communication' (in Gómez Cruz and Lehmuskallio 2016: 229). Here, I suggest that the selfie could be described as a form of deferred performance, where, by using the term performance, I mean the selfie involves the production of an action or performative event, and by using the term deferred, I suggest that the occurrence is produced again each time it is experienced and often also literally reproduced through social media. Through this distribution the selfie propagates and accrues value.

As Daniel Rubinstein and Katrina Sluis suggest, the selfie transforms snapshot photography 'from an individual to a communal activity' (2008: 9). We know that as a consequence of this, an increasing number of new practices have become associated with photography to do with the selfie, such as transmission, encoding, ordering, and reception, transforming photography from being 'print-oriented to a transmission-oriented, screen-based experience' (Ibid.). Interestingly, for Rubinstein and Sluis, 'the practice of tagging, which results in millions of images identified with "holiday", "party", "wedding", "family" reinforce a sense of identity and unity which overwhelms difference and distinctions' (24). In this sense, the selfie operates, like Wikipedia, by standardising and homologising. As Paul Frosh suggests, the stock images used in selfies are shown to erase 'indexical singularity, the uniqueness of the instance, in favour of uniformity and recurrence – the systematic iconic repetition of staged image types' (2002: 189). Selfies are therefore not so much about individual expression as they are about community and conformity. This suggests that selfie creation ought to be considered as an exercise in standardisation and homogeneity. In other words, even though they give the impression of immediacy, selfies are usually carefully constructed and framed. Thus, for example, in

noticing that the self that is produced in a selfie and in a self-portrait are not the same, Anirban Baishya points out that the selfie entails 'a sort of externalized inward look' and that 'the amateur look of the selfie also becomes an index of the real' (2015: 1688). Most selfies can be described iconographically as poses in which the head is tilted down while the subject looks up, shooting from above, illustrating perhaps, that the selfie is about the performative process involved in the 'the gendered labour of young girls under capitalism' (Gram 2013). Thus, selfies, often capture the ritual involved in the creation of adolescents.

A number of selfies show the stretched-out arms that generated the selfie, capturing the performative dimension involved in the process of their own making. Research in fact shows that selfies can be divided in two categories: those which place the documentation process at the forefront and so show mirrors and/or a stretched out arm, but also specific objects which operate like props in a set, and so tend to be used as a clear reference to the framing process, and others which show more resistance to the capture, for example by the subject covering their face, or show no awareness of the framing process (Wendt 2014: 10). It is the former that I am particularly interested in exploring here, especially in the case of artists who draw attention to the socio-political, as well as techno-aesthetic and even economic implications involved in the process of generating and sharing selfies. These kinds of selfies often direct their viewers' gaze so as to make them participants in the construction and transmission of the subject and implicate them in its distribution across media. Hence, these kinds of selfies in particular are not just constituted by the poses of their subjects, or by the architectures or scenarios in the background, but also by their circulation strategies, and so the analysis of their tags and/or hashtags, as well as any comments made on posts, should constitute part of any study of these forms of self-representation.

In investigating selfies for her monograph, Ana Peraica, created a hashtag #whataboutyourselfie for a range of social media networks including Facebook, Twitter, Google +, Instagram, YouTube, noting that practices of framing vary from generation to generation and often include 'cut-ups' and 'unusually high angles'. In this context, Peraica observes that younger generations 'recorded with a direct gaze to the camera, while older authors avoided a direct self-picture, as if trying to establish some critical relationship to the concept of the self' (2017: 11). For her, selfies, more than conventional self-portraits, communicate a sense of immediacy and simultaneity (16) though the frames do not necessarily reflect physical worlds. Thus, she points out, Miguel Angel Gaüeca's *Nobody Known Vermeer Told Me This* (2004), Coca Cola Collection, for example, shows a person reading a letter next to a wall with a number of different-sized mirrors reflecting his image. Peraica describes how the mirrors are photomontages (95–6) and do not represent the scene as a reflection but recreate it, so that 'each of the frames on the wall shows a different reflection, first of all in framing a scene' (96–7). Selfies such as these resemble photographic and video self-portraits experimenting with the construction of identity, only that the latter tend to be defined by their content as well as by their tags, hashtags, or comments, which produce or enhance the circulation of the image they accompany. What we see in the image then, is not only a representation of a subject in a specific environment but also the fabrication of the context of this subject's reception in another environment, often illustrating the process behind the creation of the image. Moreover, the selfie may offer a hint as to its broader theme ('duck face', 'kissy face', 'I am bored', 'model pout', 'stuck out tongue face', etc.) and so encourage a relatability which in turn is meant to augment circulation. This may then attract new communities who would redefine the parameters for the selfie's reception in a wider and possibly even more diverse range of contexts.

I have already discussed the role played by photography in the construction of identity. It is worth remembering in this context that research has shown that marketing campaigns launched to publicise early snapshot photography prompted a transformation of photography from an elite act to an everyday documentation activity that eventually led to self-documentation and selfie production. It is known, for example, that self-documentation through photography has been influenced by Kodak's early advertisement campaign which aimed to produce an appetite for memory creation. Thus, a campaign from 1913, for example, gave away prizes for the 'Kodak Happy Moment', capturing pictures from people's summer holidays (Murray 2008: 152). Likewise, Kodak's advert 'Keep a Kodak Story of the Baby' aimed to turn potential customers into documenters by prompting them to make a note of the dates and titles of their images. This produced a passion for self-documentation which, as Brooke Wendt shows, was instigated by Kodak's campaign aiming to encourage people to self-photograph and treat their everyday lives as something within which everything could become 'a potential photograph' (2014: 13). In this context the 'Kodak Girl' phenomenon may have played a particular role in establishing the importance of representing one's identity through selfies for younger women. The 'Kodak Girl' was in fact part of a marketing strategy developed by Kodak, aimed at presenting modern women as independent and fun-loving, seen in racing cars, playing sport, engaged in intellectual activity, but also caught in intimate family moments in which they appear as mothers and/or wives. Crucially for this investigation, the 'Kodak Girl' campaign constituted one of the first marketing campaigns encouraging aspirational and relatable forms of photographic self-documentation among women.

As Daniel Palmer indicates, Kodak was the first company to encourage customers to produce and even commodify memories so much so that the expression a 'Kodak moment' started to refer 'to any moment worth remembering' (2010: 156). Thus, Kodak prompted its customers to 'keep your camera handy – with extra rolls of Kodak film – for all those fleeting pictures of your children and your happy times with them' (Wendt 2014: 15), hereby '[reversing] the role of the consumer from spectator of a scene to the subject of an advertisement', and so placing 'the viewer in the model's position' (14–5). These findings show that marketing for Kodak and other firms probably played a significant influence on the way people started to use smart phones to document their everyday lives. Interestingly, Kodak also saw the importance of the connection between snapshot photography and the construction of the self in the image. Thus, in an advert from the 1980s, the company said: 'they'll decide what to shoot. And they'll establish a concept of "self", by recording their lives in pictures' (in Ibid.: 15), as if to say that people could only determine the concept that they had built of their 'self' by recording images of themselves. What, of course, is already noticeable here, and is clearly visible in the selfie, is that this new type of self-representation forms a consumer profile whose creation and experience are geared towards a broader set of often unrelated economic priorities.

Kodak wasn't the only company seeing a market opportunity in people's desire to self-document. A Sprint advertisement from 2012, for example, makes no distinction between 'important moments and everyday activities' (Wendt 2014: 17), and, as Brooke Wendt notes, a 2013 iPhone5 commercial suggested that phones literally formed their users' spheres of vision 'replacing his or her memory with mediated experience' (Ibid.). Thus, Wendt indicates, selfies started to be constructed as 'future-oriented' images which make it possible to 'become accustomed to our being-in-the-image' (45). However, differently from the Kodak snapshot, within the selfie's emergent concept of self is embedded not only the image of the author, but also the lives of its potential viewers. In this sense, the

selfie is a tool for the creation of affiliation, obliterating the individual subject's independence in favour of belonging to the masses.

Selfies have been found to have a dual function, and while on the one hand they entail and bookmark content, on the other they indicate 'a form of community membership, which bridges a virtual community of users' (Yang et al. 2012: 261). Thus, for artists like Jean Pigozzi, for instance, who has been described as a pioneer in the genre of 'celebrity selfies since his college days' (Greenslade 2017: 23), the hashtag defines both content and community belonging, operating, to some extent, as some kind of 'social currency' (Marwick 2015: 142; Choi et al. 2017). Celebrity selfies, which can, of course, be taken by the public or by celebrities, constitute an attempt to bring the public closer to the lives of celebrities, and represent a significant field in selfie studies, forming a strategic mechanism for personal publicity within this industry. While they do not constitute part of this study, it is worth noting here that, as Anne Jerslev and Mette Mortensen show, celebrities perform a 'phatic communicative function' in that they use 'linguistic markers (verbal or, in this case visual) to signal presence' (2015: 252), drawing not so much attention, as Vincent Miller shows, to information or content, as to the actual '*process* of communication' (2008: 394, original emphasis). This phenomenon led to an increased focus, not only among celebrities, on 'connected presence' which means that 'simply keeping in touch may be more important than what is said when one actually gets in touch' (Licoppe and Smoreda 2005: 321). This notion of a 'connected presence' is crucial within the interpretation of selfies, as it establishes a relation between practices of presence construction, which are akin to self-portraiture and circulation and communication strategies, which are characteristic of the selfie.

Selfies can be said to form part of a wider phenomenon to do with social presencing. Selfies are in fact usually produced for others not only to look at but also to participate in. To facilitate relatability, selfies are often stylised, cartoon-like. In this context, it is interesting to look at Nick Couldry's use of the term presence to indicate a set of 'media-enhanced ways' through which 'individuals, groups and institutions put into circulation information about, and representations of, themselves for the wider purpose of *sustaining a public presence*' (2012: 50, original emphasis). It is in fact the relatable and epistemic quality of the selfie that defines its success in producing value within the internet of things. The selfie's stylised dimension is what allows for identification, prompting us to write ourselves into the algorithm that interprets us and continues the work of circulation for us.

It is important to remember that the construction of presence through the selfie occurs both individually and collectively. As Paul Frosh suggests, social media such as WhatsApp and Snapchat connect interlocutors more closely than conventional means. Social media in fact, to use his words, draw 'images and their referents into the immediate moment of discursive interaction' bringing the 'now' of the photo being taken and the 'then' of the photo being viewed even closer together than in traditional self-portraiture (2015: 1609), so much so that one's 'here' and another's 'there' could be described as connected and yet also continuously fluctuating (Garcia-Montes, Caballero-Munoz and Perez-Alvarez 2006). This phenomenon acquires a particular significance in relation to the fact that, as Selfiecity has shown, it is often the very private moment of self(ie)-creation that the selfie tends to capture as if to say: 'see me showing you me' (Frosh 2015: 1610). The selfie therefore not only exhibits the subject in the act of constructing themselves for or even as an other, it also creates the conditions of relatability for others to invest into the subject in the first place. The closer to the present (to the creation of the selfie) this is, the stronger the impact of the selfie.

Frosh points out how in photography theory there is a tension dividing scholars between those who have 'an ontological commitment' to the 'essence' of the medium, which tends to privilege the image in itself as the object of analysis, versus those who also consider the production of the image. For him, there is a tension between the photograph as an 'aesthetic object' and a 'sociotechnical practice', which he notes is also evident in debates in contemporary photography (2015: 1608) that refer to the 'networked image' (Rubinstein and Sluis 2008) and to algorithmic photography (Uricchio 2011). For Frosh the selfie encapsulates this duality, in that it constitutes a 'gestural image' to be understood not only in visual terms but also for its 'kinaesthetic sociability' (Frosh 2015: 1608). So, he suggests, the selfie is both 'mediating' and 'mediated' (1610) which in turn indicates that the selfie needs to be interpreted both as medium and content. For these reasons, the selfie best captures how people wish to represent themselves in the experience economy, operating at once as a construction of a present (in time), a presence (or set of relations in space and time) and a representation of sorts (an image or object of circulation) of a self that is continuously shifting and expanding into an emergent and even-changing multitude with a growing social and economic value. Thus, not only the selfie is not a selfie unless it is circulating through social media (Raymond 2021: 6) but also the selfie is not a selfie unless it is recognisable within the Internet of Things.

Selfies form complex systems in which the relationship between self, network, including often also a mirror, and device can be best understood in terms of the concept of assemblage, a term introduced by Gilles Deleuze and Félix Guattari in *A Thousand Plateaus* (1988). It is known that the English term assemblage does not reflect the fact that the original French term *agencement*, 'to arrange, to lay out, to piece together', refers less to a grouping or gathering than an arrangement or lay out (Nail 2017: 22). The term implies 'a multiplicity' that must be considered 'neither a part nor a whole' (23) where what lies 'in between' (Ibid.) the elements is just as crucial as the assemblage itself (Ibid.). In fact, 'emergent properties' or 'properties of a whole caused by the interactions between its parts' (DeLanda 2016: 9) is a defining characteristic of assemblages in that in assemblages, the elements of these emergent wholes maintain their autonomy so that they can 'be detached from one whole and plugged into another one, entering into new interactions' (10).

Selfies entail a contingent identity in that each of them is an individual entity, representing, or presenting back the subject as an individual presence. However, selfies also generate social presence through tagging and/or hashtagging. In this sense, selfies are part of wider assemblages formed by multiple identities which have been grouped together. Within these assemblages each selfie is both an individual entity *and* part of an emergent multitude, occurring in a *now* that is continuously and often repetitively represented (or presented back) in time precisely so that the self can continuously reform itself both as a relatable subject and an interpretable object. It is the operation of this assemblage that is ultimately transforming the self from a subjectively created to a mass-produced and collectively experienced commodity. This technologically assembled self, which is time and again reduced to a product to be part of the experience economy, within the internet of things, constitutes a new form of self-portrait in which the subject acts as an assemblage of social presence. This new form of self-portrait generates a novel kind of value which is based on relatability, and the consequent ability to influence others, producing a new form of social capital that is both influencing and indeed also being influenced by the multitude.

The aesthetics of the selfie

A number of works could be read as predecessors to some of the problematics explored by the artists analysed in this chapter. Among these is *Life sharing* (2000–3), by Eva and Franco Mattes which exhibited the build-up of personal data we accumulate in our everyday life transactions as a public artwork. *Life Sharing*, which has been described as a 'radical gesture of self surveillance' (Connor, Dean and Espenschield 2019: 146), saw the artists make the content of their computer available on a website, including emails and bank statements, for a period of three years. Blurring the public and private spheres of life (Ibid.: 57), *Life Sharing* anticipated a number of trends that are also common in the works discussed in this chapter, namely the appropriation and exhibition of personal data as a form of art, and the subsequent analysis of this data, including also, in this case, the use of traffic logs, as a way to illustrate the behaviour of data, algorithms, and platforms used to produce and visualise them. This work operates as a powerful reminder that what we produce digitally can and indeed often is appropriated by third parties for purposes which have nothing to do with the original intent behind the production of the data. In this sense selfies are information clusters that form part of multiple and often conflicting assemblages.

Selfies are often cross-referential, in that they refer to other selfies, and involve appropriations of images. Appropriation is a distinctive art form and a number of artists used appropriations, such as Hans Eijkelboom who, in *My Family Series* (1973), posed as the father figure next to a number of mothers with their children, or Yasumasa Morimura, who inserted his face and body into self-portraits and portraits of other artists, such as Greta Garbo in *Self-Portrait – Greta Garbo* (1996), as well as Leonardo, Dürer, Caravaggio, van Gogh in a number of other works. Likewise, Martin Parr produced a series of what he called *Autoportraits*, which he published in a homonymous book (2000), displaying thirty years of artworks, including a number of self-portraits, featuring him with celebrities. Another artist whose works famously consists of appropriations is Richard Prince who has been re-photographing well-known images and Instagram posts by his family as well as complete strangers, including models and celebrities. At the heart of his work is the recontextualisation of well-known images such as the Marlboro cigarette adverts featuring the Marlboro Man originally photographed by Sam Abel. In *New Portraits*, which was shown at the Gagosian Gallery in London in 2015, after being first shown in New York in 2014, he used Instagram photos and selfies made by strangers, including some celebrities such as Kate Moss and Pamela Anderson, in which the only alteration to the images consisted of his own comments and hashtags. His work, which often raises complex ethical and legal questions, exemplifies the copy-cut-paste culture that characterises selfie production.

Another work anticipating some of the problematics explored by the artists discussed in this chapter is Petra Cortwright's *VVEDCAM* (2007) which used YouTube as a medium, adopting metadata as a form of 'readymade' (Connor, Dean and Espenschield 2019: 242). In this performative work the artist appears as a computer user clicking or typing while staring at her webcam, seemingly unresponsive to what she is looking at. At the same time, through the interface, the viewer sees the artist's image surrounded by the pre-set standard effects that she is clicking on, including dancing pizzas, puppies and kittens. Both a subject and an object, performer and image, Cortwright used a series of keywords in this work aimed at attracting viewers looking for offensive materials, which eventually led YouTube to take down the video in 2010. The work constitutes an early reflection about the voyeuristic and

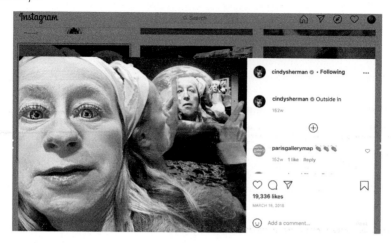

Figure 5.1 Screenshot of Cindy Sherman, 'Outside in', by permission of the artist and Metro Pictures, New York. Screenshot taken of the app by Gabriella Giannachi.

manipulative nature of self-production through social media platforms in which the user appears simultaneously in the work as a performing subject *and* a malleable object, subject to the gaze, manipulation, and even abuse of others.

Cindy Sherman, whose cut-outs and film stills I discussed in the last chapter, produced a range of cartoon-like selfies which were created through apps like Facetune, Perfect365, and YouCam Makeup, and which present some interesting features that are important to consider when analysing selfies. Made specifically for the medium rather than with a physical manifestation in mind that could one day be shown in a gallery (Becker 2017), these selfies, which Sherman started to produce in May 2017, do not necessarily represent events that took place but rather, like the figures in the cut-outs and film stills, intend to portray, in the tradition of the tronie, stereotyped and cartoon-like figures of women. The images illustrate how appearances are shaped through technologies of cultural production. Sherman's selfies deliberately distort social media conventions, producing figures which appear lost, lonely, and wrapped in their own world. Typically, her 'Outside in', posted on 18 March 2018 and liked, at the time of writing, by 19,336 people, sees her seemingly standing on the surface of the moon, and, using an iPad and a mirror, creating an endless series of self-reflections against a backdrop showing planet earth. The title, in reference to the mirroring act shown in the work, indicates the direction of the image, moving in on planet earth but also moving in on her 'self'.

Building on Mendieta's *Untitled (Facial Cosmetic Variations)* (1972), in which Mendieta's face is deformed by make-up, stockings, and creams, denouncing the reduction of women to products, Julia SH and Nic Sadler, also known as @SHSadler, have drawn attention to the manipulation behind social media representations and to the consequent commodification of the self. In a series known as *Fresh Meat* (2019), @SHSadler denounced the fabrication of beauty standards to do with self-imaging and confronted the dehumanising process created through it by showing faces of men and women from various ethnicities, heavily made up, and covered by transparent plastic, with names and price tags, placed on trays that recall the ones commonly used by supermarkets for the sale of meat produce. Here, @SHSadler exposed the outcome of the commodification of the subject, aimed at turning subjects into decodable and tradeable commodities.

An artist whose highly political work has been crucial in exposing how social media operate is Constant Dullaart who, famously, in *High Retention, Slow Delivery* (2014) bought 2.5 million fake Instagram followers and distributed them among a selection of art-world Instagram accounts, including those of Ai Weiwei and Hans Ulrich Obrist. *#Brigading_Conceit* (2018), exhibited at *All I Know Is What's On the Internet* at the Photographer's Gallery in London in 2018, consisted of a series of sim cards which Dullaart had bought on an industrial scale, and which had been used to register phone-verified accounts but were now sold for scrap. The cards have been described as a 'brigade of artificial identities in the internet, ready to be deployed at a moment's notice' (McMullan 2018). These works, as well as, in Axelle Van Wynsberghe's words, his earlier work *The Possibility of an Army* (2015), exploring the creation of digital identity, denounce the industry of social media platforms, showing that 'it is important to ask deeper questions about how identity and data are related, and how our identity becomes "liquid" through processes of social quantification' (2018). Thus, for Van Wynsberghe, *The Possibility of an Army* 'illustrates the intrinsic relationship between surveillance, data gathering, and the attention economy' (2018). Here, Dullaart presents digital identity as a form of currency, having enlisted volunteers to open Facebook accounts with the names of the soldiers of the Hessian Army, an army of mercenaries hired by the British in the eighteenth century who fought in a number of wars, including the American Revolutionary War (1775–83). Dullaart's works expose the politics of social media identity production, denouncing its economic implications, and exhibiting the apparatus behind its cultural production.

The works described in this chapter tend to represent the subject as it constructs itself into an image, caught in a performative process that is captured and broadcast by a medium, often with the intent of generating a form of social co-presence. During this process, the subject becomes social data, digital social capital. Hence these works make explicit the poses, make-up, apps, descriptive captions, that are used to shape the self into data, evidencing the manipulation, fabrication, and production of the data. Herewith, these works illustrate the operation of the practices that transform the subject into a product, a commodity, whose distribution is defined by processes of both pre- and post-production that the selfie affords us to perform.

Community and museum selfies

Given the growing popularity of selfies, it is not surprising that selfies have become increasingly common in art and heritage museums as well as in other cultural organisations, usually, but not exclusively, as a strategy for engagement. Nowadays museums in fact often encourage visitors to take selfies as part of a wider process of 'identity work' (Kozinets et al. 2016; Falk 2009), a term which refers to the 'processes through which we construct, maintain, and adapt our sense of personal identity, and persuade other people to believe in that identity' (Rounds 2006: 133). A number of community-oriented projects have, likewise, used selfies to raise cultural and social awareness among various social groups. While this chapter does not discuss them in great detail, it is worth mentioning, for example, Ayona Datta's research into the case of Indian women in the outskirts of Delhi who took selfies or 'Wishfies – Wish Fulfilment Selfies' consisting of self-portraits with people who inspired them such as Pina Bausch, Guru Dutt, Susan Sontag, as well as Phantom, Asterix, Obelix, and other fictional, mythological, or religious figures, including Krishna. Datta was a member of the 'Gendering the Smart City project' for which she

was researching the lives of young women living in slum settlements in the outskirts of Delhi. For this project, she created a WhatsApp group in which she also asked eleven women to send in diary entries as they travelled from home to the city over a period of six months (2019). These entries offer a great insight into how these women have chosen to present their cultural legacy, showing that selfies have been, like other forms of self-portraiture, used for self-imaging and social presencing in a cultural context.

More and more often, selfies are nowadays used as a strategy for exploring collections both in the museum and online. Google Arts and Culture, for example, launched a tool that allows users to explore its platform, hosting millions of artefacts and artworks, through 'a fundamental artistic pursuit, the search for the self … or, in this case, the selfie' (Luo 2018). The 'experiment' matches one's selfie with art from the collection on the Google Arts and Culture site (Ibid.), allowing users to determine the legacy of their own selfie within art history. Other museums have also used selfies as a way to encourage visitors to explore self-representation as a form of creative practice. Thus, for example, *Self Composed*, exhibited at the San Francisco Museum of Modern Art in 2016, invites visitors to arrange personal objects onto a glass table which then produces an image that they can re-post with the hashtag #SelfComposed. The work, created in collaboration with an Adobe team, can be described as a kind of photo booth. At the point of writing, this work is one of the most popular features in the newly redeveloped museum, probably also because it makes it possible for visitors to print their creation and upload it to the server so that it could be saved and shared widely online.

Recently, museums have started to explore selfies as an exhibition topic as well as a form of installation. For example, the video installation *National #Selfie Portrait Gallery* at the National Portrait Gallery in London, curated by Kyle Chayka and Marina Galperina in 2013, consisted of an installation of nineteen emerging artists from the EU and the US who had created short videos engaging with the selfie which were displayed on two screens and spanned from confessionals to humorous exhibitionism. Another significant exhibition of selfies was *From Selfie to Self-Expression*, held at the Saatchi Gallery in 2017, and organised in collaboration with Huawei, which showcased Raphael Lozano Hemmer's *This Year's Midnight*, originally shown at bitforms gallery, New York City (2012), an interactive installation showing visitors' own images reflected in a screen with plumes of what looks like white smoke or fog appearing in the image from their eyes. The title is the beginning of a poem by John Donne, 'A Nocturnal Upon St Lucy's Day, Being the Shortest', which references St Lucy's Day, 13 December, the patron saint for the blind. The work prompted many visitors to take selfies, including selfies that also showed other artists taking their own selfie in front of the work.

Raphael Lozano Hemmer's *Zoom Pavillion*, developed in collaboration with Krysztof Wodiczko, was originally shown at Museo Universitario Arte Contemporaneo, Mexico in 2015 and Art Basel in 2016. The work is an interactive audio-visual installation featuring twelve computerised surveillance cameras which capture the public and show its movements through a range of immersive projections. Using face recognition algorithms, blob tracking, and previous frame subtraction algorithms to detect the visitors' movements, the platform broadcasts the public as it moves through the exhibition space in real time. Informed by rules against public gathering in Poland, where Wodiczko grew up, the piece constitutes, according to the write-up on the website of Lozano Hemmer (n.d.), 'an experimental platform for self-representation and a giant microscope to connect the public to each other and track their assembly'. The work, creating a kind of live feedback or live archive (Giannachi 2016), is in a constant state of flux. While in the work the

Figure 5.2 Rafael Lozano-Hemmer in collaboration with Krzysztof Wodiczko, *Zoom Pavilion*, 2015. Courtesy Rafael Lozano-Hemmer.

focus of the cameras is dictated according to proximity, which is considered suspicious and prompts a close-up on the screens, it is clear that the work shows how our being in the world is increasingly interpreted in real time through our expressions and behaviour.

Finally, the exhibition showed Christopher Baker's *HelloWorld! Or How I Learnt to Stop Listening and Love the Noise* (2008), a multi-channel multimedia installation comprising thousands of video diaries collected from the internet, and *Selfie Seer* (2017), literally a sea of selfies generated by museum visitors in the gallery in real time when using the #saatchieselfie hashtag and gathered from social media. *HelloWorld! Or How I Learnt to Stop Listening and Love the Noise* (2008) in fact consisted of 5000 videos featuring an individual speaking to imagined audiences. *HelloWorld! Or How I Learnt to*

Figure 5.3 Christopher Baker, *Selfie Seer*, 2017. Courtesy of Christopher Baker.

Stop Listening and Love the Noise and *Selfie Seer* are both archival in nature and explore how data-gathering technologies produce instant feeds. Here, the viewer is simultaneously looking at an artwork and reshaping it by participating within it, caught in a consumption loop in which their own presence is instantly processed so that it can become part of the assemblage formed by the multitude of voices that exist online.

While selfies are becoming more and more common in the museum, bespoke organisations facilitating selfie creation have also emerged, such as London's Selfie Factory, charging just over £10 for people of all ages to take their selfies in a range of quirky environments, such as a pink tube train and a bath full of balls. Selfies, both images and videos, taken during the sixty-minute pop up experience can then be uploaded onto Selfie Factory's own Instagram site for all to see. Likewise, the Museum of Ice Cream, which opened in the United States in 2016 and was designed, according to its own website, to 'provoke imagination and creativity, primarily to create 'beautiful and shareable environments that foster IRL interaction and URL connections' (2020), became an Instagram sensation. Specific exhibits too became very popular on social media, such as the *Rain Room* by rAndom International, seen at the Barbican in 2012, and 29 Rooms, Refinery 29's pop-up installation, featuring, respectively, a curtain of rain that paused when people walked beneath it, and which travelled all over the world, and a snow globe people could take their photo in. Interestingly, rAndom International featured the theme of the self-portrait in a number of their works, such as *Self-Portrait* (2010), a screen that created a large scale representation of the people standing in front of it, which, however, faded as soon as it appeared, *Future Self* (2012) which presents viewers with their body image as small points of light, and *Self and Other* (2016) in which users produce a reflected image which follows them, both familiar and other to them.

Performing selves in character on social media: the case of Amalia Ulman

Amalia Ulman's work includes performance, video, photography, installation, and net art. Focusing on gender stereotypes, many of her works offer explorations into social anxiety and self-expression. One such work was *Excellences & Perfections* (2014), a four-month performance which took place on Ulman's Instagram account, via a series of posts consisting of images accompanied by texts and strings of hashtags (see Ulman 2014a). The piece consists of three parts: Innocence, Sin, and Redemption. For these parts, Ulman fabricated a fictional character who acted as three different personae. These were: a 'cute girl', a 'sugar babe', and a 'life goddess'. In the first section, Ulman is seen leaving her boyfriend and goes to LA to become a model. In the second one, she becomes socially isolated, takes drugs and goes into a rehabilitation clinic. In the third one, she practices yoga, diets, and undergoes breast surgery. The three sections have a different look, with the colour scheme changing from pink and white to black and white and then back to colour, almost like a set change in a theatrical performance.

The piece, which was very popular and attracted roughly 65,000 followers, brought together questions surrounding the veracity of performance documentation, identity construction through media, and the use of social media as a distribution platform. As in Hershman Leeson's performance of *Roberta Breitmore*, audiences stumbling across Ulman's piece generally thought, at least at the time or the original broadcast, that her posts were authentic. Moreover, in both cases the public's action, and, in Ulman's case especially, their comments to her posts, became part of the documentation of the work. In other words, the public was not only participating but also being unknowingly

Figure 5.4 Amalia Ulman, *Excellences & Perfections (Instagram Update, 24th August 2014).* Courtesy the Artist & Arcadia Missa.

implicated within the work though, generally, they had no idea that the work had been pre-scripted and was in fact following a pre-defined scenario (Smith 2017: 84). Over time, the posts become more and more intimate (for example, Ulman can be seen crying in a video), prompting more and more personal comments from her followers. Ulman, who had deliberately shaped her 'online presence/narrative to show how easy it is to manipulate an audience through images' (in Black, Shields and Ulman 2014), teased out different behaviours in her audience showing also how predictable and repetitive online commenting tends to be.

The personae Ulman created for the three parts all correspond to generic types. The first part starts on 19 April 2014. The first image Ulman posted online, Part I, sees her commenting 'Excellences and Perfections', making it clear that the posts that would follow were part of a titled event of sorts. In Part I, Ulman interprets a 'cute girl', publishing images of her feet, painted nails, tights, make up, and kittens. Here she claims to have become a 'cute, pink, grunge, blonde, LA tumblr girl, the indie girl who has only read JD Salinger, the American Apparel model, pastel colors, pink nipples, and rabbits. Cats, pale models, kawaii, violence, flowers, bondage, bruises' (in Black et al. 2014). The images and texts are quite stereotypical such as the image of cosmetics with the writing 'I love clothe I wear, things I do, and way I live' published on 22 April 2014, which was liked by the curator Hans Ulrich Obrist.

After a week of posting images, including also ones of pretty food and clothes combinations, probably because Ulman was seen modelling some swimwear (as indicated by the post on 10 May 2014, 'so happy I received this set from #peachjohn'), Ulman claims that she started to receive offers to be photographed by a professional photographer in the line of Urban Outfitters and American Apparel (Ulman 2014b). This led her, like

many of the other girls she was basing her character on, to model for an unpaid photo-shoot 'Cos girls wanna get their portrait taken. For free, of course' (Ibid.). While receiving comments by the public at large, Ulman also started to receive feedback, in the form of likes or comments, by other artists, like Petra Cortwright, for example, who on 14 May 2014 commented 'your instagram colour palette is on point'.

In the second part, Ulman was seen moving to Los Angeles to become a model. At this stage, she published posts which saw her splitting up with her 'High School boyfriend', with the aim to 'change her lifestyle', though she was then seen running out of money because she was not able to find a job. During this phase, Ulman became increasingly 'self-absorbed in her narcissism', looking for dates, until she finally got 'a sugar daddy', which then led her to become depressed, and start to do drugs, but also get 'a boob job because her sugar daddy makes her feel insecure about her body' (Ulman 2014b). In this part her language changes and the posts are darker. Thus on 27 July 2014 she posted a bathroom picture showing her dark hair saying 'ok done bak to #Natural cuz im sick of ppl thinkin im dumb cos of blond hair., srlsy ppl stop hatin!how u like me now?' The images posted also often show her in pain, even hurt, so that on 5 August 2014 for example a follower called dydelrio92 commented, somewhat after the original performance, 'I see the hurst. Possibly going for a fall, hitting rockc bottom in the part?'

Allegedly, Ulman's inspiration for these darker and more confessional posts was the actress Amanda Bynes whose drug abuse and mental health problems cut short her acting career. Ulman was specifically interested in the way that trolls, in her words, 'gorge on her disgrace. The sadder she is the happier is the troll. And that's what I wanted for myself. I wanted the audience to feel uncomfortable after desiring something that was inherently wrong: wishing other's failure' (Ulman 2014b). In the end, Ulman's character is seen experiencing a breakdown, but then 'redemption takes place, the crazy bitch apologizes, the dumb blonde turns brunette and goes back home. Probably goes to rehab, then she is grounded at her family house' (Ibid.). Interestingly, Ulman noted that the more depressed she became, the more 'acute' the trolling (Ibid.), a clear finding exposing how digital communities treat so-called social media celebrities at the point when they are perceived to be at their weakest.

During the third part Ulman was seen recovering. The hashtags, in this phase were '#health, #juices, #interiordesign, #yoga, #simple, #family'. Thus, Ulman noted, 'I posed with a random baby who I had said was my cousin, posted photographs of breakfast I had never eaten'. During this phase, she stated, 'The narrative hinted to various ideals of perfection and salvation: Gwyneth Paltrow's Goop, Miranda Kerr organic cosmetics, and yoga selfies'. The colour palette of the images changes radically, showing also calming furniture combinations, as well as kittens, flowers, positive texts, and healthy foods, aimed at proving to her followers that her life has improved. Here, Ulman appeared as a brunette 'whose boob job had been concealed under a flowery sari shirt'. With a new boyfriend, she is seen on holiday, 'saved'. Taking more time between updates, she suggested that she 'had been sent to a reformatory with no Internet access' and waited around two weeks 'to post an apology', which, interestingly, received 213 likes (Ulman 2014b). The last slide is blank, and the comments left by followers all seem to be aware that they witnessed or even had become implicated within a performance of sorts.

Ulman's Instagram posts were mainly taken while she sneaked into hotels and restaurants in Los Angeles and posted *as if* they documented her everyday life. Ulman in fact had adopted commonly used strategies for posting, including those usually implemented by fashion influencers, prompting followers to respond in fairly predictable ways. Thus,

in an interview she suggested: 'The idea was to bring fiction to a platform that has been designed for supposedly "authentic" behavior, interactions and content' (in Gavin 2015). Gaze, Ulman states in relation to this work, is a 'cultural construction' (in Black et al. 2014). Her work thus showed how Instagram posts can be constructed to elicit predictable responses. As Michael Connor suggests, here, 'through judicious use of sets, props, and locations', Ulman in fact staged 'a consumerist fantasy lifestyle' (2014). Ulman's Instagram account is therefore a stage whose audiences are manipulated into believing a fantasy simply, in her words, through 'the use of mainstream archetypes and characters they've seen before' (in Gavin 2015).

Ulman was one of the first artists whose social network-based art entered top institutional galleries. Thus, in 2016 *Excellences and Perfections* was selected to be included in the group exhibition *Performing for the Camera* at Tate Modern, London (18 February– 12 June 2016). The exhibition, which examined the relationship between photography and performance, brought together over 500 works spanning 150 years from the invention of photography in the nineteenth century to the selfie-culture of today. The work was also part of the exhibition *Electronic Superhighway 2016–1966* at Whitechapel Gallery in London (2016). Among other themes, the Tate exhibition explored, as the title suggests, the relationship between performance and documentation, ephemeral art and its remains, looking into how artists frame the work as documentation.

In an interview with Tate curator Catherine Wood about the relationship between performance and documentation in her work, Ulman noted that she thought 'these things are kind of simultaneous', suggesting that 'because of the Internet, the performance archives itself, and the moment of performance is when the image is uploaded first and people react to it first'. For Ulman, 'as soon as a photograph is uploaded online, the performance and its archive are already the same thing' (in Giannachi and Westerman 2017: 96). In *Excellences and Perfections* there is a collapse therefore between art and its documentation that is symptomatic of the collapse between art and life, but also between the physical and digital, object of art and communication strategy. Ulman's provocative piece not only draws attention to the commodification of the female body and the role-play often adopted by teenagers to construct their online identity, but also to the role played by society more widely, and social media more specifically, in influencing and even shaping our lives. Far from offering a white canvas for the representation of identity, social media reconstruct people's identities into types that are recognisable by the Internet of Things. In this sense, the selfie ultimately documents not only the performative dimension of the identity we construct for and with others, but also the moulding of our selves into the predefined personae that is imposed onto us so that we may become interpretable and tradable data.

The algorithmic construction of the subject in Erica Scourti's works

Like Ulman, Erica Scourti combined performance, digital media, the web and video to produce highly politicised artworks, often denouncing the ways in which personal data are exploited online. Her *Facebook Diary* (2008) was a performative project in which she tried to capture her networked life by using cut up parts of postings from some of her friends' Facebook pages. The work, recounted through a series of YouTube videos, makes evident the operation of social media as a field of self-imaging.

Her subsequent work *Life in AdWords* (2012) involved her keeping a diary by email and posting it to her Google account. These emails were then processed by algorithms

Sort: Preset / Date / Alphabetical / Plays / Likes / Comments / Duration

Life in AdWords: January 2013
1 year ago

Life in AdWords: December 2012
1 year ago

Life in AdWords: November 2012
1 year ago

Life in AdWords: October 2012
1 year ago

Life in AdWords: September 2012
1 year ago

Life in AdWords: August 2012
1 year ago

Figure 5.5 Erica Scourti, *Life in AdWords*, 2012–13, screenshot of Vimeo album. Courtesy Erica Scourti.

and transformed into a list of keywords, creating also some web cam videos based on which she read out the keywords that were attached to the ads in her browser. The result is a personal, almost confessional denunciation of identity management, a rendering of the self purely though its commercial potential value. In this work, Scourti in fact addressed the interfacing of personal and collective experiences though the internet within the digital economy, showing 'the way we and our personal information are the product in the "free" internet economy' (Garrett 2013). Noting that in her work she wanted to 'make visible in a literal and banal way how algorithms are being deployed by Google to translate our personal information [...] into consumer profiles, which advertisers pay access to' (in Garrett 2013), Scourti indicated that she wanted 'to experiment with a way of writing a life story that operated somewhere between software and self, so that, as Donna Haraway says "it is not clear who makes and who is made in the relation between human and machine"' (in Ibid.). Here, Scourti exposes how Google tracks individual users through email, calendars, and web browser histories, following their daily movements, so as to pass this data to advertising companies.

This work, in her words, is 'based in me talking to myself (writing a diary), then emailing it to myself and then repeating to the mirror-like webcam a Gmail version of

Erica Scourti
20 October

Weight Gain
Emotional Eating
Blood in Poop
Nervous Breakdown

Like · Comment · Share

Doctor appointment? Xxx
20 October at 11:15 via mobile · Like

TMI
20 October at 11:34 · Like

Figure 5.6 Erica Scourti, *Life in AdWords*, 2012–13, screenshot of Facebook update. Courtesy Erica Scourti.

me' (in Garrett 2013). Like Hershman Leeson and Ulman, Scourti researched how we construct identity through signifiers. She also showed how our identities are now immediately manipulated to produce a commercial gain, showing how information gathered online is converted into consumer profiles. As Annet Dekker indicates, Scourti in fact 'uses social-media networks as raw material' by probing and testing their data-processing algorithms to create 'self-portraits for a hashtagged age' (2016). Thus, in an interview with Dekker, she noted that in her work 'there is no position of purity, no space to speak from where you too are not also implicated' (in Dekker 2016). In this sense, she added, 'I'm observing myself as a subject aware of her own entanglement in sociotechnical infrastructures, using my own personal experience as a starting point' (in Dekker 2016).

In *Dark Archives* (2016) Scourti used social media and networks as raw materials for her work. Here, she uploaded her entire fifteen-year personal media archive consisting of photos, videos and screenshots to Google photos, inviting also a group of writers to search her archive, and identify what may have evaded classification (see Het Nieve Instituut 2016). These findings were then matched with a new series of videos from the archive that created new materials for the archive (see Dekker 2016). In this work Scourti used her own archive, other people's data, and again algorithms to identify what escapes Google search engines. Questioning notions of data collection and shared authorship, she challenged notions of individual memory but also, again, the relationship between art and the document, the physical and the digital, by exploring the problem of access to mass storage and personal data, drawing attention to the implications of monetising individuals' personal data.

As Scourti's work shows, the selfie is likely, in years to come, to play an increasingly significant role in the Internet of Things and within the Economy 4.0, to the point that they may, one day, become not only data selves but also intelligent objects. In Industry 4.0 smart products must in fact become uniquely identifiable so that they can be located at all times, know their own history, status and alternative routes to achieving their target state. The selfie, in this context, may still be seen as a strategy for self-imaging and

communication, or presencing even, but, as Scourti's work shows, it is undoubtedly also a strategy to turn individuals into tradable commodities. As we document our everyday lives through selfies to construct our 'self' and acquire a presence or even a social presence globally, these selfies become integral to the commodification processes that extract value from our 'self', now a resource, so that we may continue to operate as prosumers within the internet of things.

Cached Collective

Cached Collective, an international group of creatives from a range of backgrounds, including engineering, experience design, poetry, and programming, have been exploring the degree to which technology not only affects, but also exploits the data we produce in our everyday lives. The Collective draw attention to the fact that everything we type or submit online is analysed to produce a commodifiable profile. Thus, the Collective suggest, businesses make assumptions about our behaviour by reading our social media posts, analysing our choice of words, syntax, sentence structure, etc. to arrive at creating psychological profiles that describe our personality and habits in great detail. What is at stake in their work is what Rob Horning describes as a 'data self' (2013) which moves away from notions of an authentic, or even performed self, to embrace the idea of a 'post-authentic self' that excludes the subject's awareness of their own identity. For Horning, the 'data self' entails a number of characteristics which include the fact that the self is defined by filters, algorithms, and network positionality and 'what can't be shared and processed is "unreal", irrelevant to identity' (2013). Thus, he notes, the data self is therefore 'quantitative, not qualitative, so it can be grown' (2013). In other words, the data self must be shared and commented on, so that it may become part of wider data assemblages whose ownership is no longer with the subject who generated the selfie in the first place.

Cached Collective's work *Data Selfie* (2017) explores our relationship to the online data we leave behind by rendering the interpretation of this data visible to us. In fact, on this occasion, the 'self' that is represented to us is defined both by the data we produce,

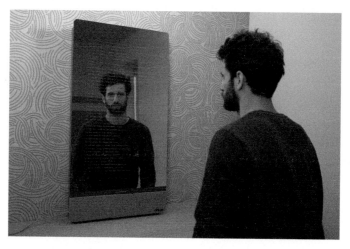

Figure 5.7 Cached Collective, *Data Selfie*, 2017.

and the data captured as we are under surveillance. In representing the interpretation of this data to the public, Cached Collective aim to show how our data profiles, the ones that have been created by our online behaviour, compare to the profiles made by the machines at Facebook, Google, and other commercial companies; in their words, 'the profiles we never get to see, but unconsciously create' (2019), and in doing so challenge the viewer to reflect about the control exerted by social media by asking the following questions: 'Why does Facebook need your phone number or your phone contacts or the data from your WhatsApp account? Why does Facebook track the time you spend looking at the posts in your news feed? Is the sole purpose of this data gathering to serve us more relevant ads? Is there something else afoot?' (Ibid.).

Cached Collective describe *Data Selfie* (2017) as 'an application that aims to provide a personal perspective on data mining, predictive analytics and our online data identity – including inferred information from our consumption', showing how 'in our data society algorithms and Big Data are increasingly defining our lives' and therefore making the public 'aware of the power and influence your own data has on you' (2019). Technically, *Data Selfie* tracks the Facebook activity of anyone who downloads it to show the trace they leave online, evidencing how Facebook's machine learning algorithms employ the data to gain insight into the user's personality. In a review of the work, John Bonazzo notes how the site used personality insights via IBM Watson to identify psychological traits which determine purchase decisions, intent and behaviour, and Tone Analyser which uses cognitive linguistic analysis to identify tones and detect, for example, emotion and social openness, while Apply Magic Sauce predicts users' psycho-demographic traits based on their digital footprints, identifying traits such as satisfaction with life, intelligence, political views, and religion (2017).

When a version of the work was exhibited at the V&A as part of the Digital Design Weekend at The London Design Festival in 2019, Cached Collective members Jon Flint and Joana Mateus helped viewers to discover just how accurately social media algorithms determine our psychometric profile. Visitors would sit at a table in a booth, log in to the *Cached* (Cached Collective 2019) tablet through their Facebook or Twitter profiles to see a mirror activate and explain their actions to them as they are perceived by the algorithm. At the end of the experience the mirror would print out a receipt offering the opportunity to delete all data analysed during the session. In my case, the algorithm identified the degree of my openness, conscientiousness, extraversion, agreeableness, and emotional range, suggesting that I am empathetic and altruistic, that I challenge authorities, I am philosophical, energetic, trusting, influenced by family, prefer quality and comfort in clothes and safety for automobiles, and that I am *not* very likely to be influenced by social media when making purchases. I was surprised how much the system had inferred by my intermittent and conservative use of social media and decided to keep the receipt in my purse to remind myself of what my data currently reveal about my*self* though we all know that another algorithm could probably tell a somewhat different story. While the painterly and photographic self-portraits persist in time, the selfie is very much ephemeral, epistemically fragile, manipulable, capitalisable. But the selfie is not only the image or even its relatability and circulation strategy, it is also the data that are inferred from all the operations involved in its production which are much more persistent over time. It is these data that, within the experience economy, form, usually unbeknown to us, a new type of self-portrait continuously reconstituted as part of a wider artificial intelligence of sorts in which my 'self' becomes plural: a product, commodity, document, assemblage, data for others to use.

Conclusion

This study has traced how the self-portrait changed throughout the centuries, often in response to the introduction of new technologies. Focussing on the practices adopted to define but also, quite literally, perform the self through these technologies, this study has shown how our understanding of what constitutes the self has shifted from an ontological given to a co-produced data assemblage that is a key commodity within the Internet of Things. Not only does the self-portrait include, whether through presence or implied absence, both the artist and the viewer, it also comprises the wider environment of its production. In this sense, the self-portrait is a technology for reproduction.

Many self-portraits analysed in this study were created when the concept of the 'self' did not yet exist in the modern sense of the term. Artists used mirrors not only to create images of themselves, or as a way to identify a given work as a self-portrait, but also as a lens through which to reinterpret the physical world and bring the viewer within the work of art. Artists used cameras for the rendering of the subject as image, or object, and they used video to explore what becomes of the self in and over time. Sculptural self-portraits made possible the rendering of subjects in space and as expanding architectures to be penetrated and inhabited, while the introduction of the selfie brought in circulation and social co-production, resulting in self-portraits, or selfies, which at once represent but also shape the self into commodifiable data. Over time, the self-portrait has become an increasingly open system formed by a range of self-replicating production points, which have turned the self into an entity that can persist in an augmented state, as part of a network, an Internet of Things, an artificial intelligence of sorts. The self in contemporary self-portraiture is often plural, the changeable object of a production instigated by a multitude, an entity that must conform to be relatable.

We know from neuroscience that the neurobiological formation of the self occurs as an ongoing mapping process, continuously merging external and internal processes. In this sense, the self does not exist. It is continuously constructed. Because the self does not exist, it cannot be captured in the present, but only retrospectively, or in anticipation of a process of intentionality. And, because of this, the self is dispersed, edited together to give the impression of the existence of a subject which in effect is not there. In this sense the self-portrait is *where* we construct our self, a laboratory for self-production.

Hopefully, in years to come, new technologies will lead to a more inclusive and environmentally oriented vision of life on this planet which might in turn lead to a new notion of the self that comprises the myriad of entities that cohabit with us. In other words, the future 'self' must be formed by a wider ecology of factors than the human species. As this study shows, the early history of this self re-evolution has already begun

DOI: 10.4324/9780429468483-7

and most of the technologies and strategies we could use to redefine ourselves (medicine, biology, AI, computer science, ecology, environmental humanities, philosophy, and the arts) are already available. Finally, it is time to acknowledge that the self must include a relationship with other species, for, in the end, who or even what are we without them ...

References

Ackerman, J. (1977) Alberti's Light, in I. Lavin and J. Plummer, *Studies in Late Medieval Painting in Honour of Millard Meiss*, New York: New York University Press, pp. 1–19.

Alberro, A. (ed.) (1999) *Two Way Mirror Power: Selected Writings by Dan Graham on His Art*, Cambridge, MA: MIT Press.

Alberti, L.B. (2011[1435]) *On Painting*, ed. and trans. R. Sinisgalli, Cambridge: Cambridge University Press.

Allan, D. (ed.) (1998) *Marc Quinn Incarnate*, London: Booth-Cibborn.

Allen, S. and Nakamori, Y. (eds) (2020) *Zanele Muholi*, London: Tate.

Alpers, S. (1983) *The Art of Describing: Dutch Art in the Seventeenth Century*, Chicago, IL: University of Chicago Press.

Alpers, S. (1988) *Rembrandt's Enterprise: The Studio and the Market*, Chicago, IL: University of Chicago Press.

Anon (1982) Michelangelo Pistoletto, *Standing Man*, London: Tate Pre-Acquisition record, PC10.1, Tate Archive.

Anon (1984) *Penone*, exhibition catalogue, Paris: ARC Musée d'Art Moderne de la Ville.

Anon (1995) Paranoid Mirror, *Northwest Pace*, Autumn 1995, 5, L. Hershman Leeson Papers, M1452, Stanford University Library.

Antin, E. (1974) Notes on Transformation, *Flash Art*, 44–45, April.

Arasse, D. (1982) Les Miroirs de la peinture, *L'Imitation, aliénationou source de vérité*, Paris: Documentation Française, pp. 63–88.

Archimbaud, M. (1993) *Francis Bacon*, London: Phaidon.

Askey, R. (1981) VALIE EXPORT Interviewed by Ruth Askey in Vienna 9/18/79, *High Performance*, 4:1, 80.

Auslander, P. (1997) *From Acting to Performance: Essays in Modernism and Postmodernism*, London and New York: Routledge.

Babias, M., Becker, K., and Goltz, S. (2013) *Time Pieces, Video Art Since 1963*, N.b.k. Berlin, Band 4.

Bacon, F. (n.d.) *Francis Bacon 1950–1975: Paintings: Self-Portraits in Date Order 1969–1980*, London: Artist File National Portrait Gallery.

Baishya, A. (2015) #NaMo: The Political Work of the Selfie in the 2014 Indian general Elections, *International Journal of Communication*, 9, 1686–1700.

Baldwin, J.M. (1895) *Mental Development of the Child and the Race*, New York: Macmillan.

Barilli, R. (1970) Catalogue Entry for Gennaio 70, also in Celant (2011).

Barreras del Rio, P. and Perreault, J. (1988) *Ana Mendieta: a Retrospective*, New York: The New Museum of Contemporary Art.

Barry, C.T., Doucette, H., Loflin, D.C., Rivera-Hudson, N. and Herrington, L.L. (2017) 'Let me take a selfie': associations between self-photography, narcissism, and self-esteem, *Psychology Popular Media Culture*, 6, 48.

Barthes, R. (2000[1981]) *Camera Lucida*, trans. R. Howard, London: Vintage Classics.

Basar, S., Coupland, D., and Obrist, H.U. (2021) *The Extreme Self*, Köln: Verlag der Buchhandlung Walter and Franz König.

Batchen, G. (1999) *Burning with Desire: The Conception of Photography*, Cambridge, MA: MIT Press.

Bauman, Z. (2001) *The Individualised Society*, Cambridge: Polity Press.

Baumeister, R.F. (1998) The Self, in D.T. Gilbert, S.T. Fiske, and G. Lindzey (eds), *Handbook of Social Psychology*, 4th edn, New York: McGraw-Hill, pp. 680–740.

Beck, U. (1992) *Risk Society: Towards a New Modernity*, London: Sage.

Becker, N. (2017) How Cindy Sherman's Instagram Selfies are Changing the Face of Photography, *The Guardian*, 9 August.

Bell, D. and Kennedy, B. (eds) (2000) *The Cybercultures Reader*, London and New York: Routledge.

Benjamin, W. (1940) Thesis on the Philosophy of History, in *Illuminations*, trans. Harry Zohn, New York: Schocken, pp. 245–255.

Berger, J. (1972) *Ways of Seeing*, Harmondsworth: Penguin.

Berkeley, G. (1710) *A Treatise Concerning the Principles of Human Knowledge*, Dublin: Aaron Rhames.

Berti, L. (1973) *Inaugurazione del corridoio vasariano*, Firenze: Galleria degli Uffizi.

Beudert, M. and Rainbird, S. (1975) *Ob/De+Con(Struction): Contemporary Art: The Janet Wolfson de Botton Gift*, exhibition catalogue, Tate, also in Elisabeth Manchester, *Untitled A*, November 2000–September 2001, www.tate.org.uk/art/artworks/sherman-untitled-a-p11437, accessed 12/12/2021.

Birnbaum, D. (2008) *The Hospitality of Presence*, Berlin: Sternberg Press.

Black, H., Shields, D., and Ulman, A. (2014) Do You Follow? Art in Circulation 3 (transcript), *Rhizome*, http://rhizome.org/editorial/2014/oct/28/transcript-do-you-follow-panel-three/, accessed 1/7/2019.

Bogh, M. andFabricius J. (eds) (2017) *Gillian Wearing: Family Stories*, Berlin: Hatje Kantz.

Bogue, R. and Spariosu, M.I. (eds) (1994) *The Play of the Self*, New York: State University of New York Press.

Bonafoux, P. (1985) *Rembrandt: Self-Portrait*, London: Weidenfeld & Nicolson.

Bonazzo, J. (2017) This Chrome Extensions Reveals Exactly How Facebook Uses your Data, *The Observer*, https://observer.com/2017/09/facebook-data-selfie-chrome-extension/, accessed 16/10/2019.

Bond, A. and Woodall, J. (2005) *Self Portrait*, London: National Portrait Gallery.

Borzello, F. (1998) *Seeing Ourselves: Women's Self-Portraits*, London and New York: Thames & Hudson.

Breder, H. and Rapaport, H. (2011) Intermedia: A Consciousness-based Process, *PAJ*, 99, 11–23.

Brietwieser, S. (2001) *Double Life*, Köln: Verlag der Buchhandlung Walther König.

Brouver, M. (ed.) (2001) *Dan Graham Works 1965–2000*, Düsseldorf: Richter Verlag.

Brown, C. (1982) *Van Eyck*, Ithaca, NY: Cornell University Press.

Brown, C., Kelch, J., and van Thiel, P. (eds) (1991) *Rembrandt, The Master and His Workshop*, New Haven, CT: Yale University Press.

Brunet, F. (2009) *Photography and Literature*, London: Reaktion Books.

Buchloh, B. (ed.) (1979) *Dan Graham/Video-Architecture-Television, Writings on Video and Video Works 1970–1978*, Nova Scotia and New York: The Press of the Nova Scotia College of Art and Design and New York University Press.

Buchloh, B. (ed.) (2012[1979]) *Dan Graham: Writings on Video and Video Works 1970–1978*, Zurich: Lars Muller Publishers.

Burkitt, I. (1991) *Social Selves: Theories of the Social Formation of Personality*, London: Sage Publications.

Cadeva, E., Connor, P., and Nancy, J.L. (eds) (1991) *Who Comes after the Subject?*, London and New York: Routledge.

Cala-Lesina, G. (2011) Orlan's Self-Hybridizations: Collective Utopia or Twenty-First-Century Primitivism, *Third Text*, 25:2, 177–189.

Calabrese, O. (2006) *Artists' Self-Portraits*, trans. M. Shore, New York and London: Abbeville Press Publishers.

Caneva, C. (ed.) (2002) *Il corridoio vasariano agli Uffizi*, Siena: Banca Toscana.

Carpenter, E. (ed.) (2008) *Frieda Kahlo*, Minneapolis, MN: Walker Arts Center.

Cary, P. (2000) *Augustine's Invention of the Inner Self: The Legacy of a Christian Platonist*, New York: Oxford University Press.

Case, S-E. (1995) Performing Lesbian in the Space of Technology: Part II, *Theatre Journal*, 47:3, 5–10 and 329–343.

Cached Collective (2019) https://cached.id/#toggle-id-5, accessed 16/10/2019.

Celant, G. (1989) *Penone*, Milano: Electa.

Celant, G. (2011) (ed.) *Arte Povera 2011*, Milano: Electa.

Celant, G., Fuchs, R., and Bertoni, M. (eds) (1988) *Gilberto Zorio*, Torino: Hopeful Monsters.

Cellini, B. (1999[1558]) *The Autobiography of Benvenuto Cellini*, trans. G. Bull, Harmondsworth: Penguin.

Chadwick, W. (ed.) (1998) *Mirror Images Women, Surrealism, and Self-Representation*, Cambridge, MA: MIT Press.

Chapman, H.P. (1990) *Rembrandt's Self-Portraits*, Princeton, NJ: Princeton University Press.

Choi, T.R., Sung, Y., Lee, J.-A., and Choi, S.M. (2017) Get Behind My Selfies: The Big Five Traits and Social Networking Behaviours through Selfies, *Personality and Individual Differences*, 109, 98–101.

Cilliers, P., De Villiers, T., and Roodt, V. (2002) The formation of the self: Nietzsche and complexity, *South African Journal of Philosophy*, 21:1, 1–18.

Clayton, M. and Perov, K. (2019) *Bill Viola / Michelangelo*, London: Royal Academy of Arts.

Cole, B. (1980) *Masaccio and the Art of Early Renaissance Florence*, Bloomington, IN and London: Indiana University Press.

Connor, M. (2014) First Look: Amalia Ulman – Excellences & Perfections, accessed 12/10/2017.

Connor, M., Dean, A., and Espenschield, D. (eds) (2019) *The Art Happens Here: Net Art Anthology*, New York: Rhizome.

Conway, W. M. (1958) *The Writings of Alfred Dürer*, London: Peter Owens.

Cooley, C.H. (1902) *Human Nature and the Social Order*, New York: Charles Scribner's Sons.

Cory, T.S. (2014) *Aquinas on Human Self-Knowledge*, Cambridge: Cambridge University Press.

Couldry, N. (2012) *Media, Society, World*, Cambridge: Polity Press.

Crabbe, J. (ed.) (1999) *From Soul to Self*, London and New York: Routledge.

Crimp, D. (1983) De-synchronisation in Joan Jonas's Performances, in *Joan Jonas: Scripts and Descriptions 1968–1982*, Berkeley, CA: University Art Museum, University of California.

Cumming, L. (2009) *A Face to the World: On Self-Portraits*, London: Harper Press.

Damasio, A. (1994) *Descartes Error*, New York: Avon Books.

Damasio, A. (2003) Feelings of Emotion and the Self, in J. LeDoux, J. Debiec and H. Moss (eds), *The Self: From Soul to Brain*, New York: The New York Academy of Sciences, pp. 253–261.

Danto, A.C. (2004) Darkness Visible, *The Nation*, 15 November 2004, pp. 36–40.

Datta, A. (2019) Indian women from the outskirts of Delhi are taking selfies to claim their right to the city, *The Conversation*, 1/2/2019.

da Vinci, L. (1956[1270]) *Treatise on Painting [Codex Urbinas Latinus 1270]*, vol. 1, trans. P. McMahon, Princeton, NJ: Princeton University Press.

Day, M. (2009) Michelangelo (by Michelangelo): self-portrait discovered hidden in his first painting, *Independent*, 2 July 2009, www.independent.co.uk/arts-entertainment/art/news/michelangelo-by-michelangelo-selfportrait-discovered-hidden-in-his-final-painting-1727988.html

De Girolami Cheney, L., Craig Faxton, A., and Russo, K.L. (eds) (2000) *Self-Portraits by Women Painters*, Aldershot: Ashgate.

Dekker, A. (2016) Erica Scourti: Archiving Our (Dark) Lives, http://aaaan.net/erica-scourti-archi ving-our-dark-lives/, accessed 6/7/2019.

DeLanda, M. (2016) *Assemblage Theory*, Edinburgh: Edinburgh University Press.

Deleuze, G. (1993) *The Fold*, trans. B. Conley, London and New York: Continuum.

Deleuze, G. (1995) *Foucault*, trans. S. Hand, Minneapolis, MN: Minnesota University Press.

Deleuze, G. and Guattari, F. (1988) *A Thousand Plauteaus: Capitalism and Schizophrenia*, trans. B. Massumi, London and New York: Continuum.

Dery, M. (1996) *Escape Velocity: Cyberculture at the End of the Century*, London: Hodder & Stoughton.

Descartes, R. (1986[1641]) *Meditations on First Philosophy*, trans. J. Cottingham, Cambridge: Cambridge University Press.

Dickey, S. (2006) *Rembrandt Face to Face*, Indianapolis, IN: Indianapolis Museum of Modern Art.

Dodwell, C.R. (1973) *Essays on Dürer*, Manchester: Manchester University Press.

Donger, S., Shepherd, S., and Orlan (eds) (2010) *Orlan: A Hybrid Body of Artworks*, London and New York: Routledge.

Downie, L. (ed.) (2006) *don't kiss me: The Art of Claude Cahun and Marcel Moore*, St Helier: Jersey Heritage Trust.

Doy, G. (2007) *Claude Cahun: A Sensual Politics of Photography*, London and New York: L.B. Tauris.

Eccher, D. and Ferrari, R. (1996) *Gilberto Zorio*, Torino: Hopeful Monsters.

Elger, D. (2005) *Andy Warhol: Self-Portraits*, Ostfildern-Ruit: Hatje Cantz.

Elias, N. (1978) *What is Sociology?*, London: Hutchinson.

Falk, H.J. (2009) *Identity and the Museum Visitor Experience*, London and New York: Routledge.

Farris, P. (1999) *Women Artists of Color*, Westport, CT: Greenwood Press.

Featherstone, M. and Burrows, R. (1995) *Cyberspace, Cyberbodies, Cyberpunk*, London: Sage.

Fischer, P. (ed.) (2002) *Ana Mendieta: Body Tracks*, exhibition catalogue, Luzern: Kunstmuseum Luzern.

Flint, K. (2000) *The Victorians and the Visual Imagination*, Cambridge: Cambridge University Press.

Fore, D. (2012) VALIE EXPORT, *Interview*, 9/10/12, www.interviewmagazine.com/art/valie-exp ort#page2, accessed 29/4/2016.

Fortenberry, D. and Morrill, R. (eds) (2015) *Body of Art*, London: Phaidon.

Foucault, M. (1986) *The Care of the Self: The History of Sexuality*, trans. R. Hurley, vol. 3, New York: Pantheon.

Foucault, M. (1988) *Technologies of the Self: A Seminar with Michel Foucault*, L.H. Martin, H. Gutman, P.H. Hutton (eds), Cambridge, MA: University of Massachusetts Press.

Foucault, M. (1994[1970]) *The Order of Things: An Archaeology of the Human Sciences*, London and New York: Routledge.

Foucault, M. (2005) *The Hermeneutics of the Subject: Lectures at the Collège de France 1981–1982*, ed. F. Gros and A.I. Davidson, trans. G. Burchell. New York: Palgrave Macmillan.

Fox, J. and Rooney, M.C. (2015) The Dark Triad and Train Self-objectification as Predators of Men's Use and Self-Representation Behaviours on Social Networking Sites, *Personality and Individual Differences*, 76, 161–165.

Frankel, D. (2003) (ed.) *The Complete Untitled Film Stills: Cindy Sherman*, New York: The Museum of Modern Art.

Freedman, L. (1990) *Titian's Independent Self-Portraits*, Perugia: Leo S. Olschki Editore.

Freud, S. (1933) New Introductory Lectures on Psycho-Analysis, in J. Strachey et al. (trans.), *The Standard Edition of the Complete Psychological Works of Sigmund Freud*, vol. XXII. London: Hogarth Press.

Freud, S. (1999[1917]) Trauer und Melancholie, in GW, vol. X, Frankfurt am Mein: Fischer, pp. 27–46.

Frick, L. (2015) *Personal Data Beginning to Feel Less Sinister*, www.lauriefrick.com/blog/data_less_ sinister, accessed 12/12/2021.

Fried, M. (2010) *The Moment of Caravaggio*, Princeton, NJ and Oxford: Princeton University Press.

Frosh, P. (2002) Rhetoric of the Overlooked: On the Communicative Modes of Stock Advertising Images, *Journal of Consumer Culture*, 2, 171–196.

Frosh, P. (2015) The Gestural Image: The Selfie, Photographic Theory, and Kinesthetic Sociability, *International Journal of Communication*, 9, 1607–1728.

Galansino, A., and Perov, K. (eds) (2017) *Bill Viola, Electronic Renaissance*, Firenze: Giunti.

Garb, T. (2011) *Figures and Fictions: Contemporary South African Photography*, Göttingen: Steidl.

Garcia-Montes, J.M., Caballero-Munoz, D., and Perez-Alvarez. M. (2006) Changes in the self resulting from the use of mobile phones, *Media, Culture and Society*, 28:1, 67–82.

Garrard, M.D. (1980) Artemisia Gentileschi's Self-Portrait as the Allegory of Painting, *The Art Bulletin*, 62:1, 97–112.

Garrard, M.D. (1989) *Artemisia Gentileschi*, Princeton, NJ: Princeton University Press.

Garrett, M. (2013) A Life in AdWords, Algorithms and Data Exhaust. An interview with Erica Scourti, *Furtherfield*, www.furtherfield.org/features/interviews/life-adwords-algorithms-data-exhaust-interview-erica-scourti, accessed 13/10/2017.

Gasser, M. (1963[1961]) *Self-Portraits: from the Fifteenth Century to the Present Day*, trans. A. Malcolm, London: Weidenfeld & Nicolson.

Gavin, F. (2015) Amalia Ulman, *Kaleidoscope* #23, Winter 2015.

Gergen, K.J. (1991) *The Saturated Self: Dilemmas of Identity in Contemporary Life*, New York: Basic Books.

Giannachi, G. (2016) *Archive Everything: Mapping the Everyday*, Cambridge MA: MIT Press.

Giannachi, G. and Kaye, N. (2011) *Performing Presence*, Manchester: Manchester University Press.

Giannachi, G. and Westerman, J. (eds) (2017) *Histories of Performance Documentation*, London and New York: Routledge.

Gianelli, I. and Celant, G. (2000) *Arte Povera in Collezione*, Torino: Charta.

Giddens, T. (1991) *Modernity and Self-Identity: Self and Society in the Late Modern Age*, Cambridge: Polity Press.

Gill, C. (1990) *The Person and the Human Mind*, Oxford: Oxford University Press.

Gill, C. (1996) *Personality in Greek Epic Tragedy and Philosophy*, Oxford: Oxford University Press.

Giusti, G. (1996) *Il corridoio vasariano*, Firenze: Museo degli Uffizi.

Goffman, E. (1990[1956] *The Presentation of the Self in Everyday Life*, Harmondsworth: Penguin.

Goldscheider, L. (1937[1936]) *Five Hundred Self-Portraits, from Antique Times to the Present Day*, trans. J. Bryam Shaw, London and Vienna: Phaidon Press.

Gómez Cruz, E. and Lehmuskallio, A. (eds) (2016) *Digital Photography and Everyday Life: Empirical Studies on Material Visual Practices*, London: Routledge.

Goodyear, A.C., and McManus, J.W. (2009) *Inventing Marcel Duchamp: The Dynamics of Portraiture*, Cambridge, MA: MIT Press.

Gormley, A. (n.d.) *Event Horizon*, www.antonygormley.com/projects/item-view/id/256, accessed 2/11/2019.

Graham, D. (1978a) *Dan Graham Theatre*, Gent: A. Herbert.

Graham, D. (1978b) *Dan Graham Articles*, Eindhoven: Van Abbemuseum.

Graham, D. (1981) *Buildings and Signs*, Chicago, IL: University of Chicago.

Graham, D. and Rorimer, A. (1981) *Dan Graham: Buildings and Signs*, Chicago, IL and Oxford: The Renaissance Society at the University of Chicago and Museum of Modern Art Oxford.

Gram, S. (2013) The Young Girl and the Selfie, *Textual Relations*, http://text-relations.blogspot.com/2013/03/the-young-girl-and-selfie.html, accessed 4/4/2019.

Gray, C. H. (ed.) (1995) *The Cyborg Handbook*, London and New York: Routledge.

Greenblatt, S. (1980) *Renaissance Self-Fashioning: From More to Shakespeare*, Chicago, IL: Chicago University Press.

Greenslade, G. (2017) (ed.) *From Selfie to Self-Expression*, London: Saatchi Gallery.

Grimberg, S. (1998) Frida Kahlo: The Self as an End, in W. Chadwick (ed.), *Mirror Images: Women, Surrealism and Self-Representation*. Cambridge, MA: MIT Press, 83–104.

Groorenboer, H. (2012) *Intimate Vision in Late Eighteenth-Century Eye Miniatures*, Chicago, IL: University of Chicago Press.

Grzinic, M. (2002) *Stelarc*, Ljubliana and Maribor: Maska MKC.

Hachmeister, H. (ed.) (2010) *Ana Mendieta / Hans Breder: a Relationship in Documents*, Dortmund: Intermedia Studies.

Hall, J. (2014) *The Self-Portrait: A Cultural History*, London: Thames & Hudson.

Hanley, J.A. (1993) *The First Generation: Women and Video, 1970–75*, a travelling exhibition organized and circulated by Independent Curators Incorporated, New York.

Haraway, D. (1991) *Simians, Cyborgs, and Women: The Reinvention of Nature*, London and New York: Routledge.

Harter, S. (1999) *The Construction of the Self*, London and New York: Guilford Press.

Harvey, R. (2007) *Scandals, Vandals and Da Vincis*, London: Chrysalis Books.

Hayles, K. (1999) *How we Became Posthuman*, Chicago, IL: University of Chicago Press.

Hershman Leeson, L. (1986) *Confessions of a Chameleon*, Electronic Diary.

Hershman Leeson, L. (2015) Interview with Gabriella Giannachi, 29 August 2015, private archive.

Hershman Leeson, L. (ed.) (1996) *Clicking in: Hot Links to a Digital Culture*, Seattle, WA: Bay Press.

Hershman Leeson, L. (n.d.) File on Lynn Hershman Leeson at SFMOMA archive.

Hershman Leeson, L. (1995) *Paranoid Mirror*, Seattle, WA: Seattle Art Museum.

Het Nieve Institut (2016) *Dark Archives*, https://archiefinterpretaties.hetnieuweinstituut.nl/en/3-erica-scourti/dark-archives, accessed 14/10/2017.

Higgins, E.T. (1996) 'The Self-digest': Self-Knowledge Serving Self-Regulatory Functions, *Journal of Personality and Social Psychology*, 71, 1062–1083.

Hill, G. (2000[1991]) Site re:cite, in R.C. Morgan (ed.), *Gary Hill*, Baltimore MD: Johns Hopkins University Press, pp. 201–208.

Hill, G. (2020) *Momentombs*, Suwon: Suwon Museum of Art.

Hill, G. and van Assche, C. (1993) *Gary Hill*, trans. C. van Assche, Valencia: IVAM.

Holborn, M. (ed.) (2015) *Antony Gormley*, London and New York: Thames & Hudson.

Holmes, O.W. (1859) The Stereoscope and the Stereograph, *Atlantic Monthly*, June, 738–748.

Holstein, J.A. and Gubrium, J.F. (2000) *The Self We Live By*, Oxford: Oxford University Press.

Hoover, N. (1979) *Nan Hoover*, Amsterdam: Stedelijk Museum.

Hormuth, S.E. (1990) *The Ecology of the Self: Relocation and Self-Concept Change*, Cambridge: Cambridge University Press.

Horning, R. (2013) Google Alert for the Soul, *The New Inquiry*, https://thenewinquiry.com/google-alert-for-the-soul/ accessed 5/7/2019.

Howgate, S. (2017) *Gillian Wearing and Claude Cajun: Behind the Mask Another Mask*, London: National Portrait Gallery.

Huber, H.-D. (ed.) (1997) *Dan Graham Interviews*, Osfildern-Ruit: Cantz.

Hulme, D. (1739) *A Treatise of Human Nature*, Cleveland, OH: Langmans, Green, & Co.

Hutchinson, J., Gombrich, E.H., Njatin, L.B., and Mitchell, W.J.T. (eds) (2000[1995]) *Antony Gormley*, London: Phaidon.

Ince, K. (2000) *Orlan: Millennial Female*, Oxford and New York: Berg.

James, W. (1983[1890]) *The Principles of Psychology*, Cambridge, MA: Harvard University Press.

Jerslev, A. and Mortensen, M. (2015) What Is the Self in the Celebrity Selfie? Celebration, Pathic Communication and Performativity, *Celebrity Studies*, 7:2, 249–263.

Joas, H. (1985) *G.H. Mead: A Contemporary Re-examination of His Thought*, Cambridge: Polity Press.

Jonas, J. (1971) *Untitled Notebook*, Number 11, http://artistarchives.hosting.nyu.edu/JoanJonas/organic-honey-notebooks/, accessed 16/4/2021.

Jonas, J. (1973) Joan Jonas, *Bulletin of the Allen Memorial Art Museum*, 30:3: 131–133.

Jonas, J. (2015) Organic Honey's Visual Telepathy [Introduction and Script] in J. Simon and J. Jonas (eds), *In the Shadow of a Shadow*, New York: Gregory R. Miller & Co., pp. 145–151.

Jonas, J. (2018) Interview: Joan Jonas – The Performer: Joan Jonas and Rachel Rose, www.tate.org.uk/tate-etc/issue-42-spring-2018/interview-joan-jonas-rachel-rose-the-performer, accessed 12/12/2021.

Jonas, J. (2020) Artist Talk During the Opening of Joan Jonas's Exhibition 'Moving Off the Land II', Museo Nacional Thyssen-Bornemisza, Madrid, 24 February 2020, introduced by Francesca Thyssen-Bornemisza, TBA21 founder and chairwoman, and Guillermo Solana, Museo Nacional Thyssen-Bornemisza artistic director, www.youtube.com/watch?v=J4tX8YmMkD8.

Jones, A. (1998) *Body Art: Performing the Subject*, Minneapolis, MN: University of Minnesota Press.

Jones, A. (2002) The 'eternal return': self-portrait photography as a technology of embodiment, *Signs*, 27, 947–978.

Jones, A. (2010) Genital Panic: The Threat of Feminist Bodies and Parafeminism in *Elles@centrepomidou*, Paris: Centre Pompidou, p. 294.

Jopling, A. (2000) *Self-Knowledge and the Self*, London and New York: Routledge.

Jurgenson, N. (2011) The Faux-Vintage Photo: Full Essay (parts 1, 2 and 3), *Cyborgology*, 14 May 2011, http://thesocietypages.org/cyborgology/2011/05/014/the-faux-vintage-photo-full-essay-parts-i-ii-and-iii/, accessed 16/10/2021.

Jurgenson, N. (2019) *The Social Photo: On Photography and Social Media*, London and New York: Verso.

Kahr, M. Mi. (1975) Velázquez and Las Meninas, *Art Bulletin*, 57:2, June, 225–246.

Kant, I. (1929) *Critique of Pure Reason*, trans. N. Kemp Smith, Houndmills, Basingstoke: Macmillan.

Kaye, N. (1996) *Art into Theatre*, Amsterdam: Harwood Academic Publishers.

Keidan, L. (1996) *Totally Wired*, London: I.C.A.

Keller, C. (ed.) (2012) *Francesca Woodman*, San Francisco, CA and New York: San Francisco Museum of Modern Art and DAP.

Kenny, A. (1993) *Aquinas on Mind*, London and New York: Routledge.

Kihlstrom, J.F. and Klein, S.B. (1997) Self-Knowledge and Self-awareness, in J.G. Snodgrass and R. L. Thompson (eds), *The Self Across Psychology: Self-recognition, Self-awareness and the Self Concept (Annals of the New York Academy of Sciences)*, vol. 818, New York: New York Academy of Sciences, pp. 153–208.

Kitnick, A. (ed.) (2011) *Dan Graham*, Cambridge, MA: MIT Press.

Klibansky, R., Panofsky, E., and Saxl, F. (1964) *Saturn and Melancholy*, London: Nelson.

Knafo, D. (2014) *In Her Own Image, Women's Self-Representation in Twentieth-Century Art*, Teaneck, NJ: Fairley Dickinson University Press.

Knapton, S. (2017) 'Selfitis' – The Obsessive Need to Post Selfies – is a Genuine Mental Disorder, Say Psychologists, *The Telegraph*, December 15, www.telegraph.co.uk/science/2017/12/15/self itis-obsessiveneed-post-selfies-genuine-mental-disorder/, accessed 9/7/2019.

Koerner, J.L. (1993) *The Moment of Self-Portraiture in German Renaissance Art*, Chicago, IL and London: University of Chicago Press.

Kohut, H. (1971) *The Analysis of the Self*, Chicago, IL: Chicago University Press.

Kozinets, R., Gretzel, U., and Dinhopl, A. (2016) Self in Art/Self as Art: Museum Selfies as Identity Work, *Frontiers in Psychology*, 8: 731.

Krauss, R. (1976) Video: The Aesthetics of Narcissism, *October*, 1, 50–64.

Krauss, R. (1999) *Bachelors*, Cambridge, MA: MIT Press.

Kristof, J. (1989) Michelangelo as Nicodemus: The Florence Pieta, *The Sixteenth Century Journal*, 20:2, 163–182.

Kusama, Y. (2011) *Infinity Net: The Autobiography of Yayoi Kusama*, trans. R. McCarthy, London: Tate.

Lacan, J. (1949) The mirror stage as formative of the function of the I as revealed in psychoanalytic experience, *Écrits, A Selection*, trans. B. Fink, New York: Norton, pp. 75–81.

Laird, S. (2013) Behold the First 'Selfie' Hashtag in Instagram History, *Mashable*, https://mashable.com/2013/11/19/first-selfie-hashtag-instagram/?europe=true, accessed 5/6/2019.

Leach, D. (2010) The Hand of the Artist: Works by Nan Hoover, *Wallraf-Richartz-Jahrbuch*, 71, 285–300.

Leary, M.R. and Tangney, J.P. (2003) *Handbook of Self and Identity*, New York and London: Guilford Press.

Lee, J.A. and Sung, Y. (2016) Hide-an-Seek: Narcissism and 'Selfie'-related Behaviour, *Cyberpsychological Behaviour Social Network*, 19, 347–351.

Lerner, J. (2014) The Drowned Inventor: Bayard, Daguerre, and the Curious Attractions of Early Photography, *History of Photography*, 38:3, 218–232.

Levin, A. (2014) The Selfie in the Age of Digital Recursion, *Invisible Culture*, 20, http://ivc.lib.rochester.edu/the-selfie-in-the-age-of-digital-recursion/, accessed 7/6/2019.

Levy, S. (ed.) (2007) *The Best of Technology Writing*, Ann Arbor, MI: The University of Michigan Press, pp. 94–114.

Licoppe, C. and Smoreda, Z. (2005) Are Social Networks Technologically Embedded? How Networks Are Changing Today with Changes in Communication Technology, *Social Networks*, 27:4, 317–335.

Liu, J.-C. (2004) Francesca Woodman's Self-Images: Transforming Bodies in the Space of Femininity, *Woman's Art Journal*, 25:1, 26–31.

Lozano Hemmer, R. (n.d.) Zoom Pavilion, www.lozano-hemmer.com/zoom_pavilion.php, accessed 16/6/2019.

Luo, M. (2018) Exploring art (through selfies) with Google Arts and Culture, www.blog.google/outreach-initiatives/arts-culture/exploring-art-through-selfies-google-arts-culture/, accessed 15/6/2019.

Lupton, D. (2016) *The Quantified Self*, Cambridge: Polity Press.

Lyotard, J.-F. (1986) *The Postmodern Condition: A Report on Knowledge*, Manchester: Manchester University Press.

Manchester, E. (2007) *Action Pants: Genital Panic*, Summary, March 2007, www.tate.org.uk/art/artworks/export-action-pants-genital-panic-p79233/text-summary, accessed 28/4/2016.

Manchester, E. (1978) Study for 'Breath of Clay', www.tate.org.uk/art/artworks/penone-study-for-breath-of-clay-t06773, accessed 7/11/2015.

Manchester, E. (2000) Bus Riders 1976–2000, Summary, www.tate.org.uk/art/artworks/sherman-untitled-p78535/text-summary.

Manchester, E. (2001) Cindy Sherman, Untitled A, 1975, November 2000–September 2001, www.tate.org.uk/art/artworks/sherman-untitled-a-p11437, accessed 20/5/2016.

Manchester, E. (2006) Identity Transfer 1–3, 1968, Summary, March 2006, www.tate.org.uk/art/artworks/export-identity-transfer-3-p79180/text-summary, accessed 29/4/2016.

Manchester, E. (2007) Action Pants: Genital Panic, 1969, Summary, March 2007, www.tate.org.uk/art/artworks/export-action-pants-genital-panic-p79233/text-summary, accessed 28/4/2016.

Manchester, E. (2009a) Untitled (Blood and Feather #2) Summary, www.tate.org.uk/art/artworks/mendieta-untitled-silueta-series-mexico-t13357, accessed 27/3/2022.

Manchester, E. (2009b) Untitled (Silueta Series, Mexico) 1974 Summary, www.tate.org.uk/art/artworks/mendieta-untitled-silueta-series-mexico-t13357, accessed 27/3/2022.

Manchester, E. (2009c) Untitled (Silueta Series, Mexico) 1976 Summary, www.tate.org.uk/art/artworks/mendieta-untitled-silueta-series-mexico-t13356, accessed 27/3/2022.

Manchester, E. (2009d) Untitled (Self-Portrait with Blood) 1973 Summary, www.tate.org.uk/art/artworks/mendieta-untitled-self-portrait-with-blood-t13354, accessed 27/3/2022.

Mann, S. (1997) Wearable Computing: A First Step Toward Personal Imaging, *Cybersquare, Computer*, 30:2, www.wearcam.org/ieeecomputer/r2025.htm, accessed 27/3/2022.

Manovich, L. (2015) *Exploring Urban Social Media: Selficity and Broadway*, http://manovich.net/index.php/projects/urbansocialmedia, accessed 8/7/2019.

Mansfield, N. (2000) *Subjectivity: Theories of the Self From Freud to Haraway*, Sydney: Allen & Unwin.

Maraniello, G. and Watkins, J. (eds) (2009), *Giuseppe Penone Writings 1968–2008*, Bologna: Ikon Gallery.

Martin, J.R. (1977) *Baroque*, New York: Harper & Row.

Martin, R. and Barresi, J. (2006) *The Rise and Fall of Soul and Self: An Intellectual History of Personal Identity*, New York: Columbia University Press.

Martin, S. (2006) *Video Art*, Taschen: Cologne.

Marwick, A.E. (2015) Instafame: Luxury Selfies in the Attention Economy, *Public Culture*, https://read.dukeupress.edu/public-culture/article/27/1%20(75)/137/31071/Instafame-Luxury-Selfies-in-the-Attention-Economy, accessed 3/6/2019.

Matthews, G.B. (1992) *Thought's Ego in Augustine and Descartes*, Ithaca, NY: Cornell University Press.

Mauss, M. (2011) *The Gift*, trans. I. Cunnison, Eastford: Martino Fine Books.

McCarthy, P. (1983) The Body Obsolete: Stelarc and Paul McCarthy talk about the power the body has over itself, *High Performance*, 24, 14–19.

McCorquodale, D. (ed.) (1996) *Orlan: This is my body … This is my software …*, London: Black Dog Publishing.

McManus, J. (2008) Mirrors, TRANS/formation and Slippage in the Five-Way Portrait of Marcel Duchamp, *Space Between: Literature and Culture, 1914–1945*, 4:1, 125–149.

McMullan, T. (2018) These photos capture the invisible workers of the internet, www.wired.co.uk/article/photographers-gallery-internet-photography, accessed 30/6/2019.

Mead, G.H. (1934) *Mind, Self, and Society from the Standpoint of a Social Behaviourist*, Chicago, IL: University of Chicago Press.

Meehan, S.R. (2008) *Mediating American Autobiography*, Columbia and London: University of Missouri Press.

Melchior-Bonnet, S. (2002[1994]) *The Mirror: A History*, trans. K.H. Jewett, London and New York: Routledge.

Meller, A. (2021) Who Is Ai-Da?, www.ai-darobot.com/about, accessed 12/12/2021.

Menn, S. (1998) *Descartes and Augustine*, Cambridge: Cambridge Scholars Press.

Meskimmon, M. (1996) *The Art of Reflection: Women Artists' Self-Portraiture in the Twentieth Century*, London: Scarlet Press.

Milgram, S. (1974) *Obedience to Authority: An Experimental View*, New York: Harper & Row.

Miller, J. (1998) *On Reflection*, London: National Gallery Publications.

Miller, V. (2008) New Media, Networking and Phatic Culture, *Convergence*, 14:4, 387–400.

MoMA (1989) *Joan Jonas: Volcano Saga*, www.moma.org/collection/works/118324, accessed 12/12/2021.

MoMA (2007) Publication excerpt from The Museum of Modern Art, *MoMA Highlights since 1980*, New York: The Museum of Modern Art, p. 100.

MoMA (2016) Joan Jonas: Organic Honey's Visual Telepathy, MoMA Multimedia, www.moma.org/explore/multimedia/audios/47/959, accessed 16/4/2021.

Moore, C. (2015) *Socrates and Self-Knowledge*, Cambridge: Cambridge University Press.

Morgan, R. (ed.) (2000) *Gary Hill*, Baltimore, MD and London: Johns Hopkins University Press.

Morris, F. (ed.) (2012) *Yayoi Kusama*, London: Tate.

Mount Holyoke College Art Museum (2019) https://artmuseum.mtholyoke.edu/event/mirror-piece-i-ii-reconfigured-19692018-2019-joan-jonas-58, accessed 12/12/2021.

Mulvay, L. (1975) Visual Pleasure and Narrative Cinema, *Screen* 16:3, 6–18.

Murray, S. (2008) Digital Images, Photo-sharing, and Our Shifting Notions of Everyday Aesthetics, *Journal of Visual Culture*, 7:2, 147–153.

Museum of Ice Cream (2020) www.museumoficecream.com/about, accessed 20/12/2020.

Mussai, R. (ed.) (2018) *Zanele Muholi. Somnyama Ngnyama. Hail the Dark Lioness*, New York: Aperture.

Nail, T. (2017) What Is an Assemblage?, *SubStance*, 46:1, 21–37.

Nancy, J.L. (2006) The Look of the Portrait, in *Multiple Arts: The Muses II*, Stanford, CA: Stanford University Press, pp. 220–249.

Newman, L. (2019) Descartes' Epistemology, *The Stanford Encyclopaedia of Philosophy* (Spring 2019 Edition), Edward N. Zalta (ed.), https://plato.stanford.edu/archives/spr2019/entries/descartes-epistemology/, accessed 27/3/2020.

Nicodemi, G. (1927) Commemorazione di artisti minori: Sofonisba Anguissola, *Emporium*, 222–233.

O'Bryan, C.J. (2005) *Carnal Art: Orlan's Refacing*, Minneapolis, MN and London: University of Minnesota Press.

Owens, C. (1980) The Allegorical Impulse: Toward a Theory of Postmodernism Part 2, *October*, 13 (Summer), 58–80.

Owens, C. (1985) *Beyond Recognition: Representation, Power and Culture*, Berkeley, CA: University of California Press.

Owens, J. (1988) The Self in Aristotle, *The Review of Metaphysics*, 41:4, 707–722.

Palmer, D. (2010) Emotional Archives: Online Photo Sharing and the Cultivation of the Self, *Photographies*, 3:2, 155–171.

Panofsky, E. (1934) Jan Van Eyck's Arnolfini Portrait, *The Burlington Magazine for Connoisseurs*, 64:372 (March 1934), 117–119.

Panofsky, E. (1955) *The Life and Art of Albrecht Dürer*, Princeton, NJ: Princeton University Press.

Parr, M. (2000) *Autoportraits*, Manchester: Dewi Lewis.

Penone, G. (1977) *Giuseppe Penone: Bäume, Augen, Haare, Wände, Tongefäss*, Luzern: Kunstmuseum Luzern.

Penone, G. (1983) Letter to Alan Bowness, 16 November 1983, A21397g, Tate Archive.

Peraica, A. (2017) *Culture of the Selfie*, Amsterdam: Institute of Networked Cultures.

Perlingieri, I.S. (1992) *Sofonisba Anguissola: The First Great Woman Artist of the Renaissance*, New York: Rizzoli.

Phelan, P. and Lane, J. (eds) (1998) *The Ends of Performance*, New York and London: New York University Press.

Pierini, M. (ed.) (2010) *Francesca Woodman*, Milano: Silvana Editoriale.

Pistoletto Foundation, *Michelangelo Pistoletto: Works*, www.pistoletto.it/eng/crono07.htm, accessed 25/12/2016.

Pistoletto, M. (1966) *Minus Objects*, Genova: Galleria La Bertesca.

Pistoletto, M. (1969) Lo Zoo, in *Teatro*, 1, Milano, p. 16.

Pistoletto, M. (1979) Il rinascimento dell'arte, unpublished manuscript, www.pistoletto.it/eng/crono03.htm, accessed 25/1/2016.

Pistoletto, M. (2000) *Michelangelo Pistoletto*, Barcelona: Museu d'Art Contemporani de Barcelona.

Pliny the Elder (1983) Natural History, 35, trans. J.J. Pollitt, *The Art of Rome, c. 753 BC–AD 337: Sources and Documents*, New York: Cambridge University Press, pp. 147–148.

Podro, M. (1999) Rembrandt's Self-Portraits. London and The Hague, *The Burlington Magazine*, 141:1159, 553–556.

Pointon, M. (2013) *Portrayal and the Search for Identity*, London: Reaktion Books.

Prodger, P. (2018) *Victorian Giants*, London: National Portrait Gallery.

Qiu, L., Lu, J., Yang, S., Qu, W., and Zhu, T. (2015) What Does Your Selfie Say About You?, *Computer Human Behaviour*, 52, 443–449.

Quasha, G. and Stein, C. (1993) *Tall Ships, Gary Hill's Projective Installations, n. 2*, New York: Station Hill Arts.

Quasha, G. and Stein, C. (2009) *An Art Of Limina: Gary Hill's Works and Writings*, Barcelona: Ediciones Poligrafa.

Quinn, M. (2009) *Selfs*, Basel: Foundation Beyler.

Raymond, C. (2021) *The Selfie, Temporality, and Contemporary Photography*, London and New York: Routledge.

Reaves, W. W. (2009) *Reflections/Refractions: Self-Portraiture in the Twentieth Century*, Washington D.C.: National Portrait Gallery, Smithsonian Institution.

Remes, P. (2008) *Plotinus on Self: The Philosophy of the 'We'*, Cambridge: Cambridge University Press.

Remes, P. and Sihvola, J. (eds) (2008) *Ancient Philosophy of the Self*, Dordrecht and London: Springer.

Respini, E. (ed.) (2012) *Cindy Sherman*, New York: The Museum of Modern Art.

Reynolds, A., Peter, L., and Clayton, M. (2016) *Portrait of the Artist*, London: Royal Collection Trust.

Richards, T. (1990) *The Commodity Culture of Victorian England, Advertising and the Spectacle, 1851–1914*, London and New York: Verso.

Riches, H. (2004) A Disappearing Act: Francesca Woodman's 'Portrait of a Reputation', *Oxford Art Journal*, 27:1, 97–113.

Richter, G. (2002) A portrait of non-identity, *Monatshefte*, 94:1, 1–9.

Rideal, L. (2001) *Mirror Mirror: Self-portraits by Women Artists*, London: National Portrait Gallery.

Rose, B. (1993) Orlan: Is It Art? Orlan and the Transgressive Act, *Art in America*, 81:2, 83–125.

Rosenthal, S. (ed.) (2013) *Traces. Ana Mendieta*, London: Hayward Gallery and Salzburger Landessammlungen Rupertinum.

Roth, M. (ed.) (1994) *Rediscovering History: Culture, Politics and the Psyche*, Stanford, CA: Stanford University Press.

Rounds, J. (2006) Doing Identity Work in Museums, *Curator*, 49, 133–150.

Royal Academy: Painting the Future (2018) Sky Arts documentary.

Rubinstein, D. and Sluis, K. (2008) A Life More Photographic, *Photographies*, 1:1, 9–28.

Rush, M. (1999) *New Media in Late 20th-Century Art*, New York: Thames & Hudson.

Salley, R.J. (2012) Zanele Muholi's Elements of Survival, *African Arts*, 45:4, 58–69.

Sapir, M. (1994) Hippolyte Bayar's Self-Portrait as a Drowned Man, *MFS Modern Fiction Studies*, 40:3, 619–628.

Sartre, J-P. (1966[1943]) *Being and Nothingness: A Phenomenological Essay on Ontology*, trans. H. E. Barnes, New York: Pocket Books.

Schmidt J.-K. (2001) *Joan Jonas: Performance Video Installation 1968–2000*, Stuttgart: Hantje Cantz Verlag.

Schor, G. (2012) *Cindy Sherman: The Early Works 1975–1977*, Ostfildern: Hantje Cantz.

Schor, G. and Bronfen, E. (eds) (2014) *Francesca Woodman*, Vienna: Walther König.

Schwartz, H. (1996) *The Culture of the Copy*, Cambridge, MA: MIT Press.

Scruton, R. (1981) Photography and Representation, *Critical Enquiry*, 7:3, 577–603.

Seidel, L. (1993) *Jan van Eyck's Arnolfini Portrait, Stories of an Icon*, Cambridge: Cambridge University Press.

Seigel, J. (2005) *The Idea of the Self*, Cambridge: Cambridge University Press.

Shama, S. (1999) *Rembrandt's Eyes*, Harmondsworth: Penguin.

Sheriff, M.D. (1996) *The Exceptional Woman*, Chicago and London: University of Chicago Press.

Shrimplin-Evangelidis, V. (1989) Michelangelo and Nicodemism: The Florentine Pietà, *The Art Bulletin*, 71:1, 58–66.

Simpson, B. and Iles, C. (eds) (2009) *Dan Graham: Beyond*, Cambridge, MA: MIT Press.

Smith, G. (2017) Smoke and Mirrors: Amalia Ulman's Instagram, *OAR: The Oxford Artistic and Practice Based Research Platform*, 1, 80–93.

Smith, M. (ed.) (2005) *Stelarc, The Monograph*, Cambridge, MA: MIT Press.

Sontag, S. (2008[1977]) *On Photography*, Harmondsworth: Penguin.

Sorabji, R. (2006) *Self, Ancient and Modern Insights about Individuality, Life and Death*, Oxford: Oxford University Press.

Spence, J. (1988) *Putting Myself in the Picture: A Political, personal and photographic autobiography*, Seattle, WA: The Real Comet Press.

Steinberg, L. (1968) Michelangelo's Florentine Pieta: The Missing Leg, *The Art Bulletin*, 50(4), 343–353.

Steinberg, L. (1981) Velásquez's Las Meninas, *October*, 19 (Winter), 45–54.

Stelarc (1997) From Psycho to Cyber Strategies: Prosthetics, Robotics and Remote Experience, *Cultural Values*, 1:2, 241–249.

Stelarc (2002a) Stelarc, www.stelarc.va.com.au, accessed 12/4/2002.

Stelarc (2002b) Interview with Gabriella Giannachi, Lancaster, 10 May.

Stelarc (2003) Prosthetic Head, http://stelarc.org/?catID=20241, accessed 19/11/2019.

Stelarc (2005) Extra Ear ¼ Scale, http://stelarc.org/?catID=20240, accessed 19/11/2019.

Stelarc (2006) Ear on Arm, http://stelarc.org/?catID=20242, accessed 13/12/2020.

Stelarc (2019) Partial Head, http://stelarc.org/?catID=20243, accessed 19/11/2019.

Stiles, K. (1999) Corpora Vilia. VALIE EXPORT's Body, in C. Iles, K. Stiles and G. Indiana (eds), *Ob/De+Con(Struction)*, Philadelphia, PA: Cat. Moore College of Art and Design, pp. 17–33.

Sullivan, S.A. (1980) Rembrandt's Self-Portrait with a Dead Bittern, *The Art Bulletin*, 62:2, 236–243.

Sylvester, D. (1975) *Interview with Francis Bacon*, London: Thames & Hudson.

Thomas, R. (2004) *Marc Quinn: Flesh*, Dublin: Irish Museum of Modern Art.

Tifentale, A. and Manovich, L. (2015) Selfiecity: Exploring Photography and Self-fashioning in Social Media, in D.M. Berry and M. Dieter (eds), *Postdigital Aesthetics: Art, Computation and Design*, London: Palgrave, http://manovich.net/index.php/projects/selfiecity-exploring, accessed 7/7/2019.

Tinel-Temple, M., Busetta, L., Monteiro, M. (eds) (2019) *From Self-portrait to Selfie. Representing the Self in the Moving Image*, Oxford and Bern: Peter Lang.

Tomkins, C. and the Editors of Time-Life Books (1966) *The World of Marcel Duchamp 1887–1968*, New York: Time-Life Books.

Torchia, J. (2008) *Exploring Personhood*, Lanham, MD: Rowman & Littlefield.

Townsend, C. and Woodman, G. (2006) *Francesca Woodman*, London: Phaidon.

Tromble, M. and Hershman Leeson, L. (eds) (2005) *The Art and Films of Lynn Hershman Leeson: Secret Agents, Private I*, Berkeley, CA: University of California Press.

Ulman, A. (2014b) Miami Basel – Instagram Script, https://amaliaulman89.livejournal.com/17444.html, accessed 1/7/2019.

Uricchio, W. (2011) The algorithmic turn: Photosynth, augmented reality, and the changing implications of the image, *Visual Studies*, 26:1, 25–35.

V2 (1997) *Technomorphica*, Rotterdam: Naj Publication.

VALIE EXPORT (2000) *VALIE EXPORTt: Ob/De+Con(Struction)*, exhibition catalogue, Philadelphia, PA: Moore College of Art and Design, Los Angeles, CA: Santa Monica Museum of Art and Otis School of Art and Design.

Van De Wetering, E. (1997) *Rembrandt: The Painter at Work*, Amsterdam: Amsterdam University Press.

Van Hoogstraten, S. (1678) *Inleyding tot de hooge schoole der schiderkonst*, Dordrecht: Teeken Academie.

Van Wynsberghe, A. (2018) The Possibility of an Army in an Age of Data Prophecies & Bot Accounts, https://jesuisanthropologue.wordpress.com/2018/06/24/the-possibility-of-an-army-in-an-age-of-data-prophecies-bot-accounts/, accessed 30/6/2019.

Varela, F. J. (1999) The Specious Present: A Neurophenomenology of Time Consciousness, in J. Petiot et al. (eds), *Naturalizing Phenomenology*, Stanford, CA: Stanford University Press, pp. 266–314, www.franzreichle.ch/images/Francisco_Varela/Human_Consciousness_Article02.htm.

Vasari, G. (2007[1550, 1568]) *The Lives of the Most Eminent Painters and Architects*, New York: Modern Library.

Vattese, A. (2000) Dentro lo Specchio, Io Sono L'Altro: Michelangelo Pistoletto, exhibition catalogue, Torino: Galleria Civica d'Arte Moderna e Contemporanea.

Verdon, T. (ed.) (2014) *La porta d'oro del Ghiberti*, Firenze: Mandragora.

Vidler, A., Stewart, S., and Mitchell, W.J.T. (eds) (2007) *Antony Gormley, Blind Light*, London: Hayward Publishing.

Virilio, P. (1996[1993]) *The Art of the Motor*, trans. J. Rose, Minneapolis, MN and London: University of Minnesota Press.

Viso, O. (2004) *Ana Mendieta: Earth Body, Sculpture and Performance 1972–1985*, exhibition catalogue, Hirshhorn Museum and Sculpture Garden, Washington DC: Smithsonian Institution.

Viso, O. (2008) *Unseen Mendieta: The Unpublished Works of Ana Mendieta*, Munich, Berlin, London and New York: Prestel.

Vohra, P. (2015) Teri Selfie ki Aankh. Ladies Make Selfies, Gents Make Art, http://theladiesfinger. com/teri-selfie-ki-aankh-ladies-make-selfies-gents-make-art/, accessed 4/4/2019.

Wald, C. (2007) *Hysteria, Trauma and Melancholia: Performative Maladies in Contemporary Anglophone Drama*, Houndmills: Palgrave Macmillan.

Wasserman, J. (2003) *Michelangelo's Florence Pietà*, Princeton,NJ and Oxford: Princeton University Press.

Watson, A. (2014) Who Am I? The Self/Subject According to Psychoanalytic Theory, *Sage*, 4(3), 1–14, http://nrs.harvard.edu/urn-3:HUL.InstRepos:12328212, accessed 6/7/2017.

Wearing, G. (2012) *Wearing*, London: Whitechapel Gallery.

Weibel, P. (ed.) (2016) *Lynn Hershman Leeson: Civic Radar*, Karlsruhe, ZKM: Hantje Cantz.

Wendt, B. (2014) *The Allure of the Selfie*, Amsterdam: The Institute of Network Cultures.

West, S. (2004) *Portraiture*, Oxford: Oxford University Press.

Westgeest, H. (2016) *Video Art Theory*, Chichester: Wiley & Blackwell.

White, C. (1981[1971]) *Dürer: The Artist and His Drawings*, London and New York: Phaidon.

White, C. and Buvelot, Q. (eds) (1999) *Rembrandt by Himself*, London and The Hague: National Gallery Publications and Royal Cabinet of Paintings, and Yale University Press.

Wickham, A. and Salter, R. (2017) *Artists Working from Life*, London: Royal Academy of Arts.

Widrichm, M. (2008) Can Photographs Make It So? Several Outbreaks of VALIE EXPORT'S Genital Panic 1969–2005, in H. van Gelder and H. Westgeest (eds), *Photography Between Poetry and Politics*, Leuven: Leuven University Press.

Wilson, A. (2001) Cindy Sherman, *Art Monthly*, 242, 33–34.

Wilson, D.M. (2012) Facing the Camera: Self-Portraits of Photographers as Artists, *The Journal of Aesthetics and Art Criticism*, 70:1, 55–66.

Wilson, J. (1980) Ana Mendieta Plants Her Garden, Village Voice, 13, 71.

Wilson, S., Onfray, M., Stone, A.R., François, S., and Adams, P. (eds) (1996) *Orlan*, London: Black Dog Publishing.

Wind, E. (1958) *Pagan Mysteries of the Renaissance*, New Haven, CT: Yale University Press.

Wood, C. (1999) Pistoletto: Reflecting Ourselves, *The Lancet*, 354, 2089.

Wood, C. (2018) *Performance in Contemporary Art*, London: Tate Publishing.

Woodall, J. (1997) *Portraiture: Facing the Subject*, Manchester: Manchester University Press.

Woods-Marsden, J. (1998) *Renaissance Self-Portraiture: The Visual Construction of Identity and the Social Status of the Artist*, New Haven, CT and London: Yale University Press.

Wright, C. (1982) *Rembrandt: Self-Portraits*, London: Gordon Fraser.

Yakamura, M. (2015) *Yayoi Kusama: Inventing the singular*, Cambridge, MA: MIT Press.

Yang, L., Sun, T., Zhang, M., and Mei, Q. (2012) We Know What @You #Tag: Does the Dual Role Affect Hashatg Adoption?, *WWW 2012 – Session Behaviours Analysis and Content Characterisation in Social Media*, 261–270.

Zimbardo, P. (2007) *The Lucifer Effect: How Good People Turn Evil*, New York: Random House.

Zippay, L. (1991) *Electronic Art Intermix: Video*, New York: Electronic Art Intermix.

Zylinska, J. (2002) *The Cyborg Experiments: The Extensions of the Body in the Media Age*, London and New York: Continuum.

Index

Abramović, M. 61
Acconci, V. 93
Adorno, T. 44
Ai-Da 112–113
Alberti, L.B. 16, 18, 31, 72
Alpers, S. 31, 32, 36, 43
Ammann, J.C. 79–80, 82
Anguissola, S. 24
Antin, E. 76–77
Aquinas 2
Arasse, D. 27, 28
Arte Povera 78–82
arbitrary framing 43
Aristotle 2
Augustine 2
Auslander, P. 44, 87

Bacon, F. 33–4
Bak 71
Baker, C. 125–126
Baldwin, J. 3
Barthes, R. 43, 44, 54, 61, 69
Bateson, G. 97
Bayard, H. 45
Benjamin, W. 8
Berger, J. 30
Berkeley, G. 3
Bing, I. 47
bioart 86
Birnbaum, D. 9
Blanchot, G. 102
Boccaccio, G. 14–15
Botticelli 17, 84
Breder, H. 51, 53

Calabrese, O. 16, 18, 21, 38
Caravaggio 22, 25, 64, 121
Carracci, A. 26, 27, 30
Cahun, C. 49–51, 54, 55, 56, 62, 65
Cashed Collective 132–133
Celant, G. 41, 78–82
Cellini, B. 22
Chadwick, W. 38

Chapman, H.P. 34
Clark, T.J. 14, 37
Cooley, C. 3–4
Cornelius, R. 45
Cortwright, P. 121, 128
Crosswaite, D. 94–95
Cumming, L. 18
cyborg 7, 89, 90, 92
Cyzicus 14

Dalí, S. 38
Damasio, A. 8–9
Darwin, C. 46
David, J.-L. 37
Deleuze, G. 5–6, 120
Derrida, J. 6
Dery, M. 87, 89
Descartes 2–3
Dolci, C. 27
Duchamp, M. 47–48, 50, 56, 95
Dullaart, C. 123
Dürer, A. 18–22, 28, 29, 38, 75, 121

Elias, N. 6
Epicharmus 2
EXPORT, V. 60–61

Fenara, I. 111
Foucault, M. 5, 9, 35
Freud, S. 45, 21
Fried, M. 25

Gasser, M. 17, 32
Genet, J. 32
Gentileschi, A. 25
Ghiberti, L. 72
Giddens, A. 6
Goffman, E. 5, 7, 28
Goldin, N. 76
Gombrich, E. 83
Google Arts and Culture 124
Gormley, A. 82–84
Goya, F. de, 75

Graham, D. 96–100
Greenblatt, S. 20
Guattari, F. 120
Gumpp, J. 27, 38, 47

Hall, J. 13, 71
Haraway, D. 7
Hayles, K. 7, 51
Hershman Leeson, L. 56–60, 105–110,
 126, 131
Hill, G. 100–103
Homer 2
Hoover, N. 94
Hulme, D. 3
Husserl, E. 9, 96, 97

identity 1, 3–4, 6, 8–9, 13, 20, 22, 28, 32, 34,
 38–39, 42, 46–47, 51, 56, 60, 62, 63, 67, 77,
 84, 87, 94, 104, 105, 106, 108, 109,111,
 116–117, 120, 123, 126, 129–133
immediacy 43, 45, 55, 63, 95, 116
immersion 39
Ingres, D. 37
Internet of Things 7, 9, 12, 112–114, 116,
 119–120, 129, 131–132, 134

James, W. 4
Jonas, J. 103–105
Jones, A. 50

Kahlo, F. 38–39, 52, 76
Kant 3
Keller, C. 56
Kihlstrom, J.F. 6
Kirchner, E. L. 76
Klein, Y. 44, 46
Klein, S.B. 6
Kodak 118–119
Koerner, J.L. 20, 21
Kokoschka, O. 30
Kraft, A. 72
Krauss, R. 54, 63, 93
Kusama, Y. 39

Lacan, J. 4
Leonardo 23, 26, 35, 38, 84, 121
Locke, J. 3
Lovelace, A. 112
Lozano Hemmer, R. 124–125
Lyotard, J.-F. 6

Magid, J. 111
Manchester, E. 51, 52, 60–1, 63–64, 81
Mangolte, B. 104–5
Manovich, L. 115
Marcia 14–15
Masaccio 24

Mattes, E. and F. 121
Mauss, M. 43
Mead, G. 4
Melchior-Bonnet, S. 14, 18, 28
Mendieta, A. 51–54, 56, 70, 95, 122
Messerschmidt, F.X. 75
Metaverse 12, 113
Michelangelo, 22, 24, 72–4, 78
Miller, J. 28
Miró, J. 37, /6
Mofokeng, S. 67
Morimura, Y. 121
Muholi, Z. 67–70
Munch, E. 75, 77
murano mirror 16

Nancy, J. L. 13–14
Nauman, B. 95
Nicodemus 73–4
Ni-ankh-Ptah 71

Obrist H.U. 9, 84, 123, 127
Orlan 84–87

Panaetius 2
Panofsky, E. 18, 19, 20, 34
Parler, P. 72
Peraica, A. 117
Parmigianino 23–24, 25, 51, 94
Parr, M. 121
Penone, G. 78–82
perception 3, 34, 89, 93–98, 100, 102, 104
Perlingieri, I.S. 24
personhood 1, 3
Phidias 71
Picasso, P. 38
Pistoletto, M. 39
Pliny the Elder 14
Plotinus 2
Plutarch 2, 72
presence 1, 2, 8–10, 11, 13, 14, 16, 18, 28, 32,
 34, 35, 37, 39, 41, 43, 47, 55, 61, 67, 70, 75,
 78–79, 81, 85, 88, 91, 93, 94–96, 97, 98, 100,
 101, 102, 103, 104, 105, 106, 112, 114, 119,
 120, 123, 126, 127, 132, 134; connected
 presence 119; co-presencing 9–10; hospitality
 of presence 9; public presence 119; social
 presence 120
Ptah-hotep 71

Quinn, M. 77–78

rAndom International, 126
Raphael 17, 26, 30, 64
Ray, M. 47, 48, 59
Rejlander, O. 46
Rembrandt 28–24, 34, 38, 46, 75, 84

Ringgold, F. 77
Rist, P. 94–95
Rockwell, N. 38
Rufilus of Weissenau 15

Scourti, E. 129–132
Seidel, L. 18
self 1–9, 16; data self 132; definition 2; embodied
 self 2; extreme self 9; looking glass self 4;
 metaself 8; non continuous self 2; post-human
 selves 7; relational selves 6–7; self fashioning
 20, 36; self identity 5–6; self-network 89;
 self-obliteration 39; selves portrait 84, 86;
 social selves 3–4; socialised self 28; staged
 self 28; substantial self 3
selfie 49, 64, 113, 114–133; celebrity selfies 119;
 data selfie 111; Selfiecity 115, 119
Seneca 2
Shama, S. 30
Sherman, C. 61–64, 122
Socrates 2
soul 2, 4, 5, 34, 53
Spence, J. 77
St Dunstan 15
Steinberg, L. 35, 74
Stelarc 87–92
Stiles, K. 58

Titian 22, 30

Tissue Culture Art Project 91

Ulman, A. 126–129, 131

Van Eyck, J. 17–18, 36, 105–106
Van de Wetering, E. 29, 30, 32
Van Gogh, V. 38, 76, 121
Varela, F. 96
Vasari, G. 22, 26
Vasari Corridor 26–28, 94
Vattese, A. 39
Velázquez, D. 25, 34–36
Vermeer, J. 25, 36
Vigée Le Brun, E.L. 36–37
Viola, B. 94

Warhol, A. 48, 62
wearable computing 110–111
Wearing, G. 65–67
Weibel, P. 56
West, S. 13, 28, 35
Wilke, H. 77
Wood, C. 42, 44, 129
Woodall, J. 22, 24
Woodman, F. 54–56

Yeo, J. 111–112

Zorio, G. 78–79